IMAGE OF CHINA

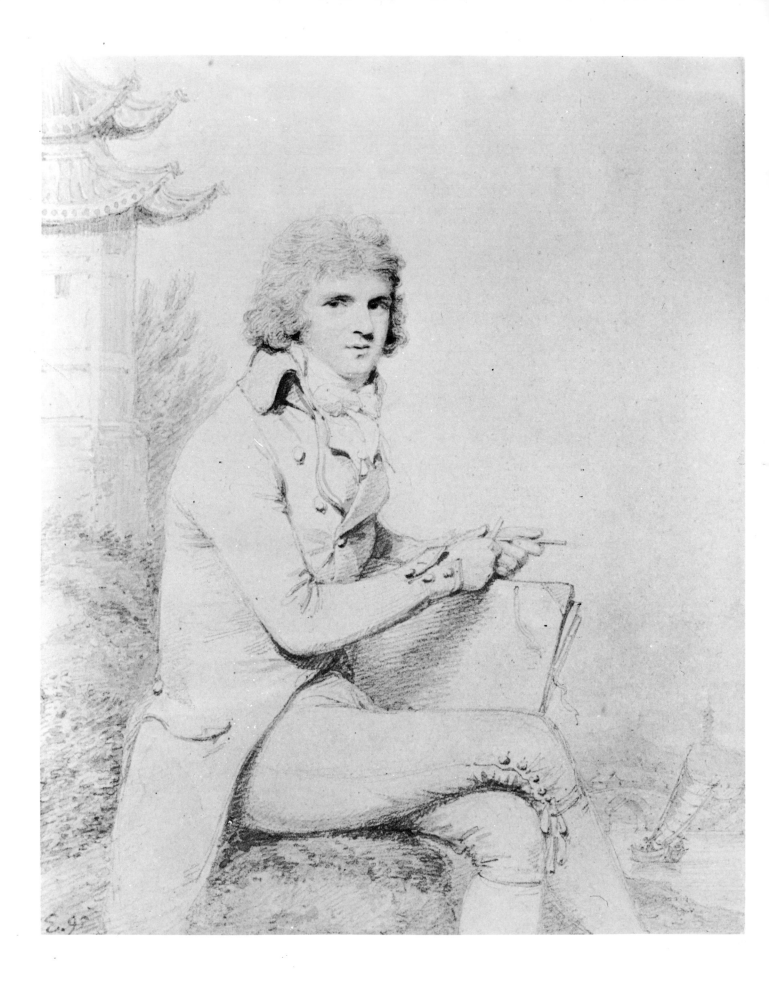

IMAGE OF CHINA

WILLIAM ALEXANDER

Susan Legouix

JUPITER BOOKS *Publishers*

London

(*frontispiece*) Henry EDRIDGE (1769–1821)
Portrait of William Alexander
LONDON, collection of the late S. R. Hughes-Smith. Pencil and grey wash 18 × 14·5 cm. Initialled and dated lower left: H.E. 95

At the Royal Acadamy in 1796 Edridge exhibited a *Portrait of an Artist* (*Mr. Alexander*), which may have been this picture. Edridge, who was a close friend of Alexander and studied with him at the Royal Academy, made two other pencil and wash portraits of him, one of which belonged to Sir Thomas Lawrence, was engraved by Charles Picart, and is now lost, and the other, dated 1804, is in the collection of the late S. R. Hughes-Smith. The drawing illustrated here, by far the most attractive of the three, shows Alexander in a Chinese setting with a portfolio at his knee, sharpening a pencil.

Notes to the Text
Alexander's manuscript *Journal of a Voyage to Pekin in China on board the Hindostan E.I.M. which accompanied Lord Macartney on his Embassy to the Emperor* is referred to throughout the book as his *Journal*, Sir George Staunton's *An Authentic Account of an Embassy from the King of Great Britain to the Emperor of China* (1797) is abbreviated to *Staunton*, Aeneas Anderson's *A Narrative of the British Embassy to China in the Years 1792, 1793 and 1794* is shortened to his *Narrative* and J. L. Cranmer-Byng's *An Embassy to China, Being the Journal Kept by Lord Macartney during his Embassy to the Emperor Ch'ien-lung 1793–4* (1962) is called *Macartney's Journal*. The Wade-Giles system of romanizing Chinese characters used by Cranmer-Byng in his edition of *Macartney's Journal* has been adopted for this book. In cases where Alexander's transcription varies significantly his spelling is also noted. When quoting from Alexander's *Journal* it has occasionally been necessary to insert punctuation in order to make a passage more easily understood, but his words and spelling are always unchanged.

First Published in Great Britain by

JUPITER BOOKS (LONDON) LIMITED, 167 Hermitage Road, London N4 1LZ.

ISBN 0 906379 37 7

This book was produced in Yugoslavia

WILLIAM ALEXANDER

WILLIAM ALEXANDER was born and died in Maidstone, the county town of Kent, but the Alexander family came from the small neighbouring village of Boxley, and it is in Boxley Church that a simple plaque to the artist's memory records his achievements:

He accompanied the Embassy to China in 1792 and by the power of his pencil introduced into Europe a better knowledge of the habits and manners of China than had before been attained. That he was rich in the feelings and knowledge of art his works evince. He was a man of mild and engaging manners, active benevolence and unsullied integrity. Waiting patiently for the glory, honour, and immortality brought to light by the Gospel. He was born at Maidstone 10th April 1767. Died 23rd July 1816.

As a brief introduction to the life and work of Alexander this summary could hardly be improved upon. It draws attention to the highlight of his career, a journey to China as a member of the first official British embassy to that country and describes the wealth of his artistic talent and his likeable and quiet character.

William was one of the four children of Harry Alexander and his wife Elizabeth Samwell who was a native of Beaumaris, Anglesey. Harry had a coach-building business at 56 Week Street, Maidstone, and his brother Thomas, William's uncle, shared the same trade and lived a little further along the road in a house seen to the extreme right in a delightful watercolour now in the Maidstone Museum (Plate II). William retained a close relationship with his family and with Maidstone throughout his life. Sadly no direct line of his branch of the Alexander family has survived. His brother James, also an artist of some ability, emigrated to America in 1818 and died in Florida in 1821 without leaving any family and his other brother Harry (Plate 70), a sailor, died at the age of 31 in 1802 without children. William's sister Sarah, however, married a Mr. Henry Ovington in 1818. She and her husband also emigrated to America and one of their descendants, a Mrs. Catherine Stephens of Columbia, South America, visited Maidstone in 1902 and presented to the museum three pen-and-ink drawings by James Alexander.

When William Alexander died in 1816 he was staying with his uncle, Thomas Alexander, and it was Thomas's grandson Edward Hughes (1823–1913) who was responsible for keeping together a number of drawings and papers connected with the artist and who safely deposited in the British Museum his manuscript account of the embassy to China and his *Self-portrait* (Plate I). In more recent times Gerald Stephen Hughes (1878–1959) of York, a nephew of Edward Hughes, actively collected drawings by Alexander and these he bequeathed to the Maidstone Museum. Maidstone and its municipal collection make a useful starting-point for the study of Alexander, but for larger collections containing first-rate examples of his work it is necessary to turn to the India Office Library, London, which houses some 870 drawings, to the British Museum, London, the Victoria and Albert Museum, London, the Yale Center for British Art, New Haven, and the Huntington Library, San Marino, California. A considerable number of works of quality are also in private hands and today Alexander drawings, and in particular those of China, are much sought after at auction.

Given the fascinating oriental subject matter of many of the artist's drawings and the widespread distribution of his work in collections public and private (see Appendix II) it may at first seem curious that his name is not better known. One of the reasons may be that his drawing style is, like his character, quiet and unassuming, but there are also several practical explanations for the relative obscurity of his reputation. Much of his work was and still is contained in albums and cannot be easily displayed, and, being very delicate in colour, those works intended to be hung on the wall are susceptible to the damaging effect of light and are nowadays, if they belong to Museums, only placed on public view for strictly limited periods of time, if at all. Furthermore many of his sketches of both Chinese and English subjects were destined to be book illustrations rather than wall pictures and so the finished objects have come under the care of librarians rather than art historians and have been physically dissociated from the working drawings from which they evolved. Although it is known from the catalogue of the sale of Alexander's collection after his death that he executed a few oil paintings, this medium was clearly not his forte and no

oils are known today.

In attempting to piece together a picture of the artist's career one must start at Maidstone. Through his early home life Alexander would have been familiar with the practice of coach-painting rather than any form of fine art, but the locality had connections with the art world which may have played some small part in the channelling of the boy's career. Maidstone was the birthplace of the eminent engraver William Woollett (1735–85) and of his pupil James Jefferys (1751–84) who excelled as a draughtsman in the Neo-Classical style but died young. The town was also chosen as a place of retirement by William Shipley (1715–1803) founder of the academy of art usually known as 'Shipley's School' and of the Royal Society of Arts. Alexander was educated at the grammar school under the Rev. Thomas Cherry who afterwards became headmaster of the Merchant Taylors' School in London. In 1782, at the age of fifteen, he left Maidstone for London and it is generally supposed that there he began his artistic training under William Pars A.R.A. This tradition has been fostered by all the reference books from Redgrave to Thieme-Becker, although it is only necessary to turn to another page in each of the same sources to find that it cannot be substantiated. William Pars had been in Italy since 1775, when Alexander was only eight, and he died there in 1782 without having returned to England. The source of the mistake seems to be the obituary for Alexander in the *Gentleman's Magazine* of 1816. It is just possible that a grain of truth may be gleaned from the traditional Pars-Alexander story. The author of the obituary could have confused the name of William Pars with that of his less well-known elder brother Henry Pars who from the 1760s until his death in 1806 managed 'Shipley's School'. By the time of Alexander's childhood Shipley was living in Maidstone and it is not beyond the bounds of possibility that he introduced the aspiring artist to his successor Henry Pars as a pupil. This, however, remains only conjecture. What is more certain is that for some time between 1782 and 1784 Alexander was apprenticed to Julius Caesar Ibbetson (1759–1817), the painter of rustic figures, animals and landscapes. Ibbetson had come to London in 1777 from Yorkshire, but he only exhibited for the first time at the Royal Academy in 1785 and at the period of his association with Alexander he was a relatively unknown artist.

On 27 February 1784, at the age of almost seventeen, Alexander enrolled at the Royal Academy as a student of painting and he stayed there for the usual period of seven years before embarking on the trip to China in 1792, which may have been the first professional engagement he undertook. Before looking into the circumstances and results of the China expedition an attempt must be made to define the origins of Alexander's drawing style, although this is not at all easy. The usual artists cited as having an influence on him are William Pars and Ibbetson, and so without Pars it becomes necessary to examine Ibbetson more closely and to look for a stylistic link with him. The result of this exercise is rather unproductive. In general Ibbetson's brushwork is much more vigorous than Alexander's and his compositions are often dramatized by areas of contrasting tonality and by bold diagonal accents which are quite alien to anything in Alexander. Despite this, there is one sphere in which the younger artist may be seen to have profited from the influence of his master, and that is in the characterization of figures. The work of both artists shows a close interest in costume, in linking gestures between figures and a particular tenderness in the depiction of children. Another artist whose treatment of individual figures and groups may have influenced the young painter is Edward Dayes (1763–1804), who first exhibited at the Royal Academy in 1786. But it is not possible to pinpoint any one or two outstanding influences on Alexander's early style and the task of setting his work in context is made more difficult by the fact that nearly all his known drawings of before c. 1796 are of Chinese subjects. Fourteen of his pictures were hung at the Academy between 1795–1800 and thirteen of them were of China. None at all can be assigned to the pre-Chinese period and so one can only guess at the appearance of works produced at the Academy. The *Gentleman's Magazine* obituary states that he spent a good deal of time copying paintings by other artists and attracted the praise and encouragement of Sir Joshua Reynolds for his endeavours. That he had a great facility for patient copying can be seen from his drawings of Greek, Roman and Egyptian antiquities and hieroglyphs made in the last decade of his life (Plates 84 and 85) and it is likely that the steady application to copying as a student instilled in him a sense of the importance of accuracy to detail. It is the impression of the 'close-up' view which makes his Chinese drawings so rich visually and interesting historically.

Alexander's place in relation to other artists of his day emerges more clearly when the later part of his life and his English topographical works are considered. Meanwhile his Chinese work has to be assessed more or less in isolation, as until George Chinnery (1774–1852) went to Macao on the China coast in 1825 no British artist had quite the same opportunity to depict the oriental way of life (fig. 1). Even Chinnery's work does not make a fair comparison as he did not share the experience of visiting Peking and witnessing the ceremonial of the anachronistic imperial court, the subject the British public at home particularly wanted to see. Macao and Canton, the towns which feature in Chinnery's work, were also visited by Thomas Daniell (1749–1840) and his nephew William (1769–1837), but the majority of their Eastern drawings, and the best of them, come from India rather than China. Another artist who visited China was John Webber (1750–1793) who accompanied Captain Cook's third and last voyage

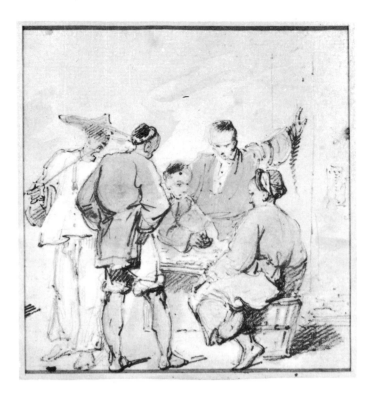

fig. 1 George CHINNERY (1774–1852)
Group of Five Chinese
London, Courtauld Institute of Art, Witt
collection. Pencil and watercolour
13·3 × 11·6 cm.

Chinnery arrived on the China coast in 1825,
over thirty years later than Alexander. He
never penetrated the interior of China but left
a full and vivid picture of Macao and Canton
in the first half of the nineteenth century
through his sketches and watercolours. If this
figure group is compared to compositions by
Alexander such as *Peasantry Playing Dice* (Plate
61), it can be seen with what greater ease
Chinnery captured the movements and
physiognomy of the Chinese, though he lacked
Alexander's interest in costume and in the
characterization of individuals.

between 1776–80 but he, like the Daniells, did not
venture far inland.

The inaccessibility of the interior of China was the
fundamental reason for the British embassy which
Alexander accompanied. Since the 1760s when Western
trade with China first became substantial the so-called
'Canton system' had been in operation. British merch-
ants, in practice the East India Company who had been
granted a monopoly of the China trade, were obliged to
deal only with the Cohong, a body of Chinese merchants
in Canton. The foreigners were limited to living and
working in 'factories' outside the city walls and were
subject to endless restrictions, including not being
allowed to have their wives with them. The trade for
the British was mainly in selling cottons and woollens
from India and the West and purchasing silk, tea and
curios. The British, wishing to establish more friendly
relations and to open up contacts with Peking in order

to improve trading prospects, planned to approach
Ch'ien-lung, the Emperor of China himself, through an
official deputation and to place an ambassador in
permanent residence in the imperial city. A first
attempt to achieve this end had been made in 1788
with Charles Cathcart as ambassador, but the trip was
abortive. Cathcart died of tuberculosis on Java and the
expedition was forced to return home. On this occasion
the official draughtsman employed to record the mission
had been Ibbetson, Alexander's former master. When
he was asked to join the new embassy under Lord
Macartney (fig. 2) in 1792, Ibbetson declined, recom-
mending instead the young Alexander. Although it was
the unusual practice to engage artists on explorative
voyages (Cook had taken John Webber and William
Hodges), the case for obtaining a full and reliable
picture of China was of more than usual importance.
The influence of the orient had been a vital factor in
European architecture, ceramics, furniture design and
landscape gardening for the best part of the eighteenth
century. During the period 1730–60 in particular, the
British gentry had been busily decorating their gardens
with Chinese pavilions and bridges, installing lacquered
furniture and fittings and generally indulging in every
kind of *chinoiserie*: the duke of Cumberland even had a
Chinese yacht. Although the call for *chinoiserie* was
waning by the end of the century, it remained a positive ·
feature of British taste into the nineteenth century (as is
dramatically demonstrated by the Royal Pavilion at
Brighton) and so any first-hand study of Chinese life
was bound to be viewed with considerable curiosity and
interest by the educated public. Alexander must have
realized that he would have every chance of capitalizing
on his experiences on his return home. In the event he
spent at least seven years reworking his China sketches
to produce a large body of finished watercolours and
printed illustrations.

After being delayed for several days by bad weather
the ambassadorial party sailed from Portsmouth on 26
September 1792. Lord Macartney and his immediate
entourage travelled in the warship *Lion* (on which,
coincidentally, Alexander's brother served, see Plates
67 and 70) while Alexander was one of those on board
the second ship the *Hindostan*, which was also laden
with gifts for the emperor. Alexander noted in his
Journal on 9 July 1794 that his cabin was the aftmost on
the *Hindostan* and being thus situated had no gun posi-
tion which meant he did not suffer the same inconveni-
ence as his fellow travellers during the firing of salutes
or other exercises. The *Journal* which supplies this and
a wealth of other information is the most important
documentary source for Alexander's part in the embassy.
It belonged to the family and was deposited with the
Maidstone Museum until 1897 when Edward Hughes
removed it, as a result of his disapproval of the curator,
and gave it to the Department of Prints and Drawings
of the British Museum. It was transferred to the manu-

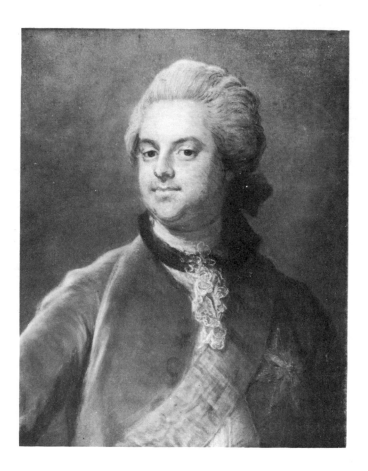

George Macartney was born in County
Antrim, Northern Ireland, and studied at
Trinity College, Dublin. He embarked on a
political career in London under the infl ence
of Lord Holland and Lord Sandwich in the
early 1760s. In 1764 he was appointed envoy
to Russia and this pastel portrait of him was
probably drawn in Stockholm in 1767 when
Macartney was returning home from St.
Petersburg. After Russia Macartney was
employed in various diplomatic posts in
Britain and abroad, culminating in his
appointment as governor of Madras in 1781.
In 1791 he was in England without
employment and his experience in foreign
diplomacy coupled with his personal qualities
made him the obvious choice as Ambassador
to China. He was raised to the title of viscount
Macartney of Dervock in the County of
Antrim a few months before the departure for
the East.

scripts section of the British Museum Library the
following year. The bound manuscript consists of
eighty pages of continuous notes in the form of a diary
followed by numerous notes and jottings on weather
conditions, soundings, flag-signalling codes, a list of
Chinese words, a record of the occupants of the
Hindostan and even one or two drawings of coastlines.
At first sight the principal diary section would appear to
be the original manuscript. It is often hurried and
contains corrections and changes of mind suggesting
that it was written on the spot, but closer scrutiny
reveals that it is more likely to be a copy of earlier notes
and that Alexander may even have intended to prepare
it for publication. In parts of the text there are notes,
proposing alternative arrangements of sentences or
paragraphs and there are references to Sir George
Staunton's published account of the embassy which
appeared in 1797 and to Alexander's own *The Costume
of China* which was published in 1805. Moreover it is
clear from the way the ink flows from one entry to the
next that the notes were not always made day by day.
This does not of course detract from the interest of the
manuscript and if it is read in conjunction with the
other journals kept by several of Alexander's fellow
travellers it provides much information which is
essential for an understanding of the drawings.

Journals were kept by Lord Macartney; Sir George
Staunton, secretary to the embassy; George Thomas
Staunton, his son, and page to Lord Macartney; Sir
John Barrow, comptroller; Aeneas Anderson, Lord
Macartney's personal valet; Sir Erasmus Gower,
captain of the *Lion*; Samuel Holmes, a private in the
detachment of light Dragoons who accompanied the
trip; Dr. Hüttner, the tutor to young George Staunton;
and James Dinwiddie, a doctor. Perhaps the most
valuable and absorbing of these accounts is Lord
Macartney's *Journal*, a detailed account which was only
published as recently as 1962, admirably edited and
annotated by J. L. Cranmer-Byng.

From all this documentation we can gain a full and
often amusing picture of the expedition. Anderson, for
instance, gives a colourful description of the most tense
and long-awaited moment of the whole trip, the pro-
cession of the ambassador and his retinue and escort
from their lodgings in Jehol to their official meeting
with the emperor (Plates 42 and VI). The party had to
embark very early in the morning when it was barely
light and Anderson related, 'Whether it was the attrac-
tion of our music, or any accidental circumstance, I
know not, we found ourselves inter-mingled with a
cohort of pigs, asses, and dogs, which broke our ranks,
such as they were, and put us into irrecoverable con-
fusion.' Alexander too was not afraid to put on record
one of the indignities he personally suffered while
riding through Peking. He wrote:

The horses are indifferent and generally very ill appointed with
furniture, I had no stirrups, and my animal lagging, received as is
customary, a lash from an attendant. The plunge made me lose my
seat, and my falling was an exhibition which offered much
entertainment to the numerous spectators in a public street in
Peking . . .

Alexander, like the other diarists, kept notes from the
moment of departure from Portsmouth. The *Lion* and
Hindostan journeyed together to China via Madeira,
Tenerife, the Cape Verde Islands, Rio de Janeiro, Java
and Cochin China. For our purposes the most import-

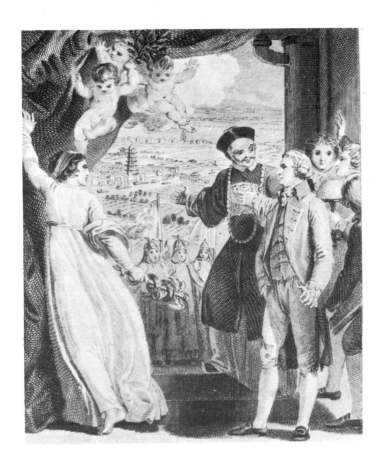

fig. 3 Charles GRIGNION (1716–1810) after
Thomas STOTHARD (1755–1834)
An Historical Account of the Embassy to China (Sir
George Staunton, 1797), frontispiece: *The Earl
of Macartney's Entrance to China*
Line engraving 14 × 11·2 cm.

An explanation of this illustration precedes the
text to the shortened edition of *Staunton*
compiled by John Stockdale. 'The Frontispiece
represents the Earl of Macartney's Entrance to
China, introduced by a Mandarine. In the
background are Cities, Canals etc. The three
Figures, between the Mandarine and the
Female representing Commerce, are Soldiers of
the Emperor.' This grandiose conception of
commerce opening up a way into China
appears rather absurd in the light of the
negative outcome of the embassy. John Barrow
in *Travels in China* quotes from a letter written
by a French missionary concerning the failure
of the British to make any impression on the
Chinese. It begins, 'Never was an Embassy
deserving of better success! Whether it be
considered on account of the experience, the
wisdom, and the amiable qualities of Lord
Macartney and Sir George Staunton; or of the
talents, the knowledge, and the circumspect
behaviour of the gentlemen who composed
their Suite; or of the valuable and curious
presents intended for the Emperor—and yet,
strange to tell, never was there an embassy
that succeeded so ill.'

ant section is that which deals with the period from the
arrival in Cochin China (now Vietnam) in May 1793
until the departure from Macao in February 1794. It is,
however, worth quoting briefly from Alexander's notes
on Madeira, in which he wrote on 10 October 1792:
'The island had a romantic yet beautiful appearance
while rounding it. The forms of the rocks varying as we
approached it were grand and picturesque'. By
'romantic' as used here and elsewhere in the *Journal* he
probably meant rugged, wild or striking in appearance.
The concept of the romantic and the picturesque was
of particular significance at this time. Within two years
the antiquary Richard Payne Knight (1750–1824) was
to publish his poetic essay on the picturesque, *Landscape:
A Didactic Poem*, and in 1798 the Preface to *Lyrical
Ballads* by Wordsworth and Coleridge contained a
passage of writing which is usually accepted as the
starting point of the romantic movement in literature.
Cranmer-Byng noted how close in style some of
Macartney's descriptive passages are to Wordsworth,
and Alexander, while admitting himself not a man of
'literary attainments' showed by his word usage that he
was very much a man of his time. A drawing by him
which expresses particularly well the idea of the
romantic in nature is *The Rock of Kuan-yin* (Plate 68),
executed some time after the return to England.

The first location for which a large body of drawings
survives is Cochin China. Here the ships of the embassy
spent just over two weeks anchored in the harbour of
Tourane Bay (now Da Nang) while provisions and
water were taken aboard and the sick were taken
ashore to be cared for. At this time Alexander gave one
of his very rare accounts of making a drawing. The
entry in his *Journal* for 3 June 1793 reads:

This morning a Mandarin from court with many attendants came
on board to see our ship. He came into my cabin with another
[mandarin] of inferior rank who sat a few minutes while I made a
slight sketch of him at which he seemed highly pleased and pressed
me to let him have it, which I declined, and offered him any other
prints instead, or to make a copy of that, but nothing else would do.
I persevered in keeping [the] sketch, so he went out in a huff. His
servants (who carry his betel, umberellas, swords, etc.) made free to
carry off some of my drawing implements and other articles which
were scattered about.

The India Office Library collection contains a number
of attractive drawings of the Tourane Bay region
including a *View near Tourane Bay* (Plate 22) and an
Elephant, Tourane Bay (Plate 21) made on the same day
as the unfortunate incident with the mandarin occur-
red. About the town of Tourane (which he spells
'Turon') Alexander noted in the *Journal* with obvious
distaste, 'On walking about the town or environs you
are continually importuned by the men, making signs
for you to go [to] their women, even to their wives
I have no doubt in consideration of a Dollar or two.'

From Cochin China the *Lion* and *Hindostan* sailed
northwards and anchored off Macao on 20 June and off
Chusan on 3 July. At Chusan Sir George Staunton went

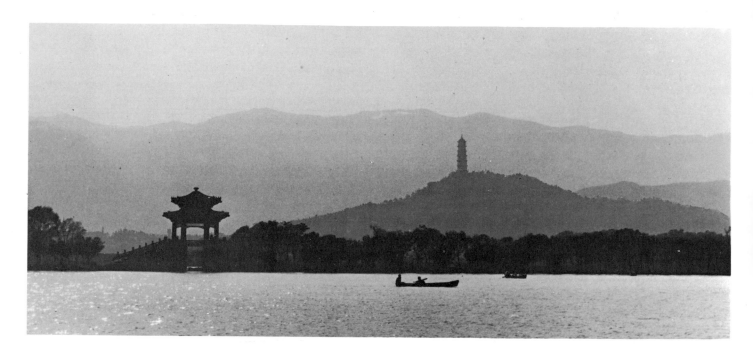

fig. 4 Kunming Lake and the Pagoda of the
Jade Fountain
Photograph by Ron Sloman, 1978

The 'new' Summer Palace, first developed by
the Emperor Ch'ien-lung and later re-created
by the Empress Tzu Hsi in the nineteenth
century, is on the shores of Kunming Lake,
north west of Peking. The hilltop pagoda is
probably the one adapted by Alexander for
his *View in the Gardens of the Imperial Palace in
Peking* (Plate 40).

ashore to find pilots to guide the ships to the Gulf of
Peichihli from where the party intended to travel up
the Peiho River to Peking. On 6 August, after all the
baggage and presents had been transferred from the
British ships to Chinese river-craft for the next stage of
the journey, the passengers were themselves installed in
junks and began at last, after eleven months away from
home, to experience the Chinese way of life. Alexander
recorded that he, Mr. Hickey, Dr. Dinwiddie and Mr.
Barrow shared a junk. 'Mr. Hickey' was the portrait
painter Thomas Hickey (1741–1824), a friend of
Macartney's, who was officially 'painter' to the
embassy, while Alexander was 'draughtsman'. John
Barrow in his *Autobiographical Memoir* said of him, 'Mr.
Hickey, an indifferent portrait-painter, was a country-
man of Lord Macartney, whose portrait he had painted;
and being now out of employment, his lordship, it was
said, took him out of compassion; I believe he executed
nothing whatever while on the Embassy, but in con-
versation he was a shrewd, clever man'. Despite the fact
that he received £200 per annum, twice Alexander's
salary, it appears to be true that Hickey made very few
drawings while in China. There are two slight sketches,
one in the British Museum and one in the India Office
Library collection, and one other framed and therefore

probably finished drawing is listed as lot 1217 in the
catalogue of the sale of Alexander's collection as '*View
in China* by Tho. Hickex [sic], Painter to the Embassy to
China 1793 and 4.' Whatever Hickey's real part in the
embassy may have been, he and Alexander appear to
have been on good terms and his name is regularly
mentioned in the *Journal*.

It was at the entrance to the Peiho that the embassy
first met up with the two mandarins who were to act as
guides throughout the stay in China, Wang and Chou.
Alexander, in common with all the other British
commentators, immediately took a liking to both men.
On 8 August, within only a few days of Wang's
appointment, he wrote of him:

A mandarin of the first rank having a red ball and peacock's feather
in his cap, is appointed by the Emperor to the charge and care of
the Embassy and is to accompany his Excellency [Lord Macartney]
on his route. He is a fine, jolly fellow and of most free and affable
manners. I made two marine drawings for him while here at Ta-kou
[Taku], the subjects being our squadron, viz. H.M.I. the Lion, 64,
the Hindostan E.I.M., 30 guns, and the three brigs, Jackall,
Clarence and Endeavour.

Alexander's confidence in the Chinese officialdom,
which must have been shaken by his earlier encounter
with the Cochin Chinese mandarin, was fully restored
by the example of Wang and Chou, and the number of
drawings of them which exist bears witness to the
friendly relations he enjoyed with both men (Plates 24
and 25).

On 16 August the junks carrying the embassy com-
pleted their passage up the Peiho River at Tungchow,
about twelve miles from Peking. Here Alexander
executed one of his most beautiful views of China
(Plates 28 and V) and wrote in his *Journal* of the
'Prodigious concourse of people [who] were assembled
to witness our arrival, immense numbers standing up to
their middles in the water.' From Tungchow the British

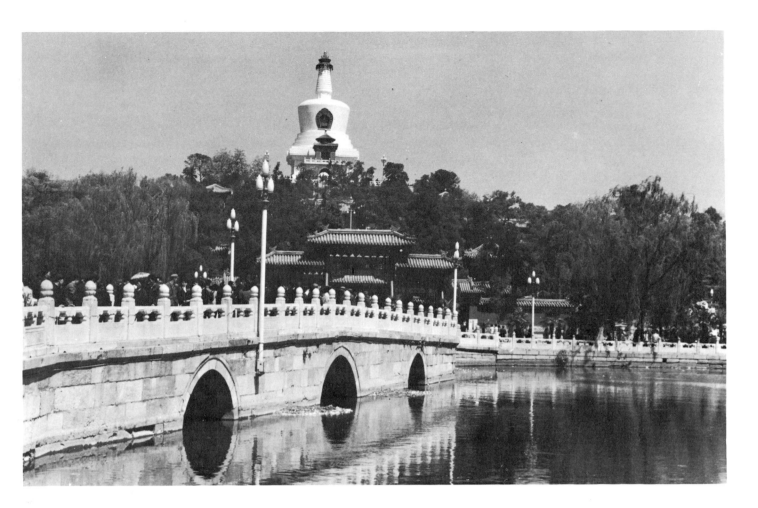

fig. 5 Ch'ung Hua Tao, the Island of
Hortensias on Pei Hai, the northern lake in
Peking
Photograph by Ron Sloman, 1978

A view of the island surmounted by the White
Dagoba, Pai T'a, appears in Alexander's *View
in the Gardens of the Imperial Palace in Peking*
(Plate 40). The bridge and the gate at the end
of it can be seen in the top right corner of the
print after a design by Castiglione (fig. 9)
which Alexander used as a basis for his
representation of the audience ceremony at
Jehol (Plates 42 and VI).

embarked on what was for the less-privileged the most
uncomfortable leg of the journey. While the ambassador
and his immediate retinue travelled in the relative
comfort of sedan chairs, the rest of the party were
confined to unsprung horse-drawn carts (Plates 29 and
30) in which they suffered so badly from the heat, dust,
jolting and lack of air that they did not fully recover for
a week. On arrival in Peking the ambassador passed
through the main public street, festooned with stream-
ers, and on to Yuan-ming Yuan where the embassy was
to be accommodated. Alexander and one or two others
chose to cross the city by humbler streets in order to see
more of the reality of the life of ordinary citizens. Yuan-
ming Yuan, a magnificent complex of pavilions and
gardens about seven miles outside Peking, was found to
be unsuitable for a stay of any length of time and

Macartney quickly organized a transfer to better
lodgings in the town itself (Plate 32).

Shortly after the arrival at Peking Alexander had to
shoulder the blow of learning that he was not to be
included in the ambassador's party who were to pro-
ceed to Jehol to meet the emperor. The emperor tradi-
tionally remained at his summer residence in Tartary
until the end of September and rather than await his
return the Chinese arranged for Macartney to go north
to meet him there. Hickey, Alexander, Maxwell, one
of the secretaries, Barrow and Doctors Scott and Din-
widdie were among those left behind, ostensibly to
supervise the unpacking and arranging of presents for
the emperor at Yuan-ming Yuan. Alexander never got
over this great disappointment. In his *Journal* he wrote,

To have been within 50 miles of that stupendous monument of
human labour, the famous Great Wall, and not to have seen that
which might have been the boast of a man's grandson, as Dr.
Johnson has said, I have to regret forever. That the artists should be
doomed to remain immured at Peking during the most interesting
journey of the Embassy is not easily to be accounted for.

The ambassador set out for Jehol on 2 September and
did not return until the 25 September. Alexander later
told Farington that during this time he and Hickey were
confined to a house in Peking surrounded by a high
wall and were not allowed to go freely into the city (see
Plate 32). It was therefore a 'great joy' to welcome back
the ambassadorial suite who brought presents from the

fig. 6 Two porcelain bowls presented to Alexander
London, collection of the late S. R. Hughes-Smith. Chinese, second half of the eighteenth century.

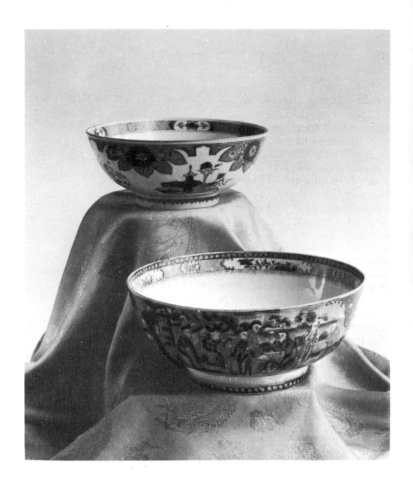

These bowls bear old labels stating that they were presented to Alexander by the emperor and they have remained with the family collection to the present day. How the artist actually acquired them is, however, something of a mystery. He mentioned in his *Journal* that he received gifts from the emperor on two occasions, 30 September and 3 October 1793, but none of the objects he listed sounds like either of these pieces of porcelain. On 30 September he wrote: 'Those who remained at Pekin while his Excellency was in Tartary also received presents from the Emperor. Mine were 3 Rolls of Silk, a hard lump of Tea having the shape and size of a bowl, a handsome China cup, an embroidered purse and a fan'. On 3 October members of the embassy visited the Imperial Palace at Peking and found presents laid out for them. Alexander's were '8 Rolls of cut velvet, satin and silk of various patterns, each piece containing from 10 to 15 yards, 2 small cannisters of Tea flowers, 2 flat cakes of [word illegible] Tea, 1 Chest of Tea, of very bad quality, about 80 lb., a small box of tobacco, and a few trifles as a sandalwood fan etc. etc.'.

emperor for those who had remained behind. Alexander listed the gifts he received (see fig. 6): 'Mine were 3 Rolls of Silk, a hard lump of Tea, having the shape and size of a bowl, a handsome China cup, an embroidered purse and a fan.' Very soon after the return of the emperor to Peking the British received notice that they were to prepare to leave the country. So instead of a leisurely stay in the city until the spring, as Macartney had planned, the embassy was forced to pack hurriedly and begin their journey south on 7 October.

Since he was left behind during the trip to Jehol, Alexander had to make drawings of events and views in Tartary from verbal descriptions and from the drawings of Lieutenant Henry William Parish who was required to make sketches, plans and measurements of the Great Wall and other features of interest in addition to commanding the twenty Royal Artillerymen escorting the ambassador. Parish's watercolours are uninspired (fig. 8), but they provided enough information for Alexander to build upon and later create convincing representations of the Potala at Jehol (see Plate 47) and other scenes which he had not personally witnessed. For his reconstruction of the meeting of the British ambassador and the emperor, Alexander looked further afield, to an earlier print after a design by Giuseppe Castiglione (1688–1766), the Jesuit artist working in Peking (fig. 9).

From Peking the British were allowed to take an overland route to Canton. They travelled down the Peiho and the Grand Canal by means of junks, taking about a month to reach Hangchow, a city situated roughly at the half-way point between Peking and Canton. Alexander busied himself making innumerable sketches of life on the Canal, some of which were later worked up into large finished watercolours such as those of Lin-ching-shih (Plate 49), and Soochow (Plates 51 and VII). On 7 November, three days before arriving at Hangchow, Alexander faced his second major disappointment of the trip. He was told that he and several other members of the retinue were to discontinue their journey inland and to join the *Hindostan*, which was anchored off Chusan, and travel ahead by sea to Canton. He lamented, 'His Excellency saw my sketches etc. etc. and applauded my industry, but I cannot reconcile this with preventing the exercise of my pencil in passing through such an extent of country as from hence to Canton through the interior of the Empire.' No satisfactory explanation for Alexander's unhappy treatment can be given, but it appears that Macartney did not rate particularly highly the importance of making a visual record of the embassy. He would not, after all, have taken Hickey, a portrait painter, if one of his prime concerns had been to bring back the fullest possible picture of the country.

The *Hindostan* took only a few days to sail to Canton and Alexander and Dinwiddie went ashore on 12 December. Alexander mentions visiting the English

fig. 7 Alexander's name written in Chinese characters
London, British Library, Department of Manuscripts. (Add. MS 35174, fol. 94). Ink 11·5 × 3 cm.

This label was attached to the presents Alexander received 'kneeling' at the Imperial Palace on 3 October 1793. It is affixed among miscellaneous items at the back of his *Journal* in the British Library. The Wade-Giles romanization of the characters is 'Ting-shi-kuan E-le-sang-te'. 'Ting-shi-kuan' means literally 'official waiting for orders' which the Chinese presumably thought was a suitable title for a rather junior member of the British delegation. The transliteration 'E-le-sang-te' is not only a phonetic approximation for Alexander but also a name in Chinese. 'E-le' is a Manchu (or Tartar) surname and 'sang-te' is a respectable Chinese given name. The members of the embassy were in general given names with aristocratic or at least respectable overtones, a sign of approval on the part of the imperial court. Foreign visitors regarded as enemies or barbarians had their names transliterated by means of strange or derogatory words.

'factory' and admiring the views of India by Thomas Daniell which hung in the dining-room there, and also the informal calls he paid on two local artists Puqua and Chamfou whom he was rather surprised to find copying prints by the British artists Henry Bunbury and Angelica Kauffman. He also visited on more than one occasion the workshop of a sculptor who modelled portrtrait busts in a European style and advertised himself on his door as 'Handsome Face Maker'. His work would, Alexander observed, have been quite acceptable had it not been coloured with 'blue coats, red cheeks and powdered hair.'

After spending some time in the Portuguese settlement of Macao (Plates 65–67) the *Lion* and *Hindostan* set out for England, and apart from some frightening storms near the Cape of Good Hope, where Alexander described the scene as 'altogether awfully sublime', the journey home was uneventful and the travellers thankfully put ashore on 10 September 1794. Although Alexander does not mention it in his *Journal*, the artists Thomas and William Daniell travelled home on another ship in the same convoy as the *Hindostan*. The outbreak of war with France had made all sea-travel dangerous and a number of ships had assembled at Canton in order to return to England with Lord Macartney's embassy. The whole convoy comprised thirteen East Indiamen and three foreign vessels as well as the *Lion* and *Hindostan*. The Daniells, who were returning from a spell of working in India, were presumably aboard one of the East Indiamen.

Of the very large number of Chinese drawings by Alexander known today, only a fairly small proportion are the original sketches made during the embassy. Occasionally the spontaneous handling of a sketch such

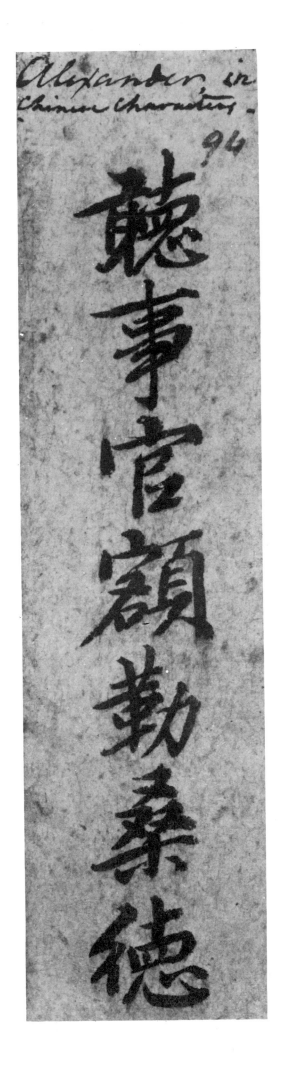

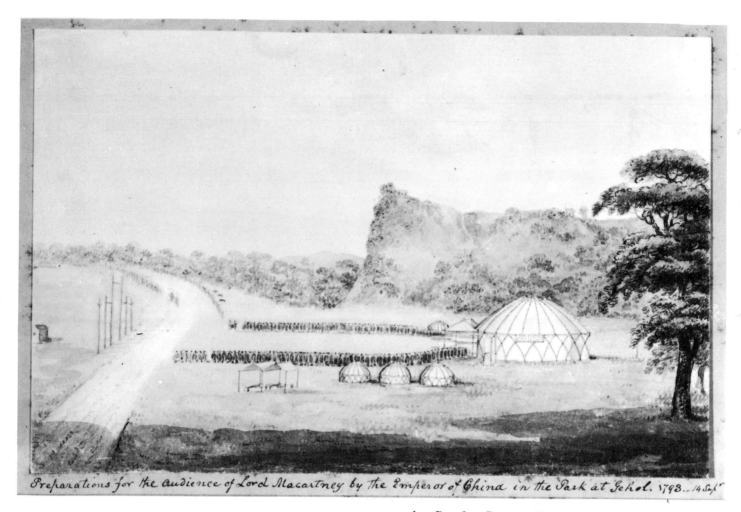

Preparations for the audience of Lord Macartney by the Emperor of China in the Park at Gehol. 1793.— 14 Sept.

fig. 8 Henry William PARISH (d. 1798?)
Preparations for the Audience of Lord Macartney by the Emperor of China at Jehol
London, sold Sotheby's 1 April 1976. Pencil, pen and watercolour 17 × 26 cm. Signed and dated lower right: H. W. Parish 1793.

Alexander made a copy of this sketch by Parish. It is now preserved in volume III of the India Office Library collection and is inscribed by Alexander: 'Emperor's arrival at the Tent in Vun shiu yuen or garden of 10,000 trees on the morning of the British Ambassador's introduction. From a drawing by Capt. Parish. Roy: Art:' Accompanying the Parish watercolour in the Sotheby sale of 1 April 1976 was a sketch map of the same scene which was also copied by Alexander in a sketch in the same volume in the India Office Library collection. Despite this Alexander chose to ignore or change a good deal of the information about the audience contained in Parish's sketch and map when he came to make his own drawings of the scene (Plates 42 and VI). Parish shows quite clearly small circular tents on either side of the Imperial tent and a frame for the use of acrobats opposite the opening of the main tent. For these Alexander substitutes a grouping of one circular and one rectangular tent and a tree, features which appear in Giuseppe Castiglione's engraving of an earlier audience ceremony given by the same Emperor Ch'ien-lung (fig. 9).

as the *Barefoot Peasant* (Plate 13) convinces us that it must have been made from life, but in many other cases drawings which give every appearance of being first sketches are found to exist in two or three other versions and it is almost impossible to establish the sequence in which they were produced. The collection which contains the largest number of unfinished and seemingly early sketches is that in the India Office Library, London, and although the provenance of these drawings, now bound in three volumes, is unrecorded, they may be the set sold for £173 and 5 shillings to 'Wilkins' as lot 868 on day 7 of the sale of Alexander's collection in 1817 (see Appendix II). From the early studies Alexander set to work producing finished watercolours for sale and for the use of engravers, his first major task being the illustrations for Sir George Staunton's *An Authentic Account of an Embassy . . . to the Emperor of China* (*Staunton*). This was published in 1797 as two text volumes, with vignette illustrations after Alexander, and a folio volume of line-engraved plates. Many of the engravings are dated 1796 and so the drawings for them must have been made within a year or eighteen months after the arrival home. In addition to the plates for *Staunton* (see Plates 7, 38 and 47), Alexander provided John Barrow with drawings to be reproduced in aquatint in his *Travels in China* published in 1804 and *A Voyage to Cochin China* of 1806 (see Appendix II). The publication of greatest interest to the student of

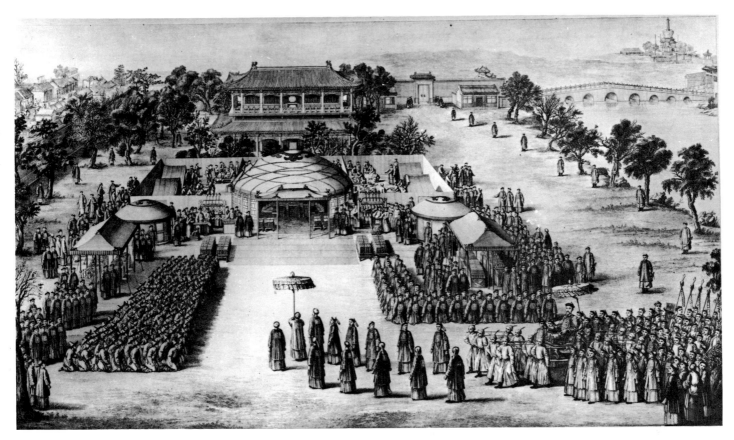

fig. 9 Jacques Philippe LE BAS (1707–1783)
after a design attributed to Giuseppe
CASTIGLIONE (1688–1766)
The Emperor Giving a Victory Banquet in Peking to
the Officers and Soldiers who Distinguished
themselves in Battle
Paris, Musée Guimet. Print dated 1770. Line
engraving 52 × 89 cm.

This is the last print in a series of sixteen
Conquests of the Emperor Ch'ien-lung. The original
designs were made for the emperor by
Castiglione and other Jesuit painters working
in Peking, and the one illustrated here depicts
the arrival of the emperor at a victory banquet
in April 1760. The scene is beside Pei Hai in
Peking and a view of the White Dagoba (fig.
5) can be seen in the top right corner. Ch'ien-
lung was an admirer of the European
technique of line engraving and he
commissioned prints of the sixteen scenes in
1765, instructing that the drawings should be
'sent to Europe where the best artists in
copper shall be chosen so that they may
render each of these prints perfectly in all its
parts . . .' Charles-Nicolas Cochin of Paris
was given overall charge of the project, and
the plates, together with 200 impressions of
each design, were sent to China in 1772.
Alexander must have seen this print before he
composed his *The Approach of the Emperor of*
China to his Tent in Tartary to Receive the British
Ambassador (Plates 42 and VI). The placing
and style of the tents is very similar in both
pictures as is the formation of the emperor's
attendants in front of his palanquin. The high
viewpoint taken by Castiglione is also adopted
by Alexander. It is not known whether
Alexander saw an impression of the Le Bas
print illustrated here or one of the small scale
set copied by Isidore-Stanislas Helman, one of
Le Bas's pupils, which was published in 1785.

Alexander is, however, *The Costume of China*, a series of
forty-eight aquatints etched by the artist himself and
accompanied by his own explanatory captions.

The Costume of China appeared as a bound volume in
1805, published by William Miller at six guineas, but
the prints were originally produced in groups of four at
three-monthly intervals, the first set being dated 20 July
1797 and the last 1 November 1804. Whether or not the
prints were ever put on sale in these small groups is not
clear, but today *The Costume of China* is only known
through Miller's single volume and most commentators
overlook the fact that the earliest of its illustrations
belong to the same year as *Staunton.* William Miller
issued a series of costume books, the first of which, in
1800, was another *Costume of China* with plates after the
Chinese artist Puqua whom Alexander had met in
Canton. In 1812 John Murray took over Miller's
Albermarle Street premises and in 1814 published a
cheaper series under the general title of *Picturesque*
Representations which sold at three guineas each. To this
series belongs Alexander's *Picturesque Representations of*
the Dress and Manners of the Chinese. The title-page of
Picturesque Representations of the Dress and Manners of the
Austrians shows that Alexander was also the author of
the text of this book and the British Library catalogue
attributes the text of the two remaining books in the
series, on the Russians and Turks, to him. The differ-
ence in quality between *The Costume of China* and
Picturesque Representations . . . of the Chinese echoes the
difference in price. In the first book the figures are seen
against carefully planned backgrounds and are drawn

and etched with great affection and precision while those in the second are starkly set on the white page and generally lack facial character. There is no documentary evidence that Alexander was not himself responsible for the plates to *Picturesque Representations . . . of the Chinese* although the quality of the etching is greatly inferior to that in the earlier book.

The Costume of China appears to have been a popular success. A French edition was published in two volumes in 1815 and the plates were copied in lithography for Bazin de Malpière's *La Chine*, published in Paris between 1825–?39. Thomas and William Daniell's *Picturesque Voyage to India by the Way of China* of 1810 is probably influenced in a general way by both plates and text of *The Costume of China* and many of the illustrations by Thomas Allom to the Rev. G. N. Wright's *China Illustrated* (1843) include direct borrowings from Alexander's plates (see fig. 10). Further interesting examples of the influence of Alexander's printed work are in the Royal Pavilion, Brighton. The Music Room, thought to have been designed to resemble the Palace of the Great Khan at Shandu as described by Marco Polo, is lined with wall-paintings containing architectural elements and figures taken from *The Costume of China* and the folio plate volume of *Staunton* (see Plate 52). The scheme for the paintings, which are romantic landscapes in yellow and gold on a red ground, was designed by Frederick Crace (1799–1859) and the actual painting was carried out by an obscure artist named Lambelet between 1818–22. It is thought that the details of pagodas, shrines and figures selected from Alexander may have been provided by an equally little-known painter, Edward Fox. Elsewhere in the Pavilion, over the stairs at either end of the Corridor or Long Gallery are windows painted with figures taken from Sir William Chambers's *Designs for Furniture, Pottery, Figurines etc. . . . in the Chinese Style*, Alexander's *Costume of China* and the plate volume of *Staunton*. The figures derived from Alexander are after plates fourteen and twenty-nine of *The Costume of China* (Plate 62) and plate thirty of *Staunton*.

While it is clear that Alexander's Chinese work occupied him on and off until his last years (*Picturesque Representations . . . of the Chinese* was published only two years before he died), he also made a name for himself as an English topographical artist and, as a close friend of Dr. Thomas Monro, was at the centre of that most exciting period of watercolour painting associated with the 'Monro Academy'. The *Journal* provides us with much useful documentary information on the early part of his career, but it is less easy to form a picture of Alexander's personal life after 1794. In 1795 he married a Miss Jane Wogan who died not long afterwards. It was said that he never fully recovered from the shock of her death and he never remarried. The Royal Academy catalogues show him to have been resident at 79 Berwick Street, Soho, in 1795 and then at 4 Poland Street until 1801 when he moved to 42 Newman Street. Probably the most important influence on Alexander's English drawing style in the 1790s was the senior watercolourist Thomas Hearne (1744–1817). Hearne was a regular visitor to the Maidstone home of William Jefferys, father of the Neo-classical draughtsman James Jefferys, and so Alexander might first have met him in his home town, but it is equally possible that the two artists became acquainted through Dr. Monro. Between 1795 and 1805 Monro rented a house at Fetcham, near Leatherhead (Plate 73), and here artists including Turner, Cotman, Varley, Farington, Edridge, Hearne and Alexander met and went out on drawing expeditions in the neighbourhood. Alexander's *Old Cottage near Dorking* (Plate 77) was probably made during one of these visits to Fetcham. Monro also entertained artists at his London home, 8 Adelphi Terrace, where in the evenings he allowed them to study and copy his own collection of paintings and drawings. Alexander would have had ample opportunity to assimilate the style of Hearne, who was one of Monro's favourites, as well as learning from the example of the older masters such as Canaletto, Gainsborough and Wilson. A copy by him of *Buildings* by Canaletto appeared in a sale at Christie's on 13 February 1872. The sale of Alexander's collection in 1817 shows that he had a taste for Gainsborough drawings which was probably acquired from Monro. He owned a *Portrait of a Boy*, a small oil *Landscape*, a 'beautiful specimen', and a group of fifty-five sketches of landscapes, figures, cattle and 'horses ploughing', three of which were engraved by Wells and Laporte (fig. 11). The oil may have been the 'small upright landscape' lent by Alexander to an exhibition at the British Institution in 1814, but as with the other works by Gainsborough from his collection its present whereabouts cannot be traced.

Alexander's association with Monro lasted throughout his life. In his diaries Edward Thomas Monro, eldest son of Thomas and also a doctor, mentioned Alexander's name a number of times. On 13 January 1807, for example, he noted that 'Mr. Daniell, Farington, Hearne, Edridge and Alexander dined'. On 12 July 1816, shortly before the artist's death he wrote, 'Saw Mr. Alexander at British Museum with my Father.'

In 1799 a group of artists from the Monro circle formed a sketching club under the leadership of Thomas Girtin (1775–1802), one of the younger artists who, after Hearne, appears to have made the most impression on Alexander. The club met in the evenings at the house of each member in turn. The host member set the subject to be drawn, provided the materials and refreshments and afterwards became the owner of all the pictures produced during the evening. Alexander was host at one of these meetings on 5 May 1802 when the others present were Paul Sandby Munn and his brother William Munn, T. R. Underwood, John Sell

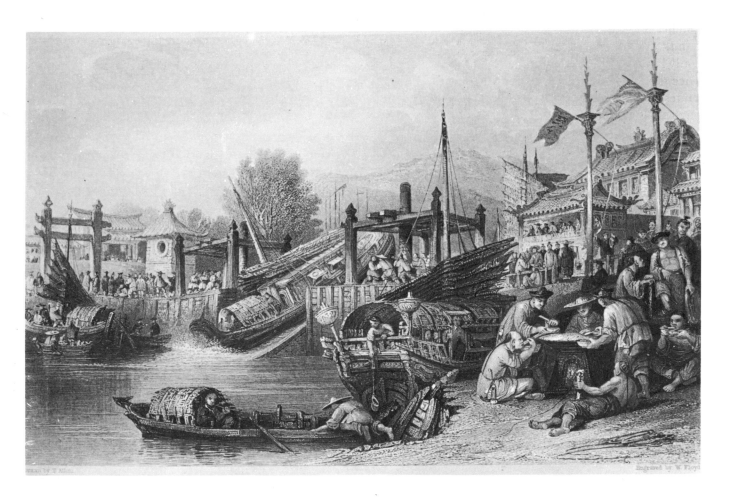

Allom was trained and practised as an
architect but he is probably better known
today through his numerous topographical
watercolours and book illustrations. Although
his views of China are particularly attractive,
there is no evidence that he ever visited the
country himself. Several of the illustrations to
China Illustrated by Allom are inscribed 'From a
sketch on the spot by Lieut: White, Royal
Marines', or 'sketched on the spot by Capt.n
Stoddart R.N.', but those which are clearly
borrowed from Alexander bear no
acknowledgement. *Junks Passing an Inclined
Plane on the Imperial Canal* is a disguised and
glamourized version of Alexander's *Boat
Passing over an Inclined Plane near Ning Po* (Plates
59 and IX) incorporating features of *Peasantry
Playing Dice* (Plate 61). Allom has altered the
viewpoint, tidied the rough thatch of the small
tabernacle and given finials to the plain
wooden beams of the capstan equipment. He
has also misunderstood the function of the
semi-circular mat held up at the front of the
boat in Alexander's picture, making it a part
of the structure of the junk. His greatest
misunderstanding, and one which certainly
suggests he did not know the geography of
China, is in the title he gives to his
illustration, for the glacis depicted by
Alexander was on a waterway between
Hangchow and Chusan near Ning Po and it is
unlikely that there were any such devices on
the Grand Canal. Allom's illustrations *A
Devotee Consulting the Sticks of Fate, Melon Islands
and Irrigating Wheel, Chinese Boatmen Economizing
Time and Labour, The Poo-ta-la or Great Temple
near Zhehol, Tartary, Raree Show at Lin-sin-choo*
and *Western Gate, Peking* and a large number of
others from the same publication are all
derived from designs by Alexander for *Staunton,
The Costume of China and Picturesque
Representations.*

Cotman and Fleetwood Varley.

By 1802 Alexander's income from his Chinese
drawings and prints had become insufficient for him to
live on and he sought regular employment. With the
support of Joseph Farington he secured the post of
master of landscape drawing at the Royal Military
College at Great Marlow in Buckinghamshire. This,
however, was only achieved after some complex
behind-the-scenes debate between the authorities of the
college and after the withdrawal of no less a competitor
than the young John Constable. The position was
advertised in January 1802 and a warrant confirming
Alexander's appointment is dated 29 August 1802. On
19 December Farington recorded a visit from Alex-

fig. 11 John LAPORTE (1761–1839) after
Thomas GAINSBOROUGH (1727–1788)
*A Collection of Prints Illustrative of English Scenery
from the Drawings and Sketches of Thomas
Gainsborough R.A.* (London, 1819), unnumbered
plate: *Tree Study*
Print published March 1802. Engraving
27 × 19·5 cm.

An inscription beneath this print indicates
that it was 'From the Original in the
Collection of Mr. Alexander.' Two other
illustrations from the collection produced by
Laporte and Wells were after drawings in the
possession of Alexander, a *Wooded Valley* and a
Landscape with a Lake. The catalogue of the sale
of Alexander's collection at Sotheby's after his
death shows that he owned drawings by a
wide variety of masters including Reynolds,
Wilson, Hogarth, Mortimer, Paul Sandby,
Ibbetson, Hearne, J. R. Cozens, John Varley,
Rowlandson, Turner and Girtin, and oils and
oil sketches by Reynolds, Webber, Zuccarelli,
Zoffany and Fuseli.

ander:

Alexander called today. He is established . . . at the Military
College, by my recommendation to Col. Le Marchant.—He feels
the advantage of the situation as a relief from Anxiety abt. Income.
After the lesson of the day is over He can sit down by his fire, witht.
the reflection that the business of the day is interrupted, or the
means of living not earned.—His Salary is £200 a year,—and a
sufficient allowance to pay for his House rent. He has 6 Bushels of
Coals a week allowed, and candles,—paper etc.—His time of
teaching is from 10 o Clock in the morning till 12.

On 29 October 1803 the young William Delamotte
joined Alexander at the College as an assistant drawing
master, and a second assistant, William Sawrey Gilpin,
son of the animal painter, was appointed on 8 March
1806. Although it appears from Farington that Alex-
ander was at first well satisfied with his employment,
the situation changed in 1806, and a letter from him to
Colonel Butler, commandant of the Junior Department,
outlines his grievances:

Great Marlow 5th Aug. 1806
Dear Sir,
 By the new Regulations I am employed three times in each week
beyond my engagements with the college, this, added to the portion
of time allotted to preparing examples, as also the great dis-
advantage of an afternoon attendance, which deprives me of any
long interval of time, has altogether rendered my appointment too
laborious and inconvenient for my present salary.
 It will not therefore I trust be considered unreasonable, that I
should expect for such additional service an adequate compensa-
tion. Should my request be deemed inadmissable in the judgement
of the Board, I regret to say I must in justice to myself retire from a
duty I have so long endeavoured to discharge to their satisfaction.
 I am, Sir . . .
 Wm. Alexander

There is no indication as to how or whether these
problems were resolved, but further representations
made by Delamotte and Gilpin suggest that difficulties
persisted, and it comes as little surprise that Alexander
resigned in 1808.

He was fortunate enough to be appointed Assistant
Keeper in the Department of Antiquities at the British
Museum, with responsibility for prints and drawings,
a new post created after it was discovered that Robert
Dighton, a trusted dealer friend of the librarian had
been helping himself to prints from the collection.
Alexander was at first not confident of his chances of
getting the job. On 12 January 1808 Farington wrote:
'Alexander thinks he has the wishes of Mr. *Planta* in
favour of his being appointed Keeper of the Prints etc.
at the British Museum,—but he is apprehensive they
may require the person who shall be fixed upon to
possess *literary attainments* which He has not.' He was,
however, successful and in a letter of 21 June 1808 we
find him commiserating with one of the unlucky
applicants for his post at Great Marlow (see Appendix
I).

The British Museum keepership might almost have
been made for Alexander. He already knew some of the
collections, having started making drawings of the
Egyptian antiquities during his vacations from Great
Marlow (Plate 84), he was keenly interested in anti-
quarian studies and apparently possessed the gift of
being a natural teacher. William Young Ottley in the
preface to his *The Origin and Early History of Engraving*
wrote, 'I still have to return my best thanks to William
Alexander Esq. for the obliging attention which I have
at all times experienced from him, during my researches
in the extensive collection of Antient Engravings at the
British Museum; a collection of which his gentlemanly

conduct, politeness, and his acquirements as an artist, render him, in every respect, so worthy a superintendent and guardian.' The *Gentleman's Magazine* obituary noted, in a similar vein, 'A prominent trait in his character was an ardent desire to facilitate the studies and interests of young Artists, striving to attain this desirable end with a rare liberality, and with an assiduity truly parental . . .'

In 1802 Alexander was elected a Fellow of the Society of Antiquaries and throughout the period of his employment at Great Marlow and the British Museum he actively involved himself in a number of personal projects and schemes associated with his antiquarian interests. He planned to publish a book on old market crosses and collected drawings by his contemporaries to use in addition to his own as illustrations (Plates 81 and 82), and it is also likely that he proposed to compile a *History of the County of Kent*. Three volumes of notes, cuttings and occasional sketches on the county are preserved among the Additional Manuscripts in the British Library. From these volumes it is clear that as well as having a good first-hand knowledge of the churches and historical monuments of Kent, Alexander was familiar with the principal written sources such as Hasted and the Harlean manuscripts in the British Museum and that he had mastered the terminology and the practical application of the art of heraldry.

Although almost nothing is known about the extensive journeys made by Alexander throughout the rest of England, when he made drawings for various topographical books (see Bibliography, page 21), two rather different excursions from London are documented. The first is a visit made in December or January 1807–08 to the home of Sir George and Lady Beaumont at Dunmow, Essex. On 12 January 1808 Alexander called on Joseph Farington and related to him how he passed the ten days spent in their company:

Fire laid in each Bedchamber at Seven o Clock in the morning. Shaving water etc. brought at 8 o Clock.
Breakfast at nine.
After breakfast Sir George and Alexander put on their painting aprons and went into the painting room where they passed their time till towards 3 o Clock. They then walked out for an Hour or more and returned and dressed for dinner, which was always had at ½ past 4.

In the evenings Sir George and Lady Beaumont read from *Cook's Voyages*, a form of entertainment which must have particularly pleased Alexander.

The second of Alexander's outings which is recorded in some detail is his trip to Dove Dale, Derbyshire, and Beresford Hall, Staffordshire, between Saturday 9 September and Monday 18 September 1815, less than a year before his death. A facsimile of Alexander's own manuscript account of the trip was published in 1841 by the antiquarian John Russell Smith. Beresford Hall was the seat of Charles Cotton (1630–87) the poet and angler friend of Izaak Walton. Having made the main part of the journey by the London-Manchester stage-coach Alexander and his companion 'Mr. Elliott' (as yet unidentified) went on foot to Beresford Hall, stopping to make sketches *en route*. Alexander wrote:

We soon came in sight of Beresford Hall which opened on us at the distance of about 2 miles. Of this first appearance of Cotton's residence a slight sketch was made, and having soon afterwards reached this luxuriant spot so interesting not only from the Salvator-like subjects and romantic scenery of the River Dove . . . but from having been the residence of so eminent a character as Charles Cotton Esq., soon after our arrival I commenced a sketch of the mansion from a nearer point of view.

On the return journey to London Alexander called on a Mr. Sharpe, an antiquarian of Coventry who allowed him 'liberal use' of his collection. It is possible that the pilgrimage to Dove Dale was inspired by the artist Edward Dayes, who, it has already been mentioned, may have been one of the early influences on Alexander's drawing style. The *Works of the Late Edward Dayes*, published in 1805, contains an *Excursion through Derbyshire and Yorkshire* as well as short biographies of contemporary artists and various instructions for the landscape painter. Alexander is named in the list of subscribers to the publication and so he would certainly have been familiar with its contents. Dayes extolled the splendours of Dove Dale in his notes on Derbyshire, 'Delightful Dove-Dale! In thee Nature exhibits one of the finest of her productions! Beautiful spot! Well may Cotton have spoken so rapturously of thy stream . . .'.

Apart from the references to his epitaph and obituary and William Young Ottley's praises, little has been said of Alexander's character. Snippets of information can be gathered from the handful of letters from the artist which survive (Appendix I) and his *Commonplace Book* which is preserved in the British Library. An obscure little note in the Anderdon collection in the Royal Academy Library offers an intriguing glimpse of his character and life style. Undated and without any name or address it reads simply:

Dear C.
Your Brother has promised me the future etching—whereby he has made me the happiest man in the world.
Pray accept the enclosed and believe [word illegible]
I hope the meeting will not take place on Tuesday, Wednesday or Thursday next I am engaged all these days to dinner.
Yours very truly W.A.

Another reference to frequent dinner engagements is given by Farington in 1806. William Gilpin, one of Alexander's assistants at Great Marlow, reported 'Alexander resides in Marlow and visits much, dining out 4 days in a week and attending card parties.' The happy, gregarious side to his nature suggested here was tempered by bouts of depression, worsened perhaps by the gout from which he suffered in his last years and which he blamed on the dampness of the British Museum (fig. 12). The *Commonplace Book*, compiled between 1808–11, reveals a morbid preoccupation with sickness and death. It contains notes of remarkable longevity observed on tombstones, cuttings about cases

fig. 12 Letter from William Alexander London, collection of the late S. R. Hughes-Smith.

This letter, dated 7 March 1809 and posted from the British Museum to his aunt Mrs. Parkin, concerns the illness of his 'Aunt Alexander' who was consumptive. In it, Alexander regrets that he did not call on her when he returned from Canterbury to London a few days earlier but explains that he was hurrying to see the pictures at Cobham Hall before dark. He concludes: 'I am much delighted with my appointment at the Museum but I fear that a Rheumatic Gout from which I have suffered much, has been contracted by spending so many hours in a new building the walls of which still continue damp.'

of extreme obesity, gout, physical deformity and particularly unusual or tragic causes of death as well as numerous unrelated small woodblock illustrations from old books. The *Commonplace Book* also includes some samples of Alexander's humour, for instance, 'If a Bird should settle on a Peach [tree] how would you gather the fruit without disturbing the bird—answer, stay till the bird had flown.'

Sadly, the circumstances of Alexander's own death were unusual and untimely. In July 1816, three months after his forty-ninth birthday he became suddenly afflicted with some kind of brain disease. The first indication of his illness is in the diary of Edward Thomas Monro. On 11 July he wrote, 'Saw Mr. Alexander at the British Museum by his brother's wish.' On the following day, after Edward Monro had called again, this time with his father, James Alexander wrote to his uncle Thomas at Rocky Hill, Maidstone,

My dear brother for excess of study has become *flighty* and Dr. Munro [sic] (his intimate friend) [word illegible] an immediate change of air and scene. I will bring him down tomorrow in a post chaisse and you must bear with us for a fortnight or so. It gives me unspeakable pain to write on this distressing subject but I know your love for us . . .

On arrival at Maidstone Alexander's condition deteriorated and on Sunday 14 July his brother and uncle called on a Mr. Ralph of West Malling, a doctor who had made cases of insanity his special study. On 16 July James wrote to Edward Monro enclosing a letter from

Mr. Ralph describing the symptoms of his brother's illness and asking for his and his father's advice. Alexander was apparently in a state of incoherence, excitement and fever. Mr. Ralph thought it judicious to 'bleed generally to the amount of sixteen ounces', and locally from the temples by leeches. At the same time he administered a purgative, shaved the head, covered it with an evaporating lotion and bathed the feet and legs in warm water. The next day, 17 July, Dr. Monro replied, adding the suggestion that blisters should be applied to the legs. Despite, or perhaps partly because of all these remedies, Alexander died a week later on Tuesday 23 July. His old friend Henry Edridge attended his funeral at Boxley Church on Tuesday 30 July (see Appendix I). He was buried in the graveyard within a few feet of the north-east corner of the chancel in a simple grave marked only by a dwarf headstone inscribed 'W.A.'. Later an application was made to Lord Romney, Maintainer of the Chancel, for permission to erect a commemorative tablet on the church wall above. Lord Romney suggested it should go inside, and a position on the south side of the chancel was selected. In 1876 the stone was moved to the south wall of the nave where it can be seen today.

BIBLIOGRAPHY

Abbey, J. R., *Scenery of Great Britain and Ireland*. London, 1952.

Abbey, J. R., *Travels in Aquatint and Lithography*, 2 volumes. London, 1956 and 1957.

Alexander, W., *Picturesque Representation of the Dress and Manners of the Austrians*. London, 1814.

Alexander, W., *Narrative of a Journey to Beresford Hall, Derbyshire, the Seat of Charles Cotton the Angler* (lithographic facsimile). London, 1841.

Allen, B. S., *Tides in English Taste 1619–1800*, 2 volumes. Cambridge, Massachusetts, 1937.

Anderson, A., *A Narrative of the British Embassy to China in the Years 1792, 1793 and 1794*. London, 1795.

Archer, M., 'From Cathay to China', *History Today*, December 1962.

Archer, M., *British Drawings in the India Office Library*, volume 2: *Official and Professional Artists*. London, 1969.

Barrow, Sir J., *Autobiographical Memoir*. London, 1847.

Bazin de Malpière, D., *La Chine*. Paris, 1825–39.

Berry-Hill, H. and S., *Chinnery and China Coast Paintings*. Leigh-on-Sea, 1970.

Beurdeley, C. and M., *Giuseppe Castiglione, A Jesuit Painter at the Court of the Chinese Emperors*. London, 1972.

Binyon, L., *Catalogue of Drawings by British Artists in the Department of Prints and Drawings, British Museum*. London, 1898.

Binyon, L., *English Watercolours*. London, 1933.

Boyd, A., *Chinese Architecture and Town Planning*. London, 1962.

British Artists (together with some Chinese) working in China in the 18th and 19th Centuries, Martyn Gregory Gallery, London, exhibition catalogue, 1977.

Britton, J., *Autobiography*, 3 parts. London, 1850, 1849–57.

Catalogue of the Entire and Genuine Collection of Pictures, Prints and Drawings of the Late William Alexander, Sotheby's sale catalogue, London, 27 February–3 March and 10–14 March 1817.

Catalogue of the Highly Important Collection of Drawings by J. M. W. Turner etc. formed by the late John Edward Taylor, Christie's sale catalogue, London, 5 and 8 July 1912.

Catalogue of Watercolours by William Alexander, Sir John Barrow Bt., and Captain Henry William Parish R.A. illustrating the Earl of Macartney's Embassy to China, Sotheby's sale catalogue, London, 1 April 1976.

Clay, R. M., *Julius Caesar Ibbetson 1759–1817*. London, 1948.

Collis, M., *The Great Within*. London, 1941.

Cotton, W., *Catalogue of the Portraits painted by Sir Joshua Reynolds*. London, 1857.

Cranmer-Byng, J. L., 'Lord Macartney's Embassy to Peking in 1793, from Official Chinese Documents', *Journal of Oriental Studies IV*, 1961.

Cranmer-Byng, J. L., *An Embassy to China, Being the Journal Kept by Lord Macartney during his Embassy to the Emperor Ch'ien-lung 1793–4* (including 'Lord Macartney's Observations on China'). London, 1962.

Croft-Murray, E., *Decorative Painting in England*, volume 2: *The 18th and Early 19th Century*. London, 1970.

Daniell, T. and W., *A Picturesque Voyage to India by the Way of China*. London, 1810.

Dayes, E., *The works of the late Edward Dayes, Containing an Excursion through Derbyshire and Yorkshire*. London, 1805.

Dr. Thomas Monro and the Monro Academy (including extracts from F. J. G. Jefferiss' forthcoming publication *Biography of Dr. Thomas Monro*), Victoria and Albert Museum, London, exhibition catalogue, 1976.

Ellis, H., *Journal of the Proceedings of the Late Embassy to China*. London, 1817.

Exhibition of English Watercolours, The Leger Galleries, London, exhibition catalogue, 1976.

Farington, J., *The Farington Diary* (ed. J. Greig), 8 volumes. London, 1922–28.

Fulcher, G. W., *The Life of Thomas Gainsborough*. London, 1856.

Gentleman's Magazine, 86 part ii (Alexander's obituary), London, 1816.

Graves, A., *Royal Academy, Dictionary of Contributors 1769–1904*. London, 1906.

Guillemard, Dr., 'Girtin's Sketching Club', *The Connoisseur*, August 1922.

Hamilton, J., *The Sketching Society 1799–1851*. London, 1971.

Hammelmann, H., *Book Illustrators in Eighteenth-Century England*. New Haven, 1975.

Hardie, Martin, *Watercolour Painting in Britain*, 3 volumes. London, 1966–68.

Hayes, J., *The Drawings of Gainsborough*, 2 volumes. London, 1970.

Hedin, S., *Jehol, City of the Emperors*. New York, 1933.

Honour, H., *Chinoiserie, The Vision of Cathay*. London, 1961.

Hutchinson, S. C., 'The Royal Academy Schools 1768–1830', *Journal of the Walpole Society*, volume 38, 1962.

King, W. L., *A Genealogical Record of the Families of King and Henham in the County of Kent* (only forty copies printed). London, 1899.

Lamb, A., *The Mandarin Road to Old Hué: Narratives of Anglo-Vietnamese Diplomacy from the 17th Century to the Eve of the French Conquest*. London, 1970.

Legouix, S. Y., 'Lord Macartney's Audience with the Emperor of China', *The Connoisseur*, February 1979.

Mason, G. H., *The Costume of China*. London, 1800.

Mason, G. H., *The Punishments of China*. London, 1801.

Mennie, D., and Weale, P., *The Pageant of Peking*. Shanghai, 1920.

Monkhouse, W. C., *The Earlier English Water Colour Painters*. London, 1890.

Musgrave, C., *Royal Pavilion, an Episode in the Romantic*. London, 1959.

Orange, J., *The Chater Collection; works relating to China, Hongkong and Macao 1655–1860*. London, 1924.

Ottley, W. Y., *The Origin and Early History of Engraving*, 2 volumes. London, 1816.

Redgrave, G. R., *History of Water-Colour Painting in England*. London, 1892.

Redgrave, S., *A Dictionary of Artists of the English School* (second edition). London, 1878.

Reynolds, G., 'Alexander and Chinnery in China', *The Geographical Magazine*, volume XX, September 1947.

Severin, T., *The Oriental Adventure*. London, 1976.

Shober, F. (ed.), *The World in Miniature: China*. London, 1823.

Smith, B. H., *European Vision and the South Pacific 1768–1850*. Oxford, 1960.

Snelgrove, D., 'William Alexander and Lord Macartney's Embassy to China', *Art at Auction*, London, 1976.

Staunton, Sir G. T., *Miscellaneous Notices relating to China*. London, 1822; second edition 1822–28; third edition 1850.

Sutton, T., *The Daniells, Artists and Travellers*. London, 1954.

The Saturday Magazine, London 1835, 1837, 1838.

Waterhouse, E., *Reynolds*. London, 1941.

Wathen, J., *Journal of a Voyage in 1811 and 1812 to Madras and China*. London, 1814.

Wright, Rev. G. N., *China Illustrated*, 4 volumes. London, 1843.

Yap, Y., and Cotterell, A., *Chinese Civilisation from the Ming Revival to Chairman Mao*. London, 1977.

Books Containing Illustrations by or after Designs by William Alexander

Alexander, W., *Views of Headlands, Islands etc. taken during a Voyage to China*. London, 1798.

Alexander, W., *The Costume of China*. London, 1805.

Alexander, W., *Picturesque Representations of the Dress and Manners of the Chinese*. London, 1814.

Alexander, W., *Costumes et Vues de la Chine*, 2 volumes. Paris, 1815.

Barrow, J., *Travels in China*. London, 1804.

Barrow, J., *A Voyage to Cochin China*. London, 1806.

Britton, J., *The Architectural Antiquities of Great Britain*, 5 volumes. London, 1807–26.

Britton, J., *Picturesque Antiquities of English Cities*. London, 1830.

Britton, J., *Cassiobury Park, Hertfordshire*. London, 1837.

Byrne, W., *Britannia Depicta*. London, 1818.

Clarke, E. D., *The Tomb of Alexander: A Dissertation on the Sarcophagus brought from Alexandria and now in the British Museum*. Cambridge, 1805.

Collins, D., *An Account of the English Colony in New South Wales*. London, 1804.

Combe, T., *A Description of the Collection of Egyptian Monuments in the British Museum*. London, 1805–07.

Combe, T., *A Description of the Collection of Ancient Terracottas in the British Museum*. London, 1810.

Combe, T., *A Description of the Collection of Ancient Marbles in the British Museum*, 3 volumes. London, 1812–18.

Englefield, Sir H. C., and Webster, T., *The Isle of Wight*. London, 1816.

Staunton, Sir G. L., *An Authentic Account of an Embassy from the King of Great Britain to the Emperor of China*, 2 volumes and a folio plate volume. London, 1797.

Staunton, Sir G. L., *An Historical Account of the Embassy to China* (J. Stockdale edition). London, 1797.

The Antiquarian Itinerary, volume IV, London 1816.

Vancouver, G., *Voyage of Discovery to the North Pacific and Round the World in the 'Discovery' and 'Chatham' 1790–5*, 3 volumes and an atlas. London, 1798.

APPENDIX I

Manuscript Sources for the Life and Works of Alexander

London, British Library

William Alexander, *Commonplace Book*, compiled 1808–11.

London, British Library, Department of Manuscripts

William Alexander, *Journal of a Voyage to Pekin in China on board the Hindostan E.I.M. which accompanied Lord Macartney on his Embassy to the Emperor* (Add. MS 35174). This manuscript contains, in addition to the *Journal*, biographical notes on the artist and on members of the Hughes family by Edward Hughes and a letter from James Alexander to his uncle in Maidstone concerning the artist's last illness, written on 12 July 1816, in which he described Dr. Monro as Alexander's 'intimate friend'.

William Alexander, *Collections for the History of the County of Kent*, 3 volumes (Add. MSS 8836–38). Add. MS. 15966 (untitled) contains a pencil drawing by Alexander of *Rochester Cathedral* and another of *The Chapter House, Hereford*.

London, Kew. The Public Record Office

War Office Class Papers 99, sections 22–24, cover the subject *Professors, Masters and General Staff* at the Royal Military College. Box WO 99, 22, contains Alexander's warrant of appointment as Master of Landscape Drawing, dated 29 August 1802; a draft of the advertisement for his post dated 21 January 1802 and a copy of a letter from Alexander complaining about his new working conditions (see p. 18). Box WO 99, 23, gives the salary scale of Masters of the Civil Branch and details of complaints by Delamotte and other civilian masters about their wages and conditions.

London, Royal Academy Library

Anderdon Catalogues volume IX, 1794–96 and volume XII, 1803–05 contain letters from Alexander. Volume IX, fol. 142, is an undated note addressed only to 'C' and signed 'WA', concerning the gift of an etching and an evening meeting. This is quoted in full in the main text (p. 19). Volume XII, fol. 164, is a letter from Alexander at Great Marlow addressed to 'Mr. Sherlock, 7 Macclesfield Street, Soho Square' and dated 21 June 1808. It commiserates with Sherlock, probably the topographical draughtsman and engraver William P. Sherlock (c. 1780–c. 1821), over his failure to secure the post of Professor of landscape drawing at Great Marlow. Alexander informed him that the successful applicant was Mr. Schetky (John Christian Schetky 1778–1874) and said that he himself would be in London at Mr. Edmond's, 3 Old Compton Street, from 9 July, and would be glad to receive a call from Mr. Sherlock.

London, Society of Antiquaries

Minute Book volume XXIX covering the period 19 November 1801 to 16 June 1803 contains details of Alexander's introduction and subsequent election as a Fellow of the Society (on 4 February 1802), and *Minute Book* volume XXX records his gift to the library of a copy of *The Costume of China* on 24 January 1805.

London, Victoria and Albert Museum Library

Autograph Letters of Eminent British Artists, volume I (undated), includes a letter dated 19 January 1814 from Alexander to W. B. Cooke (1778–1855), the engraver, concerning a misunderstanding over a dinner engagement with 'Hakewill', possibly the architect Henry Hakewill (1771–1830), to whom Alexander's illustration *Croyland Abbey Church, Lincolnshire* in volume IV of John Britton's *Architectural Antiquities of Great Britain* is dedicated, or James Hakewill (1778–1843) also an architect and a publisher of topographical illustrations. Also mentioned in the letter are 'Mr. Miller', perhaps William Miller, the publisher, and George Cooke, the engraver, brother of W. B. Cooke.

Letters to Dr. Monro includes a typewritten copy of a letter dated 24 July 1816 from Henry Edridge to Dr. Monro informing him of the death of Alexander at which he expressed himself 'most deeply distress'd'.

A List of Paintings and Drawings by Named Artists of the British School included in Christie's Sales 1860–1899, compiled by E. Machwell Cox (1939), typewritten, includes brief details of 110 works by Alexander.

Maidstone, Kent County Archives Office

The Maidstone Land Tax records and Maidstone Rent Books contain some information on various members of the Alexander and Hughes families,

such as where they lived and what rent and tax they paid.

Maidstone, Museum and Art Gallery

The Clement Taylor Smythe collection, an undated seven-volume compilation of notes and cuttings on all aspects of the history of Maidstone, contains in volume IV, folio 202, a family tree of the Alexander family labelled 'communicated to me by Mr. Thomas Alexander [William's uncle] the 18th August 1823. Clem. T. Smythe.'

Edward Hughes, *Kent Sketches and Annotation*, 2 volumes, before 1900, contains drawings by Edward Hughes (1823–1913) of the towns and villages of Kent including one or two after Alexander.

Private collections:

Dr. F. J. G. Jefferiss

The Diaries of Edward T. Monro (1789–1856), the eldest son of Dr. Thomas Monro, contain references to Alexander as do various other MSS. in the collection of Dr. Jefferiss and other members of the Monro family.

Mrs. S. R. Hughes-Smith

William L. King, *Pedigrees of Kentish Yeomen, also some Gentry* (1912) contains some details of the Alexander and Hughes families. Also in the family collection are notes about Alexander by Edward Hughes and a letter from Alexander (fig. 12).

APPENDIX II

Collections Containing Works by Alexander

Aberystwyth, National Library of Wales
Woburn Church

Bedford, Cecil Higgins Art Gallery
Boats on the River at Soochow, China
Chinese Fishermen with Birds

Birmingham, Birmingham Museums and Art Gallery
Kirton Old Church, Lincolnshire
Stern View of a Boat Going Down one of the Glacis
Street Scene with an Inn (Plate 79)
The Approach of the Emperor of China to his Tent in Tartary

Bradford, City Art Gallery and Museum
Bishops Waltham Church, Hampshire

Brighton, Museum and Art Gallery
A Chinese Actor as a Warrior

Bristol, City Art Gallery
Shipton Market Place

Cambridge, Fitzwilliam Museum
A Bonze
A Chinese Itinerant Musician
A Stage Player (Plate 63)

Cardiff, National Museum of Wales
Caernarvon, Street Scene
Plas Mawr, Conway (Plate 75)

Dublin, National Gallery of Ireland
Chinese Junk
Suburbs of a Chinese City (Plate 52)

Eton, Eton College
A Chinese Man Smoking

Harrow, Harrow School
Conway Castle (Plate 74)

Indianapolis, Indianapolis Museum of Art
The Approach of the Emperor of China to his Tent in Tartary

Leeds, City Art Gallery
A Burial Place near Hangchow
An English Village Scene
Man Seated, Smoking a Pipe
The Churches of St. Mary and St. Cyriac at Swaffham Prior
The King Charles in Full Sail
Two Men Standing

London, British Museum, Department of Prints and Drawings

The collection was catalogued by Laurence Binyon in 1898 (including the Rev. Charles Burney's album), but nos. 4, 12, 16, 17 and 18 in his catalogue are all incorrectly attributed to Alexander. *Dr. Monro's House at Fetcham, near Leatherhead* (Plate 73) has been added since the Binyon catalogue and two drawings that were added in 1944 from the collection of Miss H. M. Turner, *Waltham Cross* and *Erith, Kent*, are not by Alexander (Plates I, V, VI, VII, 4, 25, 26, 28, 31, 33, 42, 51, 53, 54, 56, 73, 84 and 85).

London, British Library, Department of Manuscripts

At the back of William Alexander's *Journal* are a number of drawings of coastlines. The *Collections for the History of the County of Kent* contain a few slight pencil and watercolour sketches. The two volumes of drawings collected by John Barrow, *Original Drawings by Alexander and Daniell; Barrow's Travels in China, Cochin China and South Africa* (Add. MS 35300) and *Barrow's Travels in China and Cochin China; Original Drawings by Alexander, Daniell etc.* (Add. MS 33931), contain many fine drawings by Alexander (Plates 10, 11, 20 and 46). Add. MS 15966 (untitled)

contains a pencil drawing of *Rochester Cathedral* and one of the *The Chapter House, Hereford* by Alexander.

London, Courtauld Institute of Art (Witt collection)

Almshouses at Glastonbury

Chinese Village Scene

London, India Office Library and Records

The three-volume collection of drawings made in China by Alexander has been catalogued by Mildred Archer, *British Drawings in the India Office Library*, volume 2: *Official and Professional Artists*, but the catalogue does not give the measurements or any description or discussion of the drawings. The collection was deposited with the East India Company in the early nineteenth century. It may be the set of drawings sold as lot 868 on day 7 of the Alexander sale at Sotheby's in 1817 but the sale catalogue describes the lot as of 827 drawings whereas the India Office collection now numbers 870 sheets (Plates 1, 2, 8, 21, 22, 29, 41, 44, 60 and 69).

London, Royal Asiatic Society

The Approach of the Emperor of China to his Tent in Tartary

London, Victoria and Albert Museum

A Cottage

A Group of Tombs and Tombstones

An 'Indian' Building

A Scene in China

A View in the Gardens of the Imperial Palace in Peking (Plate 40)

Barges of Lord Macartney's Embassy to China on the Grand Canal

Chinese Lady, with Attendant

Chinese Observing the British Embassy

Chinese Soldiers Exercising outside the Walls of a City

Fingest Church near Great Marlow, 1804

Four Views of the Druid Temple at Park Place, Henley

Higham Abbey, near Rochester 1795

One of the Rivers in China

Shipping

The Potala or Great Temple of Fo near Jehol in China

Thorney Abbey, Cambridge, 1806

Waltham Cross, 1807

Waltham Cross, 1812

Winchester Cathedral, the South Transept

Macclesfield, West Park Museum and Art Gallery (formerly) *Market Cross, Leighton Buzzard*

Maidstone, Maidstone Museums and Art Gallery

A Chinese River Bank with Figures

Aldenham Church, Hampshire

A Pipe-bearer Attendant on the Mandarin of Tourane (Plates 6 and IV)

A Tradesman, Hangchow (Plate 58)

A Village Church

Barges Preparing to Enter the Hwang-ho (Plate 50)

Beaumaris Castle, Anglesey

Bishop's Palace, Wells

Boats on the River at Soochow

Bradford Mills, Wiltshire

Chinese Infantry Soldiers and Peasants (Plate 16)

Chinese River Scene

Chinese River Scene near a Town Wall

Chinese River Scene with a Shrine

Chinese River Scene with Junks under Sail

Chinese Watermen (Plate 17)

Cochin Chinese Man with a Sword (verso: *Barefoot Peasant*) (Plates 12 and 13)

Cottage near Bushey, Hertfordshire

Country Cottage with Figures at the Doorway

Druidical Remains, Park Place, Henley

Group of Chinese Figures

Group of Chinese Watching the British Embassy (Plate 18)

Group of Chinese Watching the British Embassy (Plate 19)

Group of Chinese with Musical Instruments

Half-timbered Houses

Northleach, Gloucestershire

Old Cottage near Dorking (Plate 77)

Old House and Church, Dorking

Pagoda of Lin-ching-shih on the Grand Canal (Plate 49)

Ping-tze Muen, One of the North-western Gates of Peking

Review of the Kentish Volunteers at Mote Park

Seated Chinese Man Smoking a Pipe (Plate 15)

St. Michael's Church, Macclesfield (Plate 80)

Street Scene, possibly Maidstone

Street Scene with Half-timbered Houses and Figures

Studies of Chinese Figures and a Military Post

Village Scene with a Mill-wheel Leaning against Old Cottages

Week Street, Maidstone, Looking towards St. Faith's Street (Plate II)

Many of these drawings were bequeathed to Maidstone by Gerald Hughes of York in 1959. Several of the English drawings were purchased during the curatorship of L.R.A. Grove 1948–75.

Manchester, Whitworth Art Gallery

Boat Passing over an Inclined Plane near Ning Po (Plate 59)

River Scene, Tientsin (Plate 27)

Newcastle, Laing Art Gallery and Museum

Gateway, Conway Castle

New Haven, Yale Center for British Art (Paul Mellon collection)

A Beggar

A Chinaman

A Chinese Girl

A Chinese Goddess

A Chinese Mendicant

A Chinese Peasant (Plate 14)

A Chinese Porter or Carrier

A Chinese 'Tiger of War'

A Mandarin in Court Dress

A Raree Show
A Street Scene in Maidstone
A View of the Coast of China
Chinese Boat
Chinese Boat in Sail
Chinese Family on the Deck of a Boat
'Chinese Neptune'
Fort opposite the Factory, Canton
Group of English Children
Kentish Street Scene
Knaresborough Castle
Lady Macartney's Villa at Chiswick
Mourning at a Tomb
Natives of Cochin Playing at Shuttlecock in China
Pagoda of Lin-ching-shih on the Grand Canal
Portrait of a Chinaman
Portrait of a Chinese Scholar (Plate 39)
Portrait of a Chinese Soldier
Review of the Kentish Volunteers at Mote Park
Section of a Wheel for Elevating Water
Stone Cottages in a Mountainous Landscape with a Figure in the Foreground
Studies for the Frontispiece for 'The Costume of China'
Study of a Farm Cart
The Dent de Lion, Margate, Kent
Three Chinese Women Street-vendors
Two Chinese Figures, a Hat Seller and Seated Man
View in China, River Bank with Pagoda
View in the Province of Kiang-nun, China
View near the City of Tientsin, 1800
Village Street, Figures by Old Cottages
Wigmore Castle, Herefordshire

Oxford, Ashmolean Museum
 Ch'ien-lung, Emperor of China
 Chinese Man Carrying a Box
 George Thomas Staunton Aged 13
 Man Smoking, Seated on a Trunk
 The Fo-yen of Canton (Plate 64)

READING, The University of Reading Library (Overstone Library)
 The Chancel of Geddington Church
 In Geddington Church
 Higham Ferrers Church
 Irtlingborough Church
 Northampton from a Window of the Bell Inn
 Oakley Parva
 Stand for an Hour Glass, Oakley Parva
 At Wellingborough
 Welby Church

San Marino (California), Henry E. Huntington Library and Art Gallery
 A Church Door
 A Village Church
 Ch'ien-lung Presenting a Purse to George Thomas Staunton inside the Imperial Tent at Jehol (Plate 43)
 Chinese Trading Ship
 Farmyard (Plate 78)
 Glen at Corwen
 Machine for Weighing Hay at Maidenhead
 Landscape with Figures
 Mandarin's Pleasure Boat
 Outside a Cottage
 Shepherd at Marlow

This list of institutions containing works by Alexander does not pretend to be exhaustive and it necessarily excludes many private collections which contain fine examples of the artist's work.
3 volumes and an atlas. London, 1798.

The dimensions of prints are given to the edge of the picture area except in the case of vignette illustrations when the measurements are to the plate mark. The first group of Plates 1–19 are used to illustrate aspects of Alexander's working method. The subjects of Plates 20–68 coincide as far as possible with the path of the embassy and the remaining Plates 69–85 feature a representative selection of the artist's English drawings.

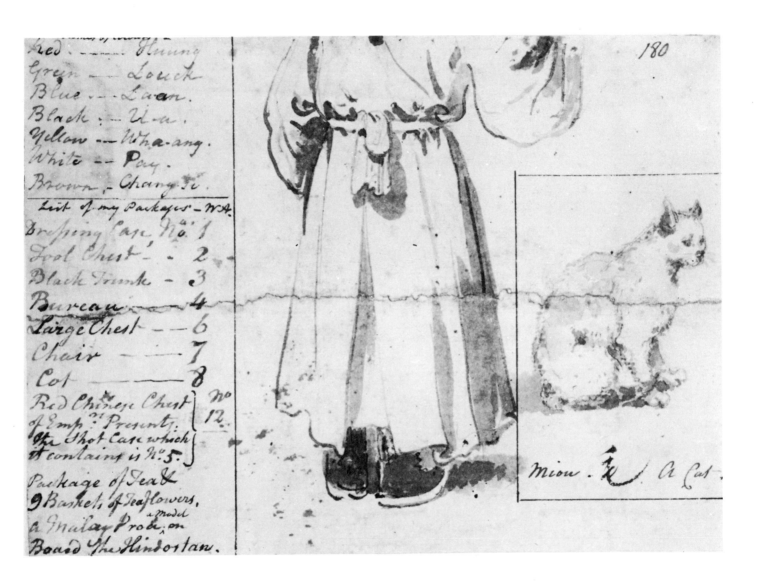

1 *Cat, Figure and List of Alexander's Baggage*
LONDON, India Office Library and Records. Pencil, pen and ink and watercolour 13·5 × 18 cm.

This is one of the 870 drawings by Alexander now contained in three bound volumes in the India Office Library collection. This, in common with the other drawings in the collection, belongs to the period of the embassy to China, and judging from the fact that the 'List of my Packages' includes a 'Red Chinese Chest of Emp.rs Presents', it must have been made after the departure from Peking in October 1793. The English transcription of the Chinese for cat is in fact 'mao', not 'miou'. The Chinese character must have been drawn by the young page George Thomas Staunton or another British member of the embassy as it too is incorrect. 'Mao' has two meanings in Chinese, 'cat' or 'hair'. The character used here is the one for 'hair'. Above his list of packages Alexander wrote his own phonetic interpretation of Chinese words for various colours, some of which make sense. This sheet from the India Office Library collection serves here as an introduction to the artist's working method and to his handwriting. It was not unusual for him to use one piece of paper for several different purposes, especially the embassy when drawing materials may have been in limited supply.

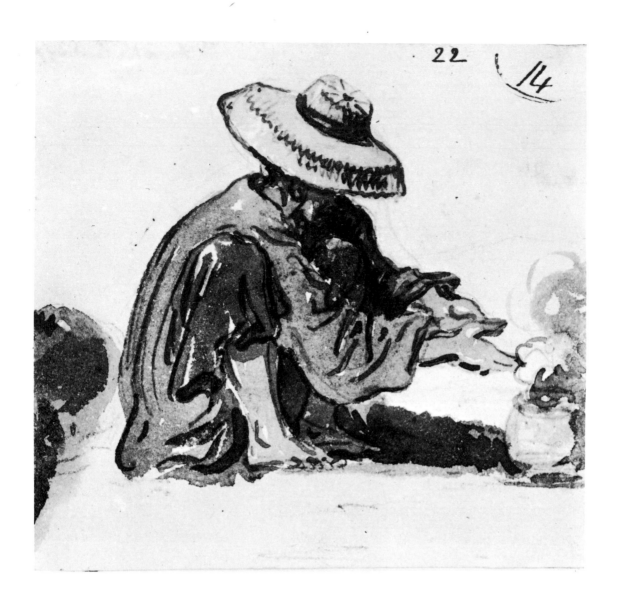

2 *Man, Probably of Tourane Bay*
LONDON, India Office Library and Records. Pencil and watercolour 9·3 × 10·6 cm.

This small sketch is mounted in volume 1 of the India Office Library collection with a group of other figures which Alexander has labelled as being inhabitants of 'Turon'. Turon, properly Tourane, was the stopping-off place of the embassy on the coast of Cochin China during May and June 1793. While the British ships took advantage of the natural harbour of Tourane Bay to rest and stock up with provisions the members of the embassy enjoyed their first sight of the Chinese people and their way of life. Cochin China, now Vietnam, was a part of the Chinese empire in the eighteenth century. Alexander made a number of sketches of local boatmen, including this watercolour, which he used in two more finished pictures (Plates 3 and 4). Throughout the captions to the Plates in this book there will be frequent reference to other versions of compositions or elements of compositions and so it is useful at the outset to appreciate the way in which Alexander developed and utilized an image, in this case one quite straightforward seated figure. Much of the interest and importance of the India Office Library collection lies in the fact that so many of the drawings are, like this one, first studies which reappear later, sometimes as often as five or six times, in finished drawings and printed illustrations.

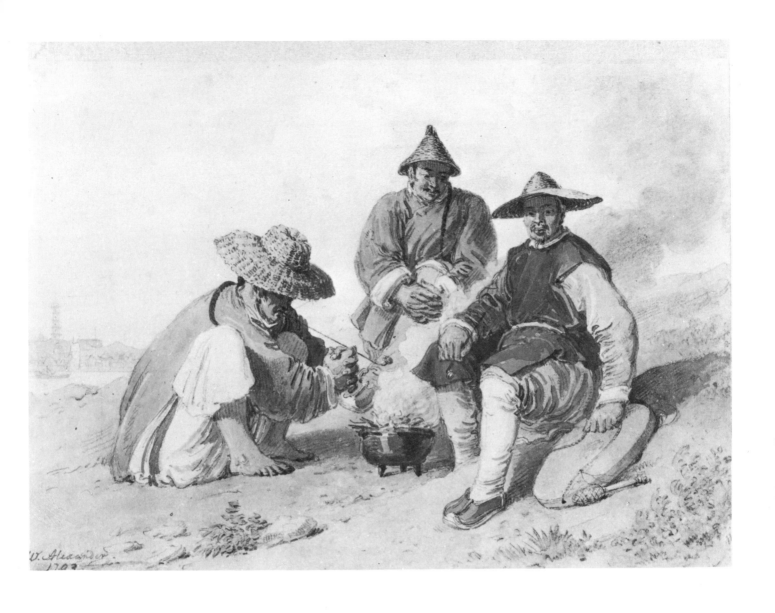

3 *Group of Boatmen Seated round a Brazier*
LONDON, Baskett & Day. Pencil and watercolour 15 × 20·7 cm. Signed and dated lower left:
W. Alexander 1793.

This drawing was bought by W. L. King from the collection of Dr. J. Percy at Christie's on 15
April 1890 as lot 8. It later belonged to the artist Edward Seago and was again sold at Christie's on
2 March 1976 as lot 101 when it was purchased by Baskett & Day. It is one of the minority of
finished drawings by Alexander which are authentically dated during the period of the embassy.
The majority of such compositions, if they are dated at all, belong to the years 1796–1805, after the
return to England. The boatman on the left, who is derived from the India Office drawing (Plate 2),
and the man on the right both hold long-stemmed pipes, a fact which has led to the picture being
called *Opium Smokers*. In fact the men are much more likely to be smoking tobacco and the related
drawing in the British Museum (Plate 4), in which the pipes are omitted, suggests that they are
seated round a brazier in order to prepare a meal. John Barrow in his *Travels in China* of 1804 noted
that while everyone, men, women and even children smoked tobacco, the use of opium was
restricted to the upper classes and was smoked in the home rather than out of doors. The gong, on
the right of the group, was one of the tools of the boatman's trade. It was used much as a car horn
is today to try and force a passage through a busy waterway or to announce the approach of some
dignitary. Alexander complained of the noise they made in his *Journal* for Friday 16 August 1793:
'Throughout the night we were disturbed by the continued ringing of the gongs by the patrole or
watch . . .'.

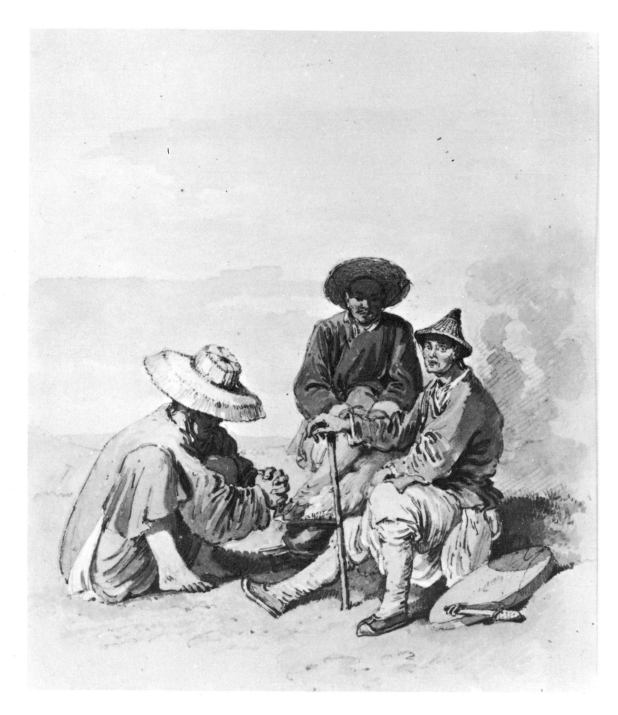

4 *A Group of Boatmen Preparing for Dinner*
LONDON, British Museum, Department of Prints and Drawings. Pencil and watercolour
20·1 × 16·7 cm.

In this drawing, which is in an album of watercolours of Chinese subjects purchased in 1865 from
the Rev. Charles Burney, the crouching boatman again makes an appearance. The album contains
eighty-two drawings, all inscribed with titles on the mounts in Alexander's hand. A list of the titles
is also given by the artist at the front of the album, together with notes on some of the subjects.
The comment 'Vide the costume of China' occurs several times in these notes indicating that the
album was probably put together after 1805 when the collection of prints illustrating *The Costume of
China* was published in book form. The drawings themselves must have been made around 1796.
Several of them, including *The City of Tungchow* (Plates 28 and V), are dated '96' on the picture
area, although on the mount Alexander has given the actual date on which he witnessed the scene
represented, 16 August 1793 in the case of *The City of Tungchow*. Alexander's own title for the
drawing illustrated here, 'A Group of Boatmen, preparing for dinner', leaves us in no doubt as to
what is happening in the picture. Aeneas Anderson recorded in his *Narrative* that 'The diet the
common people provide for themselves is always the same, and they take their meals with the
utmost regularity, every four hours: it consists of boiled rice, and sometimes of millet, with a few
vegetables or turnips chopped small, and fried amongst oil: this they put into a basin, and, when
hey mean to make a regale, they put some soy upon it'.

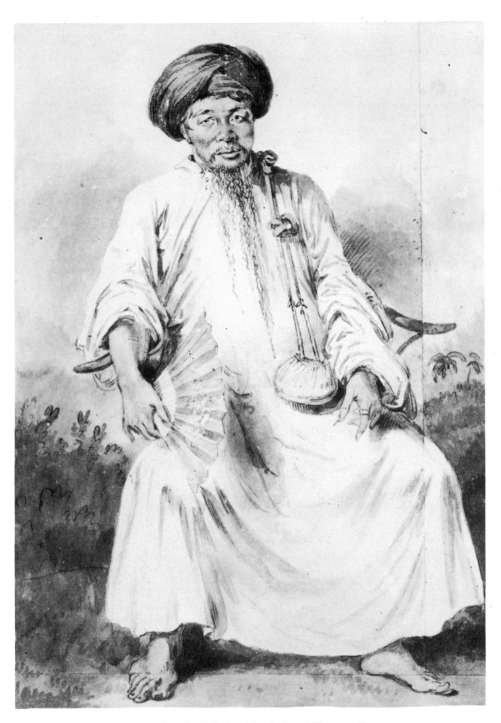

5 *An Inferior Mandarin of Tourane Bay*
LONDON, P. & D. Colnaghi & Co. Limited. Pencil and
watercolour on paper 35·5 × 23·5 cm.
Initialled on mount lower right: WA delt.

This portrait of a mandarin was one of the drawings in an
album originally in the possession of Lord Macartney
which appeared at Sotheby's on 1 April 1976. The
history of the album prior to the sale has not been
disclosed but it was split up to be sold and the *Mandarin*
went to Colnaghi of Bond Street. Until this drawing and
A Pipe-bearer (Plates 6 and IV) came to light in the sale,
the origins of the print *A Mandarin or Magistrate of
Tourane Attended by his Pipe-bearer* (Plate 7) were unknown.
Alexander entitled the portrait 'An Inferior Mandarin of
Turon Bay. Cochin China. 1793' on the mount. 'Inferior'
denoted 'lesser-ranking' in the mandarin hierarchy. The
drawing is made on three pieces of paper stuck together,
either because Alexander misjudged the placing of the
figure when he began or as a result of paper being in
short supply.

I *Self-portrait Drawn at Sea*
LONDON, British Museum, Department of Prints and Drawings. Pencil and watercolour
24 × 18·6 cm. Initialled upper right: WA.

At the top right-hand corner is the inscription by Alexander 'From myself done at sea 179 . . .'.
Unfortunately the paper has been cut so that the last figure of the date is missing, but it must be
assumed that the portrait was made either on the outward or the return journey from China in
1792 or 1794. The fanciful addition of an eye patch and the rather wild hair makes the artist look
somewhat roguish and very different from the neatly-dressed young man of Edridge's portrait of
1795 (see frontispiece). The drawing also has a certain naïvety, especially in the disproportionate
narrowness of the shoulders, which reminds us that at the time of the China expedition Alexander
was a relatively inexperienced artist on his first professional engagement. The portrait remained
with the family until it was presented to the British Museum by Edward Hughes in 1897.

6 *A Pipe-bearer Attendant on the Mandarin of Tourane*
MAIDSTONE, Maidstone Museums and Art Gallery. Pencil
and watercolour on paper 36 × 20 cm. Initialled lower
right: WA.

This beautiful watercolour was purchased for Maidstone
Museum from the Sotheby's sale of 1 April 1976 with the
aid of a National Art Collections Fund grant. It has a
richness of colour that is rare in Alexander's work and
can only be paralleled in a drawing in volume III of the
India Office Library collection which is inscribed: 'A
Cochin Chinese of Turon Bay. W. Alexander delt. ad
vitam.' *A Pipe-bearer* would also seem to be 'from life' and,
like the companion picture of the mandarin (Plate 5), it is
drawn on more than one sheet of paper; here the join is
on a level with the boy's ankles. According to John
Barrow's *Travels in China* handsome fourteen- to eighteen-
year-old pipe-bearers played a dual rôle. In addition to
publicly carrying tobacco and betel for his master, the
pipe-bearer also privately shared a homosexual
relationship with him. Barrow blamed the prevalence of
what he called the 'vice of the Greeks' on the Chinese
practice of keeping women, especially those of the upper
classes, shut away from the public eye.

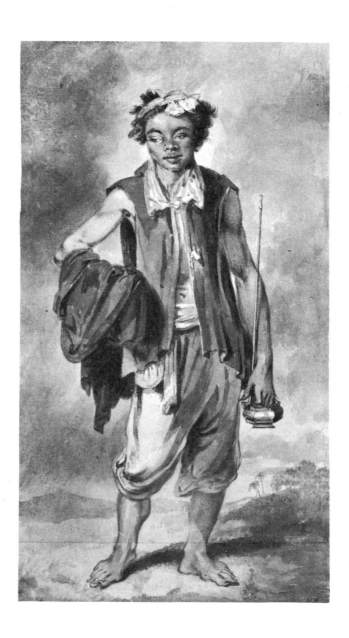

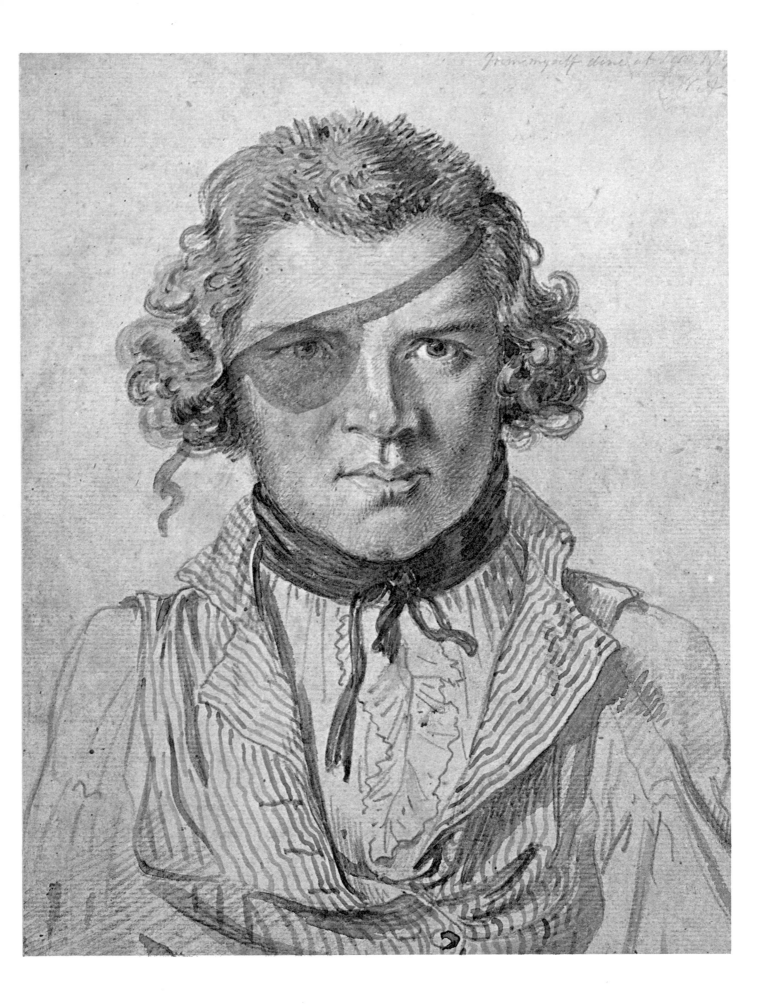

from myself done at the age of 19

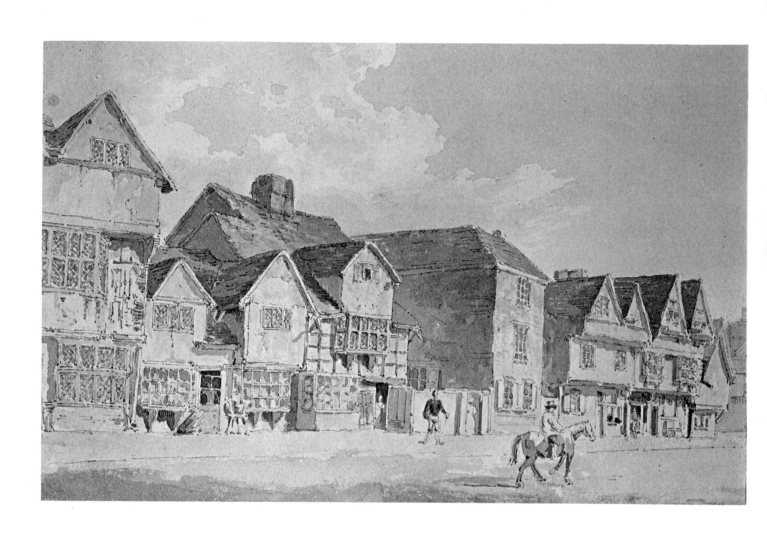

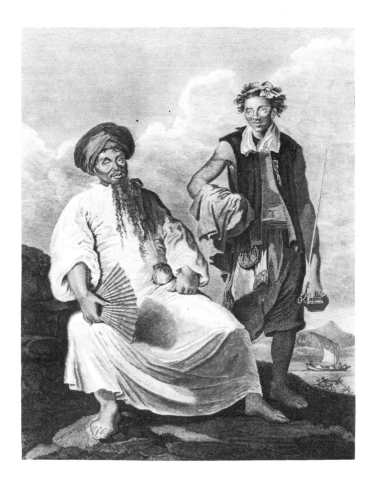

7 *Staunton*, plate sixteen: *A Mandarin or Magistrate of Tourane Attended by his Pipe-bearer*
Print published 12 April 1796. Engraving by James Caldwall (1739–after 1819) after Alexander
22·5 × 17·5 cm.

It is not known whether Caldwall worked direct from the two preceding drawings (Plates 5 and 6)
or whether Alexander provided him with an intermediate design for this engraving. Whichever was
the case, the print is a clumsy interpretation of Alexander's drawings. The draperies have become
heavy and wooden and the elegant features of the pipe-bearer are distorted beyond recognition.
The empty left hand of the mandarin has been changed from a relaxed open gesture to a clenched
fist, lending a stolid character to the figure which was clearly not intended in the original study.
Caldwall was an established engraver who contributed to such prestigious projects as Boydell's
Shakespeare and Captain Cook's *Voyages* and Alexander, nearly thirty years his junior, may not have
felt willing or able to scrutinize his work as closely as was really necessary. The engraving is a
pointed reminder that though an illustration may bear the inscription 'W. Alexander del.' it may
be far removed in spirit from the true style of the artist. This is unfortunately the case with a
number of the engravings to the folio plate volume of *Staunton* and so although the prints are often
better known than the drawings related to them they have in general been omitted from this book.

(*opposite top*)
II *Week Street, Maidstone, Looking towards St. Faith's Street*
MAIDSTONE, Maidstone Museums and Art Gallery. Pencil and watercolour 17·5 × 25·5 cm.

An aspect of Alexander's home town that is lost for ever is recorded in this beautiful watercolour.
The view is taken from near his father's coachbuilding works at 56 Week Street, looking towards
the house near the corner of Week Street and St. Faith's Street which belonged to his uncle
Thomas, an old gabled building now replaced by a monstrous twentieth-century block occupied by
the Army and Navy Stores. Thomas Alexander began as a coachbuilder with his brother but later
changed to a drapery business and finally retired in 1815 to a house at Rocky Hill, the other side
of the River Medway in Maidstone, where William stayed with him a year later during his brief
last illness. The watercolour was in the Clement Taylor Smythe collection (see Appendix I), but
it has now been mounted as part of the Maidstone Museum's watercolour and drawings
collection. A copy of it by Edward Hughes is in the collection *Kent Sketches and Annotation* in the
Maidstone Museum (see Appendix I).

(*opposite bottom*)
III *Group of Chinese Watching the British Embassy* (Plate 19)
MAIDSTONE, Maidstone Museums and Art Gallery.

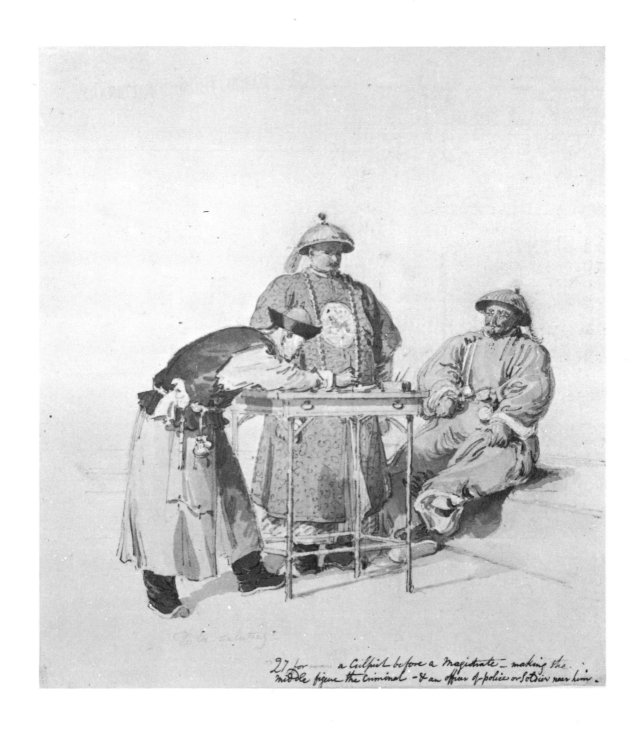

8 *Two Mandarins and a Scribe at a Writing-table*

LONDON, India Office Library and Records. Pencil, pen and watercolour 24·2 × 20·5 cm.

This illustration and the one that follows (Plate 9) again show changes in a design between drawing and print, but on this occasion both are the work of Alexander himself and the alterations are made to good purpose. The drawing, which is in volume III of the India Office Library collection, is inscribed to the left in pencil, 'To be saluting', and in pen and ink to the right '27 for a Culprit before a Magistrate—making the middle figure the criminal—and an officer of police or soldier near him.' Having made the drawing Alexander must have decided that alterations were needed before the design was fit to be used as an illustration to *The Costume of China*. His notes indicate that he considered altering the scribe to make him salute and thought of replacing the mandarin in the centre of the group with a criminal attended by an officer of the law. In the event the position of both the scribe and the standing mandarin remain little changed in the finished print, but the seated mandarin is omitted and his place is taken by a culprit and an officer of the law.

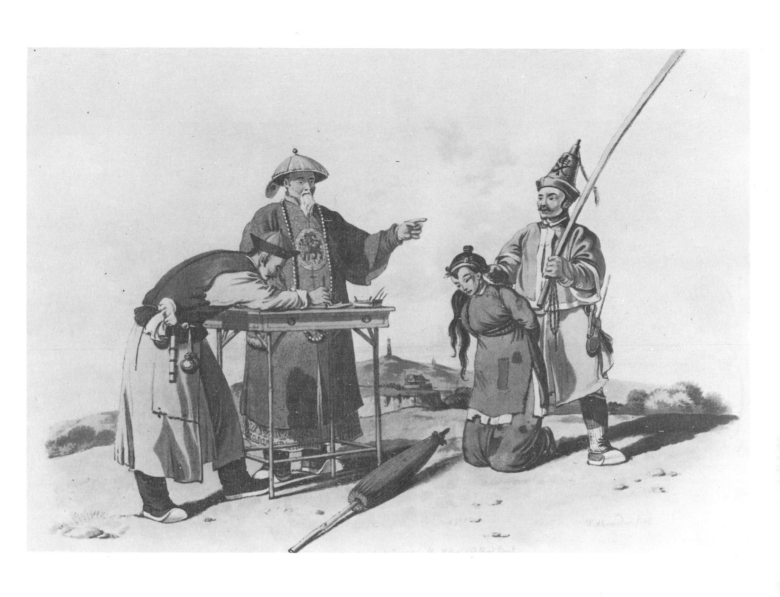

9 *The Costume of China*, plate forty-two: *Examination of a Culprit before a Mandarin*
Print published 1 January 1804. Hand-coloured aquatint 26 × 32 cm.

Although *The Costume of China* appeared as a bound volume in 1805 the plates were printed in groups of four between 1797 and 1804, and this illustration is dated 1 January 1804. The culprit, held by the hair by an attendant, is, according to Alexander's caption, accused of prostitution. The caption also notes that the circular badge on the robe of the mandarin signifies that he is of royal blood. The mandarin is given a grey beard in the aquatint and this, together with his raised hand and the alarming size of the cane held by the officer, gives an authoritarian atmosphere to the scene quite different from the informality of the drawing from which the composition was developed (Plate 8). This illustration was crudely copied for the front page of *The Saturday Magazine* of 29 August 1835.

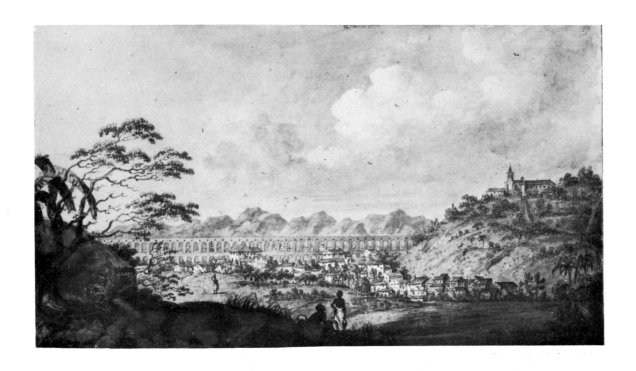

10 *Aqueduct at Rio de Janeiro*
LONDON, British Library, Department of Manuscripts (Add. MS 33931, fol. 21). Pencil and watercolour 22·7 × 39·8 cm.

This drawing belongs to one of two albums from the collection of John Barrow, comptroller to the embassy, which are now in the British Library. The album is entitled *Barrow's Travels in China and Cochin China; Original Drawings by Alexander, Daniell etc.* and an inscription inside relates that it was presented to the British Museum on 3 November 1890 by Colonel John Barrow. Nearly all the drawings in the two Barrow albums are preparatory studies for illustrations to his two books about the embassy, *Travels in China* and *A Voyage to Cochin China*. Alexander had inscribed this drawing on the mount 'The Aquaduct at Rio de Janeiro. Dec. 15th 1792', and the vigorous handling suggests that it is the original drawing made on that date. A comparison with another watercolour of the same subject (Plate 11) reinforces this view. The second picture of the aqueduct is identical in size and composition with the illustration in *A Voyage to Cochin China* and is different in a number of significant ways from this larger and bolder drawing. The differences represent the evolution of a spontaneous sketch into a carefully studied drawing made to occupy a rectangle of specified dimensions.

(*opposite top*)
11 *Aqueduct at Rio de Janeiro*
LONDON, British Library, Department of Manuscripts (Add. MS 35300, fol. 6). Pencil and watercolour 14·5 × 22 cm. Initialled and dated on the back: WA. 1805.

This, the second of two drawings of the aqueduct at Rio de Janeiro previously in the Barrow collection, is inscribed on the back by the artist 'The Aqueduct called Arcos de Carioco, at St. Sebastian, Rio de Janeiro, S.th America. Taken Dec. 17th 1792 from the right on the Road to Matta Cavallo. WA. 1805'. The album in which it is mounted is labelled *Original Drawings by Alexander and Daniell; Barrow's Travels in China, Cochin China and South Africa*, and inscribed 'Bequeathed by J. Barrow Esq. 15 Febr. 1899'. The similarity of the drawing to plate five in John Barrow's *A Voyage to Cochin China* and the date, 1805, the year before the publication of the book, indicate that this was the original which Alexander provided for the engraver. It is interesting to note that Alexander made various alterations to the earlier view of the aqueduct (Plate 10), nearly all of which give the final composition a more classical 'Poussinesque' character. The principal changes have been to raise the viewpoint, condense the composition in width and insert a winding road in the centre to aid the sense of recession. The replacement of two natives by two Franciscan monks also serves to classicize, though Alexander may simply have made this alteration at the request of John Barrow. On 25 January 1808 Alexander told Joseph Farington that he had allowed Mr. Barker of *Leicester Square Panorama* to use his drawings of Rio de Janeiro to paint a panorama 'for exhibition'. Barker paid Alexander 70 guineas for the service. Farington noted in his *Diary* that Henry Salt, another travelling draughtsman, had received 100 guineas for the use of his drawings of the Pyramids for the same purpose.

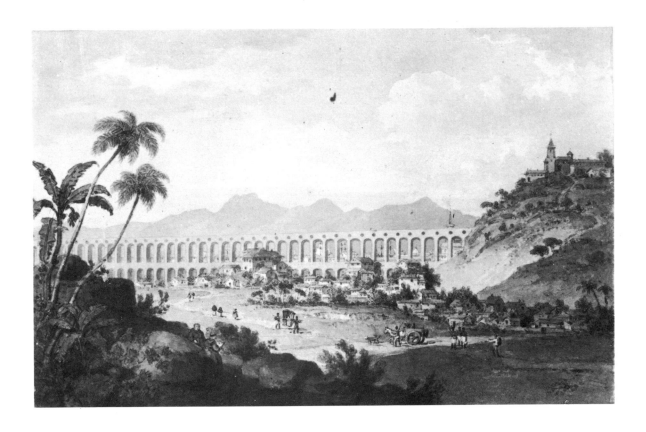

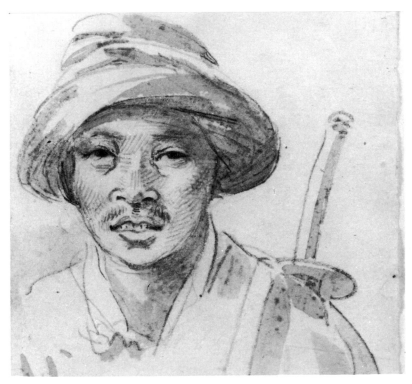

12 *Cochin Chinese Man with a Sword*
MAIDSTONE, Maidstone Museums and Art Gallery. Pencil and watercolour 18·2 × 10·5 cm.

The sketch is inscribed at the top in pencil 'Cochin China'. Another drawing on the reverse is a *Barefoot Peasant* (Plate 13) and both illustrate the artist's figure style at its most free and easy. Alexander never tired of delineating the features of the Chinese and obviously found men such as this gentle-faced native of the Tourane Bay region natural subjects for rapid pencil studies. Lord Macartney wrote in his *Journal* on 5 August 1793 that he found Chinese men 'in general well-looking, well-limbed robust and muscular', and Alexander remarked several times on the friendly and open nature of the majority of Chinese with whom the embassy came in contact. This drawing was bequeathed to the Maidstone Museum in 1959 by Gerald Hughes of York. He may have purchased or inherited it from his uncle Edward Hughes, a great-nephew of Alexander.

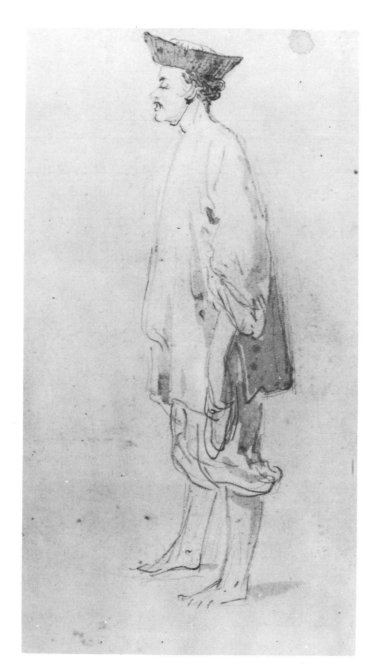

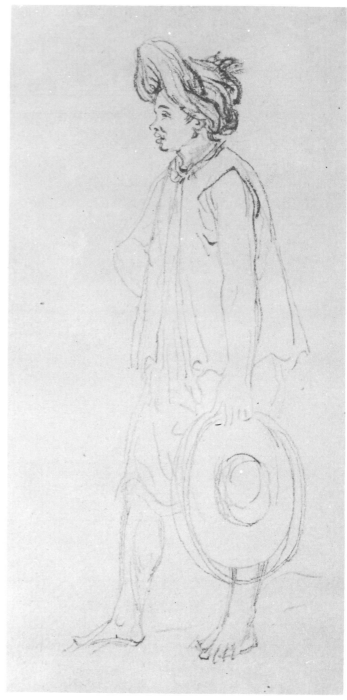

13 *Barefoot Peasant*
MAIDSTONE, Maidstone Museums and Art Gallery.
Pencil and watercolour 18·2 × 10·5 cm.

This sketch is made on the reverse of the *Cochin Chinese
Man with a Sword* (Plate 12) and therefore presumably
also represents an inhabitant of Tourane Bay, the
stopping-off place of the embassy in Cochin China. The
drawing is very freely executed in pencil with just
enough wash to give some roundness of form. It relates
closely to a drawing of a peasant in the Paul Mellon
collection at the Yale Center for British Art (Plate 14),
and it is noticeable in both studies that in his haste
Alexander suggested four rather than five toes on the left
foot of the figure.

14 *A Chinese Peasant*
NEW HAVEN, Yale Center for British Art (Paul Mellon
collection). Pencil 17·4 × 9·1 cm.

Like the previous sketch this was in the possession of the
Hughes family until fairly recent times. It was
purchased for the Paul Mellon collection and is now at
New Haven. The pose of the figure and the drawing
style are very close to the Maidstone drawing (Plate 13)
and it is likely that this sketch also represents a native of
Cochin China. The turban-style headwear is seen on
other figures drawn by Alexander in Tourane but is not
characteristic of the Chinese provinces visited by the
embassy.

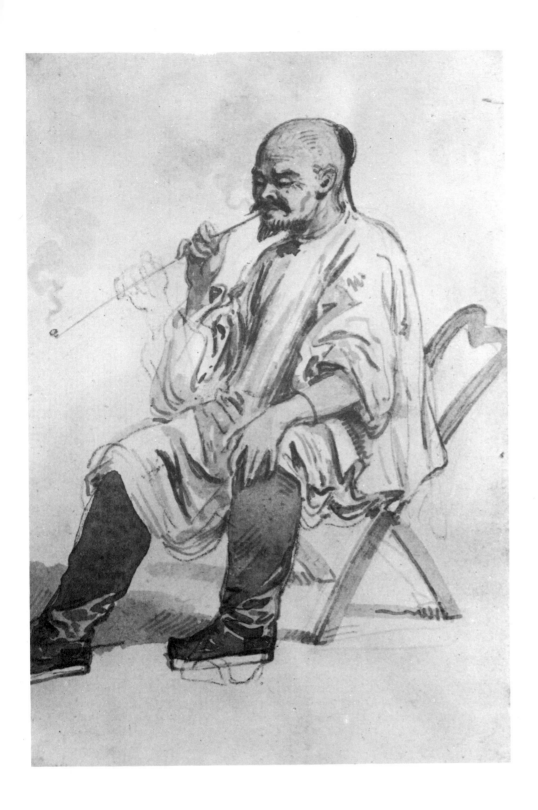

15 *Seated Chinese Man Smoking a Pipe*
MAIDSTONE, Maidstone Museums and Art Gallery. Pencil and watercolour 16·4 × 10·8 cm.

Although it is impossible to be certain with any work of Alexander, this drawing, like the previous two sketches illustrated (Plates 13 and 14), would appear to have been executed from life. The second positions indicated in pencil for the right hand and left leg of the man suggest the way in which he moved while the drawing was made. The shaved head was usual among all ranks of Chinese. Lord Macartney observed in his *Journal* on 4 August 1793, 'All the Chinese whom we have yet seen, from the highest to the lowest, have their heads close shaved, except on the crown where the hair is left untouched by the razor for about a couple of inches in diameter and suffered to grow to a great length, being considered as a very becoming ornament.' Alexander often encountered difficulties when drawing chairs and the one here is no exception. The problem lies in the perspective and as a general rule throughout the artist's work, especially in his quick sketches, there are faults in the drawing of objects near the eye. This difficulty tends to be less noticeable in figures than in geometric shapes such as furniture and is hardly present at all in the large finished watercolours.

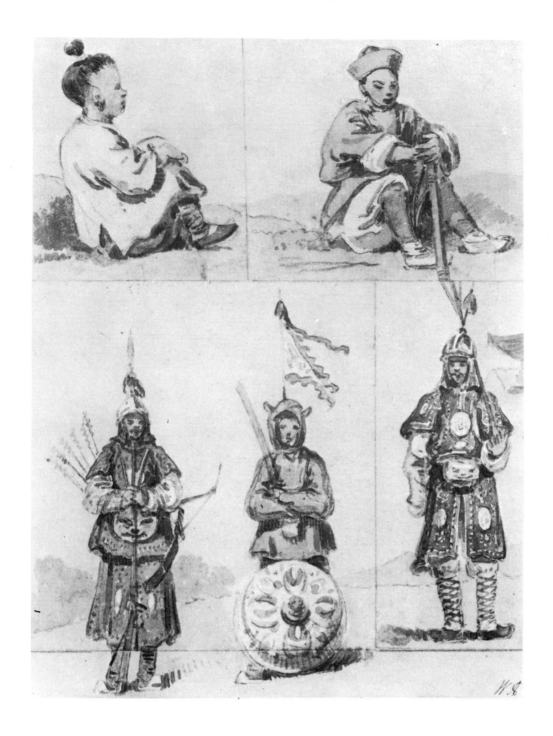

16 *Chinese Infantry Soldiers and Peasants*
MAIDSTONE, Maidstone Museums and Art Gallery. Pencil and watercolour 19·3 × 14·4 cm.

These sketches, which are on five sheets of paper pieced together, are initialled 'WA' by an unidentified hand in the lower right-hand corner. The studies were purchased with two others (Plates 6 and 17) from the Sotheby's sale of Alexander drawings on 1 April 1976, and a number of other lots in that sale which were wrongly attributed to Alexander were similarly inscribed. Although in numerical terms the military force of China was very powerful (Wang, one of the mandarins attendant on the embassy, estimated it to be 1,800,000 men strong), the British formed no high opinion of the soldiers' capabilities. Lord Macartney commented, 'As they are totally ignorant of our discipline, cumbersomely clothed, armed only with matchlocks, bows and arrows, and heavy swords, awkward in the management of them, of an unwarlike character and disposition, I imagine they would make but a feeble resistance to a well-conducted attack.' The soldier in the centre of this group of studies is one of the infantrymen nicknamed by western missionaries 'tigers of war' on account of the feline character of their uniform and, apparently, of their movements. The volume of *The World in Miniature* which deals with China, written in 1823, describes the 'tigers' thus: 'In their exercise, the men belonging to this corps of infantry, assume all sorts of whimsical attitudes: jumping and capering about and tumbling over one another, like the clowns and pantaloons of our Christmas pantomimes. When they appear under arms, they hold their shields in front, close to their breasts, and allow a few inches of their rusty blade to appear above it.'

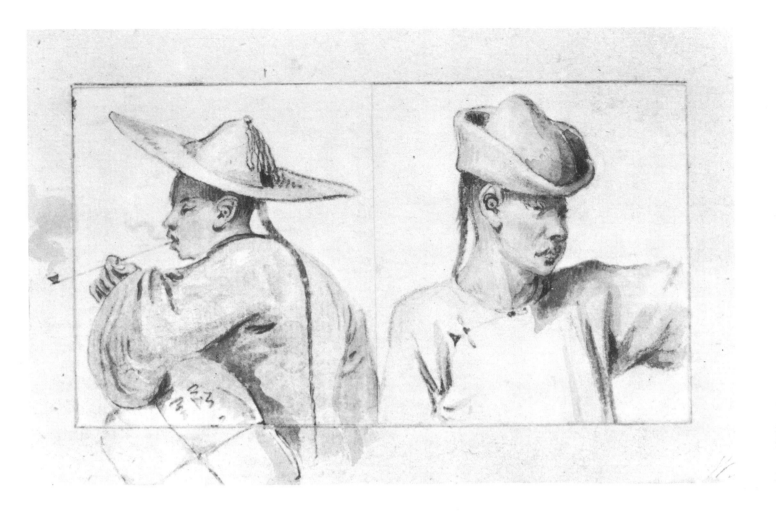

17 *Chinese Watermen*
MAIDSTONE, Maidstone Museums and Art Gallery. Pencil and watercolour 7·5 × 13·2, extended to 10 × 16 cm.

In volume III of the India Office Library collection is a drawing of these two same figures reversed in position. It is labelled by Alexander 'Money in their ears.' In his *Journal* on 25 November 1793 he noted, 'Some persons stuck money into the orifice of the ear, 'twas the current coin of the Empire having a square hole in the centre of it. Probably this is done from some superstitious motive.' The coin in circulation at the time of the embassy was the copper 'li' which was usually strung in groups of one hundred. A 1000 'li' equalled one 'tael' or 'liang' which Macartney estimated to be equivalent to 6 shillings and 8 pence sterling. A boatman could expect to be paid about 80 li a day. These two sketches are mounted on to a larger sheet of paper and the figure on the left has been extended into the margins. They were sold as part of the same lot as the *Chinese Infantry Soldiers and Peasants* (Plate 16) at Sotheby's on 1 April 1976 and on entering the collection of the Maidstone Museums and Art Gallery were set together with the other sheets on one mount. The *Chinese Watermen* bears the same false signature, 'WA', in the lower right-hand corner. Small sketches of this kind must represent the earliest stage in the artist's working method. From an enormous stock of such images Alexander was later to work up crowds and groups for his large finished watercolours and designs for engravings.

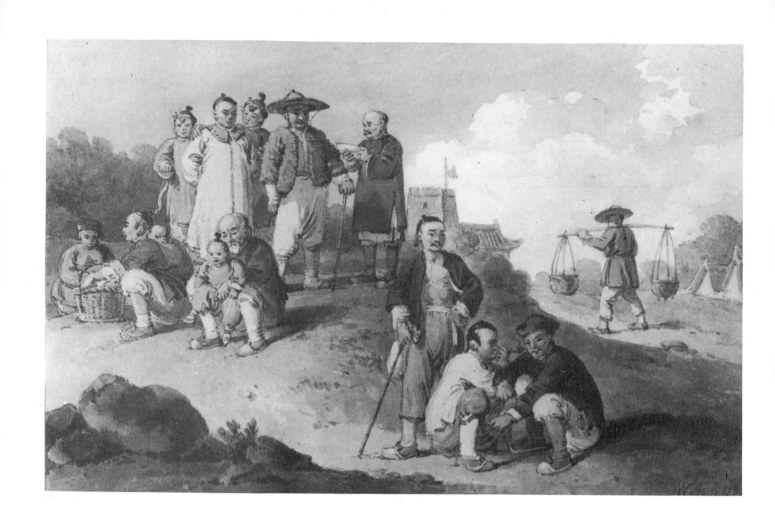

18 *Group of Chinese Watching the British Embassy*
MAIDSTONE, Maidstone Museums and Art Gallery. Pencil and watercolour 13·6 × 21·1 cm.
Initialled and dated lower right: WA.f.1803.

This drawing and its pair (Plates 19 and III) were made as long as ten years after Alexander was
actually in China. It is based on sketches of the kind illustrated in the two previous plates (Plates 16
and 17) and contains certain stock figures, such as the seated old man with a child and the basket-
carrying pedlar, which appear again and again in Alexander's work. The fact that the figures are
familiar and the date so late does not detract from the charm of the watercolour. It is a finished
picture drawn on the scale at which the artist's pencil and colour wash technique seems most
effective. The pair of drawings were purchased by public subscription for the Maidstone collection
probably at the end of the nineteenth century; they have unfortunately suffered through prolonged
exposure to daylight, as have so many other of Alexander's framed pictures.

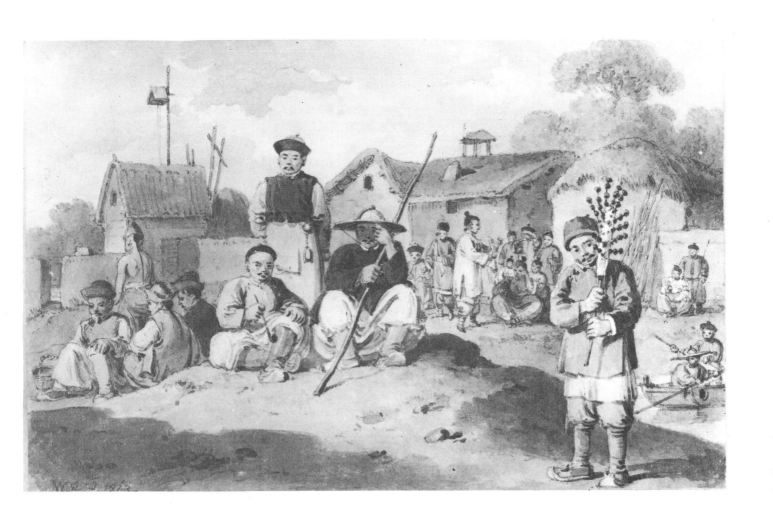

19 *Group of Chinese Watching the British Embassy*
MAIDSTONE, Maidstone Museums and Art Gallery. Pencil and watercolour 13·6 × 21·1 cm.
Initialled and dated lower left: W.A.f.1803.

The title given to this watercolour and its pair (Plate 18) is unlikely to date back to Alexander
himself. We know from his *Journal* that the Chinese peasantry were often so eager to catch a
glimpse of the British that they surged forward up to their waists in the water. This quiet group
appear simply to be enjoying a break from work. A version of the composition, similar in size
(16·4 × 20·7 cm.), is in the Witt collection at the Courtauld Institute Galleries, London. It is less
finished and is known as *Chinese Village Scene*. Another version, not by Alexander, in a private
collection at Sittingbourne, Kent, repeats the composition of the Maidstone drawing exactly in
reverse and would appear to be based on a tracing. It is on paper watermarked 1801, is gaudily
coloured and may have been a deliberate forgery made at a time when watercolours by Alexander
were highly prized by collectors. The man to the right of the picture is selling the candied fruits of
a kind of hawthorn which look somewhat like cherries. These fruits, which are displayed impaled
on split bamboo, are only sold in winter in China.

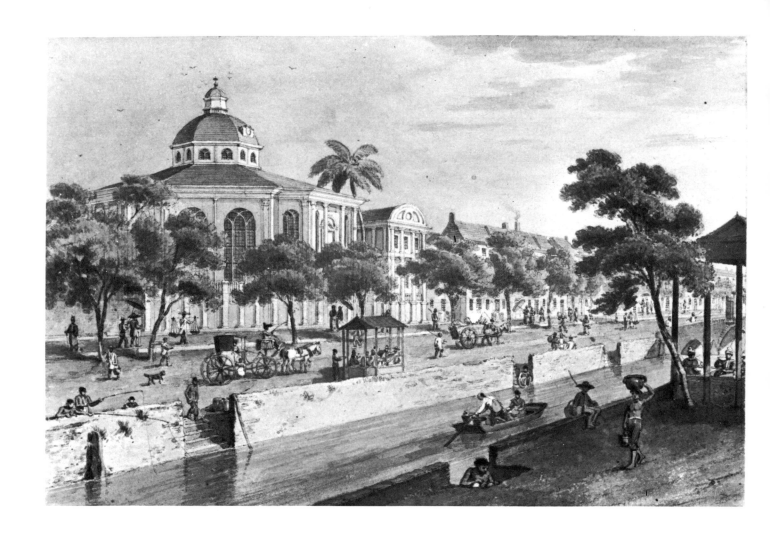

20 *The Calvinist Church in Batavia*
LONDON, British Library, Department of Manuscripts (Add. MS 35300, fol. 9). Pencil and
watercolour 14·8 × 21·8 cm.

Batavia, now known as Djakarta, is the capital of Java and was the last main port of call for the
embassy before Tourane Bay, Cochin China. *Staunton* gives a gloomy picture of the place: 'The City
of Batavia, situated amidst swamps and stagnant pools, independent of climate and inattentive of
cleanliness, is, perhaps, one of the most unwholesome places in the universe. The morning sea
breeze ushers in noxious vapours . . .'. Java was a Dutch settlement, which accounts for the
presence of a Calvinist church, and Alexander on 8 March 1793 noted in his *Journal* that the
gentlemen of the embassy were invited to a country house near Batavia to a ball and supper in
honour of the Stadthouder's birthday. The gardens there were, he observed, 'illuminated superior
to Vauxhall with the addition of Chinese lanthorns etc.' The view of the church was drawn from
near where the British were accommodated. A sketch made a little further along the canal, now in
volume III of the India Office Library collection, is inscribed 'Taken from the Inn at Batavia 1793.
WA.' This beautifully finished drawing of the church is in the collection formerly belonging to
John Barrow, bound in a volume entitled *Original Drawings by Alexander and Daniell; Barrow's
Travels in China, Cochin China and South Africa*, and was engraved for *A Voyage to Cochin China*
published in 1806.

21 *Elephant, Tourane Bay, 3 June 1793*

LONDON, India Office Library and Records. Pencil and watercolour 10·6 × 16 cm.

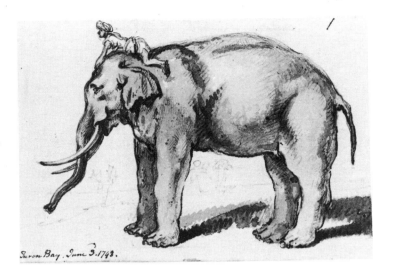

Amongst miscellaneous notices at the back of his *Journal* Alexander recorded that in Cochin China punishments for a serious crime such as adultery included being crushed or squeezed and dashed to death by an elephant. Sir George Staunton, also writing about Cochin China, mentioned the use of elephants in war and the fact that elephant meat was regarded as a great delicacy in this part of the world. Alexander's drawing represents the elephant in its more usual capacity as a beast of burden and he inscribed the sketch Turon Bay. June 3 1793.' It is the first sheet in volume III of the India Office Library collection.

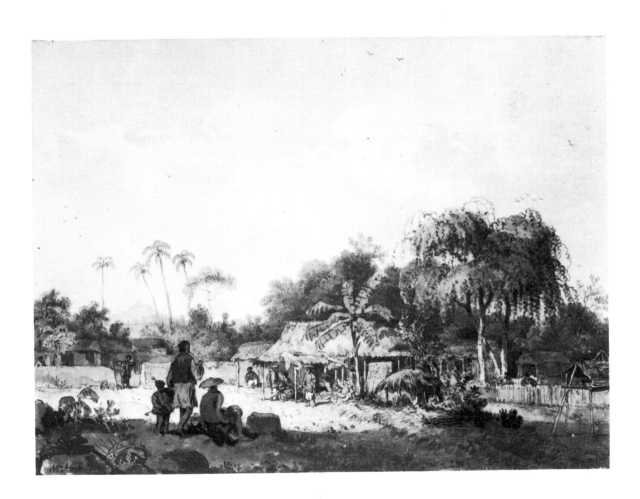

22 *View near Tourane Bay*

LONDON, India Office Library and Records. Pencil and watercolour 17·2 × 23·4 cm. Signed lower left: W. Alexander f.

The embassy arrived at Tourane, now Da Nang, at the end of May 1793 and left on 15 June. Sir George Staunton remarked on the fertility of the area, likening its rainy season from September to November to the annual flooding of the Nile valley. Lord Macartney also wrote enthusiastically in his *Journal* of the 'most excellent harbour' and the wealth of local resources: 'It produces excellent cinnamon, common rice and mountain rice in vast abundance and has many rich mines of gold and silver . . .'. This watercolour by Alexander handsomely illustrates the lush vegetation and clear air which was so much appreciated by the members of the embassy who had fallen sick on the voyage and whose first taste of good fresh water, after months at sea, came at Tourane.

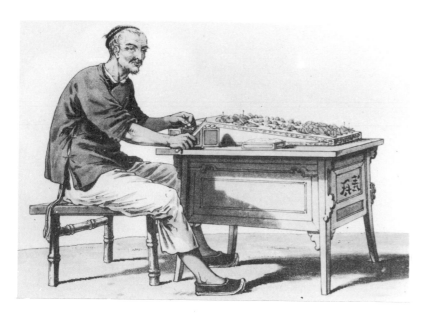

23 *Picturesque Representations of the Dress and Manners of the Chinese*, plate thirty-two: *A Man Selling Betel*
Print published January 1814. Hand-coloured aquatint 23 × 17 cm.

A drawing in pencil and watercolour for this illustration, presumably once in the same collection as those in the Fitzwilliam Museum (see Plate 63), is in a private collection in England. In the drawing the shallow box on the table is omitted but is shown at the top edge of the sheet with an inscription in pencil 'This box filled with powdered lime to lie also on the table.' The man is selling betel leaves and areca nuts, which, when ground with a paste of lime and water, make a kind of chewing-gum which was much favoured by the inhabitants of Java and China. The entry in Alexander's *Journal* for 15 June 1793, when the embassy was at Tourane, reads 'The Natives, men, women and children chew great quantities of Betel which makes their mouths look very disgusting and quite destroys their teeth.' A little earlier he had been rather disconcerted to see ladies of the Dutch aristocracy in Batavia chewing betel 'even at supper' and periodically spitting into small cups carried for the purpose by their Malay slaves.

(*opposite*)
24 *Portrait of Wang ta-jen*
LONDON, The Leger Galleries. Pencil and watercolour 10·5 × 8 cm.

The members of the British embassy referred to this mandarin variously as Van-ta-gin, Van-ta-zhin and even Van Tadge-In in their journals. Cranmer-Byng, editor of Macartney's *Journal*, identified him as Wang Wen-hsiung, a distinguished military figure who was known for his bravery in combat and died in action in 1800. Wang and a civil mandarin Chou (Plate 25) were appointed to attend the embassy from the arrival at the Peiho River in August 1793 until the departure from Canton in January 1794. Wang was liked and admired by all the members of the embassy. He was, in the words of Alexander, 'a fine jolly fellow, and of most free and affable manners.' When the time came for both mandarins to bid farewell to the British, Alexander praised them for their 'unremitting attention and constant endeavour to promote our comfort and happiness.' Wang's costume, as illustrated in this beautiful jewel-like watercolour, denotes his rank. The red coral button on his cap labels him as a mandarin of the second order, the tiger on his robe indicates that he belongs to the military rather than the civil service and the peacock's feather is a military honour which in his case had been gained as a result of being wounded three times in battle. The title 'ta-jen' approximated to 'great man'. John Barrow in *Travels in China* described an amusing incident concerning the use of the title which demonstrates that it was an appellation which had to be earned; it could not be inherited. One of the gifts brought from England for the emperor was a set of prints of the British nobility. The emperor was apparently pleased with the present and required the names of the persons portrayed to be translated into Chinese. The Chinese translator given the task went to Barrow for advice on one particular portrait of the duke of Bedford as a boy. He had translated Bedford as *Pe-te-fo-ul-te* but was stuck over 'duke'. When Barrow suggested 'ta-jen' the Chinese present were greatly amused. It was inconceivable to them that a mere boy could bear such a title. This portrait of Wang is one of several made by Alexander. Plate one of *The Costume of China* shows him full length armed with a bow and sabre. There are two oval head-and-shoulder portraits in the India Office Library collection, one of which is signed and dated on the mount 'W. Alexander 1793', and two more ovals in the Barrow albums in the British Library (Additional Manuscripts) collection, one of which is initialled 'WA'. In the album of watercolours in the Department of Prints and Drawings of the British Museum Department there is a further oval version and the frontispiece to Barrow's *Travels in China* is an oval aquatint by Thomas Medland after Alexander. The Leger watercolour was formerly in the collection of Mrs. E. V. B. Macartney (1976) and is signed and inscribed with the title and date 1793 on the reverse of the original mount.

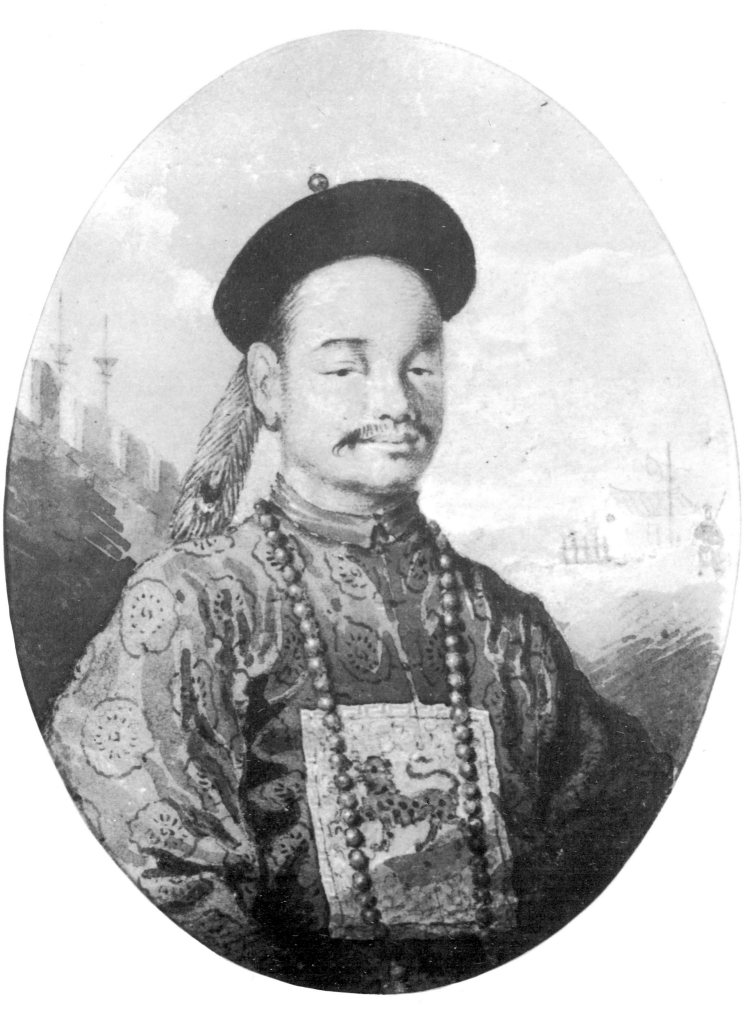

47

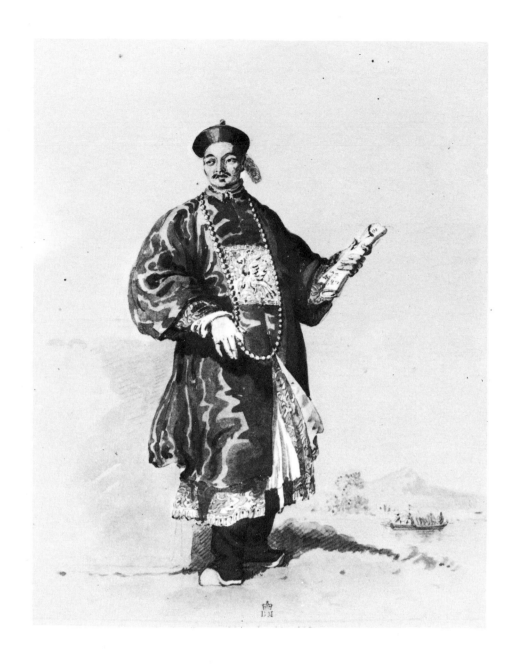

25 *Portrait of Chou ta-jen*
LONDON, British Museum, Department of Prints and Drawings. Pencil and watercolour
23·2 × 18·5 cm.

Lord Macartney wrote in his *Journal* on 25 August 1793 of Wang and Chou's responsibilities: 'The expense incurred by their attendance on the Embassy was considerable, but . . . it chiefly fell upon Chou, who was very rich and well able to bear it; . . . Wang was not rich, and did not therefore contribute to it; but then, he had the principal share of the business, in renewing and stationing the boats, hiring the porters, horses, and carriages, etc., while Chou did little else than receive the reports, write out the register, and pay disbursements.' Alexander depicted Chou with a scroll in his hand as a mark of his capacity as a man of letters rather than as a soldier. The bird image on his robe has the same significance. Like Wang he wears a long row of beads which were of coral, agate and perfumed wood. Cranmer-Byng in his notes to Macartney's *Journal* tentatively identified Chou as Ch'iao Jen-chieh, a successful civil administrator who went on to hold the important post of Provincial Judicial Commissioner of Chihli in 1800–01. Like Wang, Chou endeared himself to the British and Macartney writes of him with particular affection. Alexander's portrait of Chou, plate twenty-one in *The Costume of China*, differs from this watercolour only in the pattern of the fabric which makes up the inner skirt of his garment. Another portrait of him in volume I of the India Office Library collection was inscribed by Alexander 'Chow Tazhin'. The British Museum watercolour is contained in the album which was formerly in the collection of the Rev. Charles Burney and which was purchased for the museum in 1865.

(*opposite*)
IV *A Pipe-bearer Attendant on the Mandarin of Tourane* (Plate 6)
MAIDSTONE, Maidstone Museums and Art Gallery.

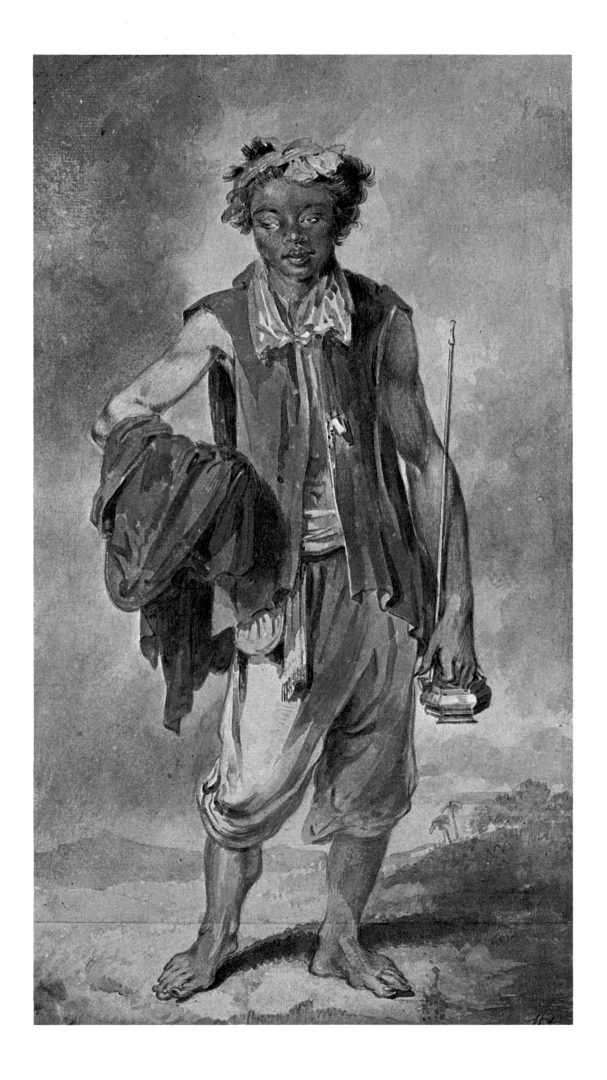

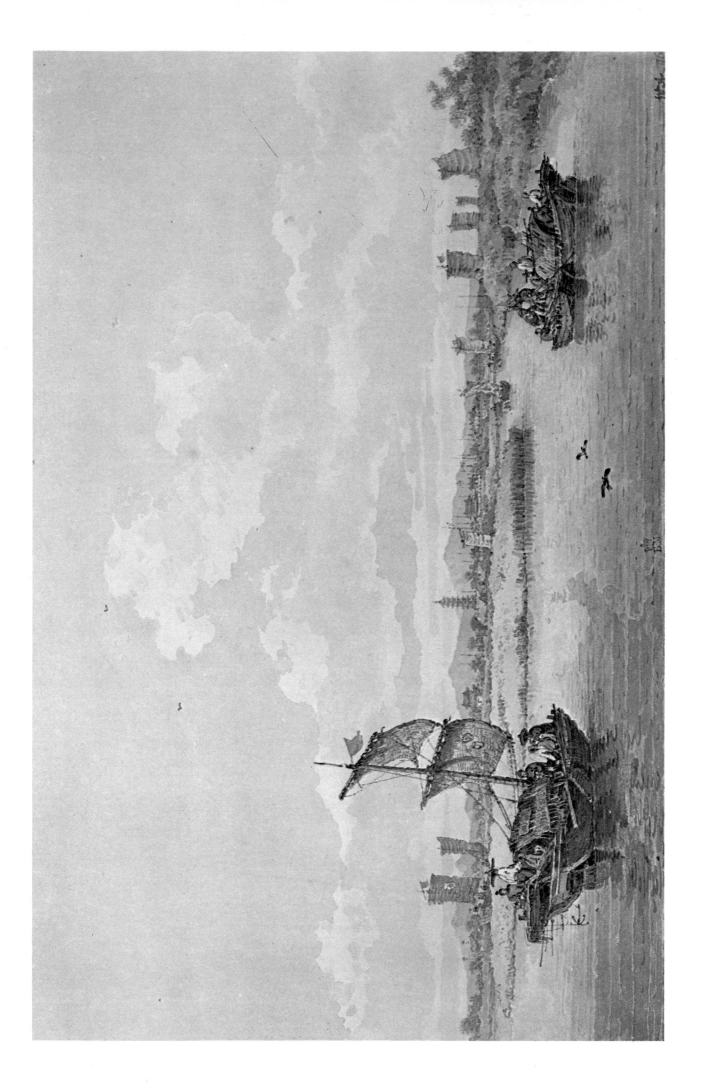

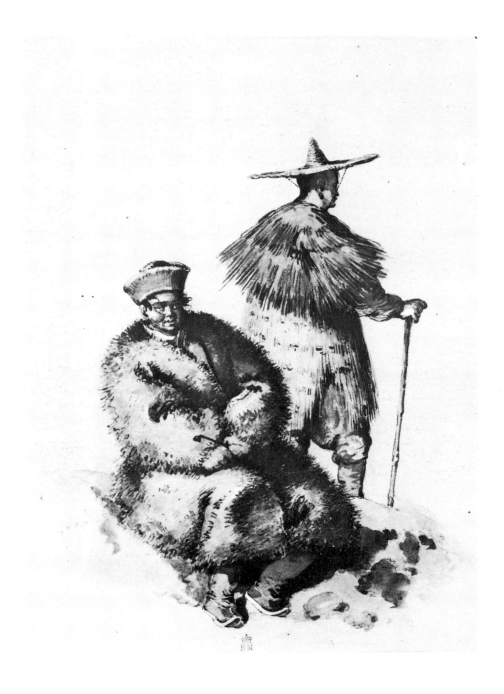

26 *Figures Equipped for Cold or Rainy Weather*
LONDON, British Museum, Department of Prints and Drawings. Pencil and watercolour
23·6 × 18·3 cm.

Plate thirty of *The Costume of China*, published on 13 August 1801, shows these two figures with an additional seated man sheltering with an infant under an umbrella to the right of the group. This drawing was probably made around 1796, which is the date borne by several other Chinese scenes in the same album as this one (see Plates 28 and V). The standing man wears a coat of *cajam* leaves and the seated one a fur coat, which, according to Alexander's caption in *The Costume of China*, was reversible: it could be worn with the fur inside. Sturdy clothing was a necessity in most parts of China as the British were to discover. Not only did the temperature drop dramatically at night but rain-storms were of unusual severity. Macartney wrote on 26 July 1793: 'It rained most violently at the forenoon, and in the evening we had for several hours together such a series of lightning and thunder as I never remember before!' An illustration of *Chinese Husbandmen* in the Daniells' *A Picturesque Voyage to India by the Way of China* of 1810 shows a man wearing a *cajam* coat like the one in Alexander's drawing and the caption in this book describes how the foliage of the *cajam* tree, like the plumage of aquatic birds, has the property of repelling water.

(opposite)
V *The City of Tungchow* (Plate 28)
LONDON, British Museum, Department of Prints and Drawings.

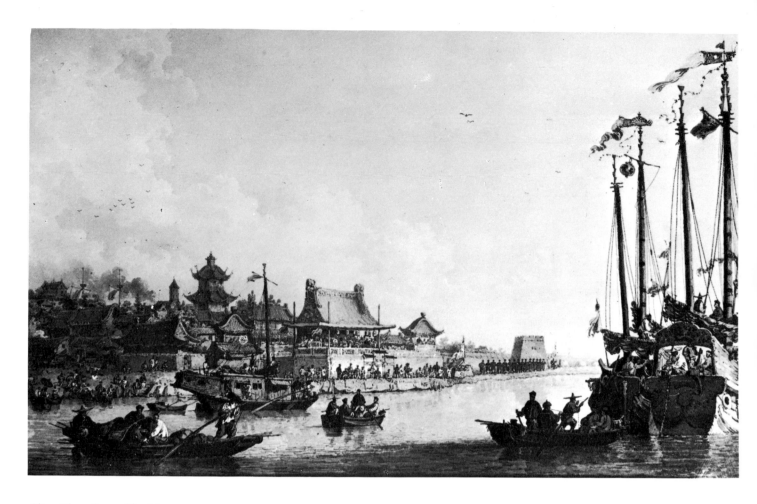

27 *River Scene, Tientsin*
MANCHESTER, University of Manchester, Whitworth Art Gallery. Pencil and watercolour
28·6 × 45·7 cm. Signed and dated lower right: W. Alexander 96.

Traditionally known simply as *Chinese River Scene* this fine watercolour represents the arrival of the
embassy at Tientsin on the Peiho River on Sunday 11 August 1793. Lord Macartney described the
scene just as it appears in Alexander's picture: '. . . close to the water was erected for this occasion
a very spacious and magnificent theatre, adorned and embellished with the usual brilliancy of
Chinese decorations and scenery, where a company of actors exhibited a variety of dramas and
pantomimes, during several hours almost without intermission.' He added that 'Both sides of the
river were lined, for near a mile in length with the troops of the garrison . . .'. *Staunton* describes
Tientsin as a 'heavenly spot' with a good climate and fertile soil. A sketch for this watercolour, the
same size but less finished, is in volume III of the India Office Library collection and three smaller
sketches of the same scene are in volume I, one of which is inscribed 'Theatre at Tiensin 1793'.
One of the drawings sold at Sotheby's on 1 April 1976 as lot 12 was *Temporary Pavilion . . . at Tien-
sin*, and an aquatint of the theatre appears under the title *Temporary Building at Tien-sin* as plate
forty-four of *The Costume of China*. Alexander exhibited a *View at Tien-Sin in the Province of Petchi-Li*
[sic], *China* at the Royal Academy in 1796 and a *View of Tien-Sing* [sic] in 1800, the first of which
might have been this picture. The Friends of the Whitworth Art Gallery purchased the watercolour
in 1955 from Miss K. C. Lupton. It had previously belonged to Miss M. Lupton and to Thomas
Ashton of Hyde.

(*opposite top*)
28 *The City of Tungchow*
LONDON, British Museum, Department of Prints and Drawings. Pencil and watercolour
19·2 × 30·1 cm. Initialled and dated lower right: WA.96.

Alexander entitled this view on the mount 'The City of Tong-tcheou-fou, twelve miles from Peking.
Aug.t.16.1793', but he actually made the drawing in England in 1796. In its quiet simplicity it is
one of the most appealing of all Alexander's watercolours of China. The embassy arrived at
Tungchow at half-past six on the evening of 16 August, according to Macartney's *Journal*. This
town marked the end of the 180 mile journey up the Peiho and the remaining twelve miles to
Peking were to be negotiated by land. The transfer of the gentlemen of the embassy and their
luggage from river-craft to carriages and palanquins was arranged by the Chinese at Tungchow
and the departure for Peking took place early on 21 August. Lord Macartney described Tungchow
as a city 'of great extent, encompassed with very high walls, washed by the river on one side and
defended by a broad wet ditch on others.' This drawing is one of those mounted in an album
purchased for the British Museum from the Rev. Charles Burney in 1865.

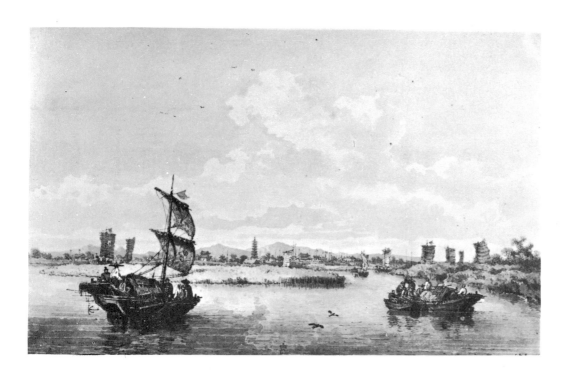

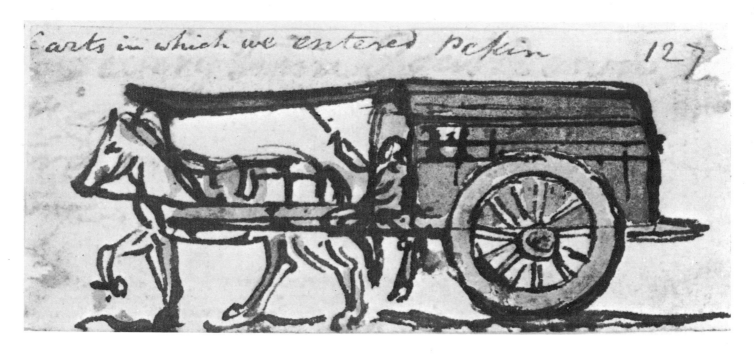

29 *'Carts in which we entered Pekin'*
LONDON, India Office Library and Records. Pen, pencil and watercolour 3·2 × 7·8 cm.

This tiny drawing, hardly more than a scribble, is included here as its character reflects so well the hectic events of Wednesday 21 August 1793, the day of the overland journey of twelve miles from Tungchow to Peking and from there to the palace of Yuan-ming Yuan about seven miles further on. While the ambassador and his immediate retinue travelled in sedans. Alexander and most other members of the British party were subjected to the greatest possible discomfort in small, unsprung horse-drawn carriages. Alexander described in his *Journal* how the passenger was obliged to sit cross-legged on a cushion in a suffocating atmosphere of dust and heat: 'My eyes being weak I wore a bandage of green silk, and sat without my coat *a la Turque*, with a fan, which I found of infinite service. Some others looked equally ludicrous with goggle spectacles to defend them from the dust etc.' John Barrow, who travelled in the same mode, recorded the heat in his carriage as ninety-six degrees farenheit, 'almost insupportable'. The company arrived at Yuan-ming Yuan at about three o'clock in the afternoon, having taken two hours to cross Peking from the east to west gates. Aeneas Anderson regretted in his *Narrative* that the procession through the city had not been more stately: 'I cannot but feel some degree of regret, that no alteration was made in the ordinary travelling, and shabby appearance of the embassy on such an important occasion . . . our cavalcade had nothing like the appearance of any embassy, from the first nation in Europe, passing through the most populous city in the world.'

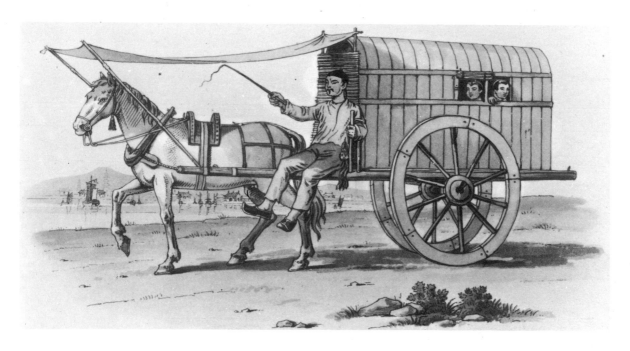

30 *Picturesque Representations of the Dress and Manners of the
Chinese*, plate thirty-three: *A Chinese Carriage*
Print published January 1814. Hand-coloured aquatint
23 × 17 cm.

Lord Macartney wrote in his *Observations on China*
attached to his *Journal*, 'They have no wheel-carriages for
travelling on a better construction than that of a higler's
cart . . . The lightness, neatness, and commodiousness of
my post-chaise, in which I travelled to Jehol, they were
quite delighted with; but the fearlessness and celerity and
safety with which my postilions drove it almost petrified
them with astonishment.' Alexander's illustration shows a
cart very similar to the one in which he travelled from
Tungchow to Peking. Paradoxically the horse is better
cared for than the driver or passengers; he is given a
canopy to protect him from the heat of the sun while the
driver perches awkwardly on one of the shafts and the
passengers suffer from heat and vibration inside.

(*opposite top*)

31 *Ping-tze Muen, One of the North-western Gates of Peking*
LONDON, British Museum, Department of Prints and Drawings. Pencil and watercolour
28·2 × 44·5 cm. Signed and dated lower right: W. Alexander f. 1799.

Ping-tze Muen was the busy gate through which members of the embassy passed on their journeys
to and from Yuan-ming Yuan, the palace outside Peking where the gifts brought from England for
the emperor were assembled and laid out. This and other similar gates in the city walls were,
sadly, destroyed in the 1950s. A comparison with old photographs shows that Alexander
exaggerated the upward curve of the roofs, as he tended to do in many of his representations of
Chinese architecture. The watercolour is dated 1799, as is another version of comparable quality in
the collection of the Maidstone Museums and Art Gallery. Unfortunately the Maidstone picture,
which is marginally larger (30 × 45·3 cm.), is badly faded and discoloured. These two watercolours
differ very little in design but the engraving by J. Dadley of the same subject for plate twenty of
the folio volume of *Staunton* includes a willow tree in the left foreground and shows a number of
figures differently placed. The whereabouts of Alexander's drawing for this illustration is not
known. A picture of the gate dated 1799 was sold by W. B. White for 25 guineas to 'Hogarth' on 29
January 1880 at Christie's. The British Museum drawing was purchased in 1882. John Barrow,
who was one of those employed at Yuan-ming Yuan while the ambassador went to Jehol, wrote of
this gate in his *Travels in China*: 'I scarcely ever passed the western gate which happened twice, or
oftener, in the week, that I had not to wait a considerable time before the passage was free,
particularly in the morning, notwithstanding the exertions of two or three soldiers with their whips
to clear the way.' Barrow himself made a drawing of the gate from the same viewpoint as
Alexander. It is preserved in the album *Barrow's Travels in China and Cochin China; Original Drawings
by Alexander, Daniell, etc.* in the British Library. A poor copy of Barrow's sketch, perhaps by Parish,
was included in the Sotheby's sale of 1 April 1976 as lot 17 and was wrongly attributed to
Alexander.

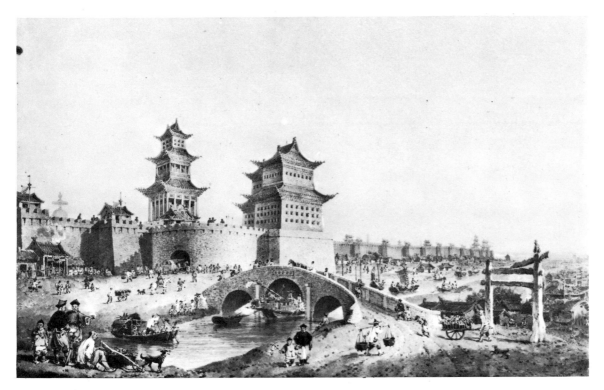

32 *The Costume of China*, plate forty-seven: *Stone Building in the Form of a Vessel*
Print published 1 November 1804. Hand-coloured aquatint 32 × 26 cm.

It was originally planned to house the members of the embassy at Yuan-ming Yuan outside Peking, but on 22 August, the day after their arrival, Lord Macartney asked if alternative accommodation could be found as the quarters were 'somewhat out of repair, and rather inconvenient to us Europeans, whose modes of living were different from the Chinese.' On 26 August the British were moved to 'a vast palace' in Peking which Alexander described in his *Journal* as consisting of 'paved court-yards and gardens fancifully laid out with artificial rocks etc.' The illustration in *The Costume of China* represents a building in one of these courts which was made to resemble a boat and surrounded by a hollow which was sometimes filled with water from a nearby well. The upper part of the building was used by the suite of the embassy as a dining-room. The whole extravaganza had been built by a rich customs official and confiscated by the government when he was found guilty of fraudulent practices in Canton where he was the *Hoppo* (the official in charge of the revenue of the province) and in Tientsin where he was the collector of salt duties. The 'boat' building appears in two drawings in volume III of the India Office Library collection, the first of which had been mistakenly catalogued as 'Junk like a houseboat.' A marble boat built on the shores of Lake Kunming (fig. 4) by Ch'ien-lung still exists, though with nineteenth-century wooden additions.

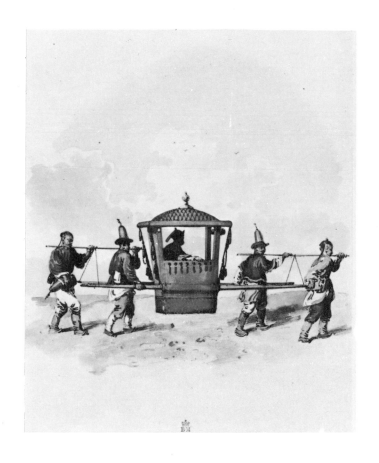

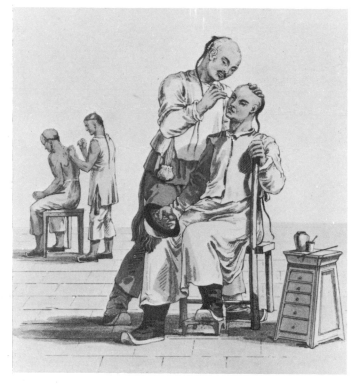

(*top left*)

33 *A Mandarin in his Sedan*

LONDON, British Museum, Department of Prints and Drawings. Pencil and watercolour
21·7 × 18 cm.

When travelling on land privileged citizens such as mandarins favoured the sedan, presumably because of the primitive character of all available horse-drawn vehicles. Engraved versions of this drawing appear on page 73 of the second text volume of *Staunton* published in 1797 and opposite page 180 in the Stockdale edition of *Staunton*, the latter was engraved by Sansom. Another pencil and watercolour version is in volume III of the India Office Library collection. A man was ennobled to the rank of mandarin in recognition of meritorious service to his country either in a civil or military capacity. In the reign of Ch'ien-lung the eight different classes of mandarin could be distinguished by the style and colour of the buttons on top of their caps, which ranged from smooth red coral for the first order to engraved gilt brass for the eighth. This drawing is one of those contained in an album purchased by the British Museum from the Rev. Charles Burney in 1865.

(*top right*)

34 *Picturesque Representations of the Dress and Manners of the Chinese*, plate twenty-two: *Chinese Barbers Champooing*
Print published January 1814. Hand-coloured aquatint 23 × 17 cm.

Aeneas Anderson in his *Narrative* recorded that in Peking barbers were seen 'running about the streets in great plenty, with every instrument known in this country for shaving the head and cleansing the ears.' In addition Alexander informs us in the caption to this plate, 'The luxury of champooing is enjoyed by all ranks of men: it consists of pulling the joints till they crack, and of thumping the muscles until they are sore'. At the same time the barbers 'tickle the nose, and play a thousand tricks to please and amuse their customers.' The barbers advertised their presence in the streets by making a strange twanging noise, rather like the sound of a Jew's harp, with their tweezers. Thomas and William Daniell also included an illustration of a *Chinese Barber* in their *Picturesque Voyage to India by the Way of China* published in 1810.

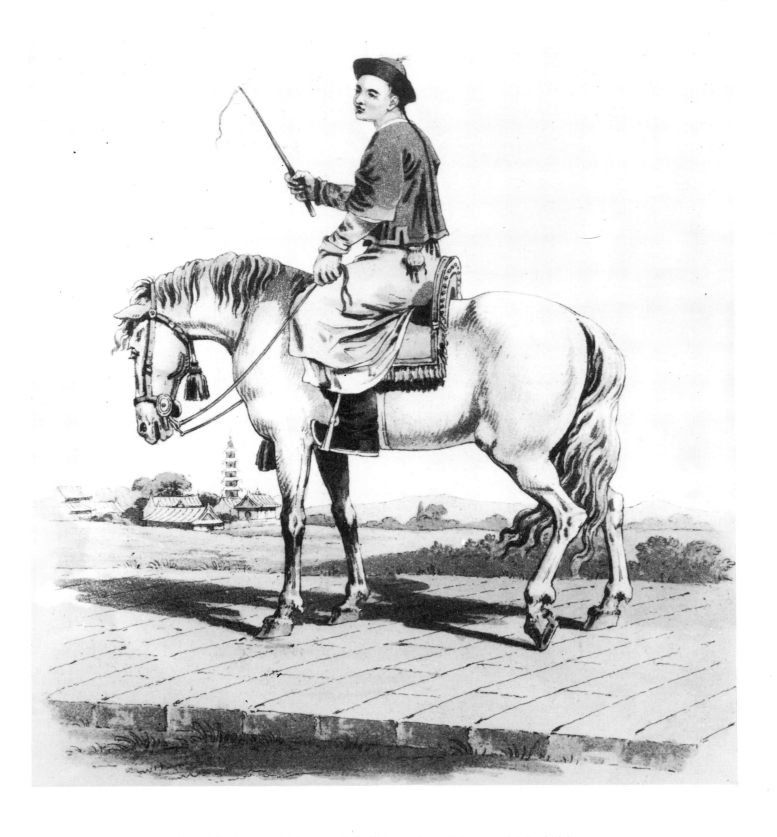

35 *Picturesque Representations of the Dress and Manners of the Chinese*, plate eighteen: *A Mandarin's Servant on Horseback*
Print published January 1814. Hand-coloured aquatint 23 × 17 cm.

To the members of the embassy accustomed to the refinements of riding in Great Britain the quality of Chinese horses.and saddlery left much to be desired. Lord Macartney lamented in his *Observations on China* that 'The saddles, bridles and accoutrements of their horses are inelegant and ill-contrived, and equally inconvenient to the beast and his rider.' In this illustration Alexander eloquently expressed the stubborness which was apparent in most of the Chinese horses, and it is not surprising that the sight of Lord Macartney's amateur coachman trying to break four of these animals to harness in the streets of Peking attracted much interest. The coachman must have succeeded, for Lord Macartney described in his *Journal* how on 2 September 1793 he set off for Jehol in his post-chaise, which he had brought from England, drawn by 'four little Tartar horses not eleven hands high.'

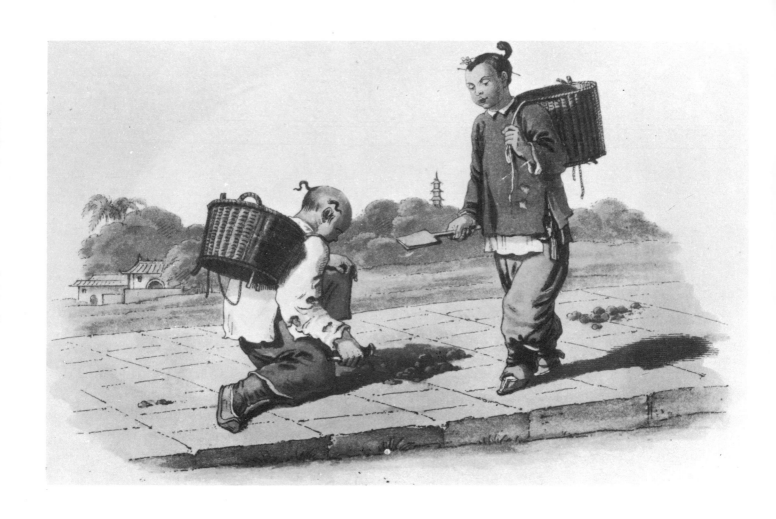

36 *Picturesque Representations of the Dress and Manners of the Chinese*, plate eight: *Children Collecting Manure*
Print published January 1814. Hand-coloured aquatint 23 × 17 cm.

In China one of the duties of the young was to follow behind riders and horse-drawn vehicles in order to collect manure for the fertilization of the fields. According to Macartney 'an undutiful child is a monster that China does not produce.' While this was clearly an over-simplification, it was noticed by members of the embassy that family ties among the Chinese were strong and boys and girls lent a hand in their father's trade from an early age. In stark contrast to the evident affection of most families there was the repeated rumour of the exposure of unwanted babies in the most destitute areas of Peking and other large cities. John Barrow claimed that about twenty-four children were abandoned every night in the streets of Peking and several other authors reported higher figures, but none of the British record having seen evidence of the practice themselves. Most of the children in Alexander's drawings look simply but adequately clothed and well cared-for.

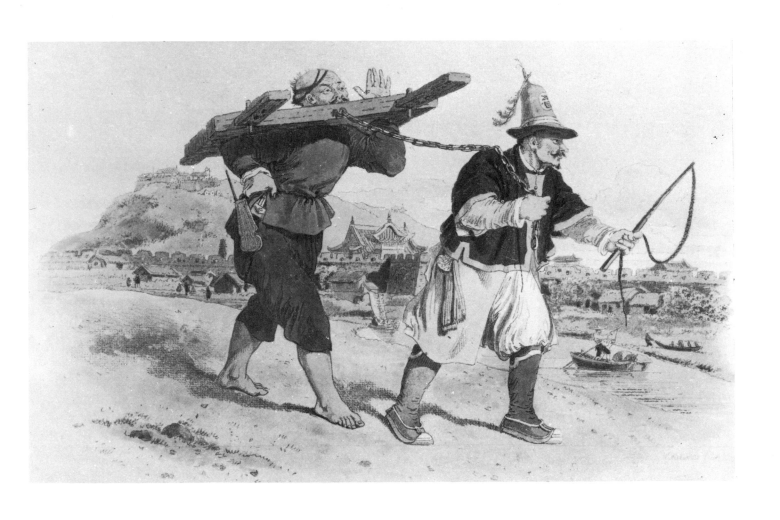

37 *The Costume of China*, plate ten: *The Punishment of the Cangue*
Print published 1 May 1798. Hand-coloured aquatint 26 × 32 cm.

Despite the unpleasantness of the subject this is one of the most attractive plates in *The Costume of China*. The figures are full of life and the background is detailed and colourful. Alexander explains the subject of this print in some detail in his caption. Offenders punished by the *cangue* or *tcha* spent their nights in prison and in the morning were led to some busy place where they were forced to pass the day shouldering a weight of anything from 60 to 200 lbs. while being derided by passers-by. The number of days the *tcha* had to be carried depended on the magnitude of the crime committed: up to three months was not unusual. Justice was administered by the mandarins who in turn were subject to punishment by higher-ranking mandarins and other officers such as city governors. A study for this print is in volume III of the India Office Library collection. It is the reverse way round to the aquatint, with the figures facing left, which is unusual in Alexander's work. He nearly always reversed the image on to the etching plate so that the preparatory drawings and the finished print were the same way round.

38 *Staunton*, volume I, textual illustration: *Chinese Women's Feet*
Line engraving by Benjamin Thomas Pouncy (d. 1799) after Alexander 5·5 × 11 cm.

The engraver responsible for putting the letters to this print mistakenly inscribed it *R. Alexander, del.*
Sir George Staunton, in his text next to the illustration, described the practice of binding women's
feet in order to stunt their growth, and added, 'An exact model was . . . procured of a Chinese
lady's foot, from which the annexed engraving has been taken.' Alexander mentioned in his *Journal*
how he tried repeatedly but without success to obtain such a cast from the sculptor whom he met
in Canton, so it must be assumed that the model referred to by Staunton belonged to some other
member of the embassy. On 16 August 1793, while the embassy was at Tungchow, Alexander
wrote, 'This extraordinary custom compels females to be domestic as walking about must be
irksome. While yet in their infancy the 4 inferior toes are bent under the foot, the great toe forming
the point. This is now bandaged, with tight ligatures to prevent the foot growing longer.' Elsewhere
he mentions watching women 'stumping along' on their tiny feet. Female footwear was quite
elaborate; it was the most decorative part of a woman's dress except for her hairstyle which often
incorporated beads, artificial flowers and bodkins (see Plate XII). Although foot-binding was
universal among the Chinese it was not considered essential by the inhabitants of China who were
of Tartar blood. A drawing for this engraving is in volume I of the India Office Library collection,
and another very similar print of the same subject engraved by Charles Grignion illustrates the
Stockdale edition of *Staunton*.

39 *Portrait of a Chinese Scholar*
NEW HAVEN, Yale Center for British Art (Paul Mellon
collection). Pencil and watercolour 22 × 18 cm.

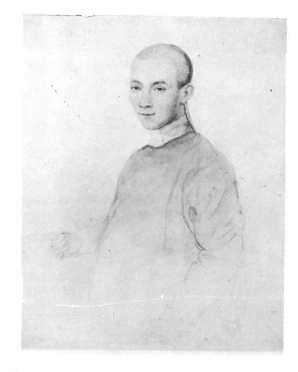

Unfortunately the identity of this Chinese man is not
known, but the drawing illustrates beautifully
Alexander's ability as a portraitist. In studies such as this
he came close to the sensitivity of the work of his good
friend and near contemporary Henry Edridge (see
frontispiece). Although at the time of the embassy the
Chinese empire was at a peak of prosperity and power,
scholarship was at a low ebb, mainly as a result of the
conservatism of the imperial court. The British found even
the most intelligent of the Chinese they met extraordinarily
poorly informed about world affairs and all branches of
science and the arts. It was firmly believed, for instance,
until well into the nineteenth century, that Britain was an
island so small that most of its people had to live in boats
on the water. This drawing was purchased for the Paul
Mellon collection from Colnaghi, London, in December
1961 and had formerly been in the collection of L. G.
Duke.

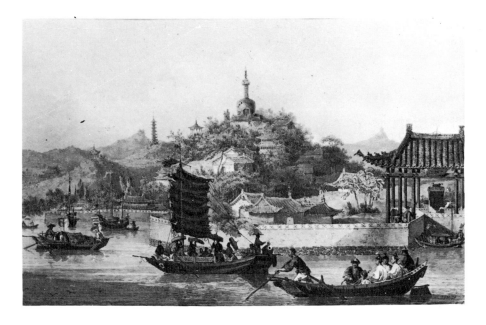

40 *A View in the Gardens of the Imperial Palace in Peking*
LONDON, Victoria and Albert Museum. Pencil and watercolour 23·5 × 35·5 cm. Initialled lower right: WA.f.

The view is of Pei Hai, the northern lake in Peking. The artificial island Ch'ung Hua Tao, surmounted by the White Dagoba, looks much the same today as it did in Alexander's time (fig. 5). The Dagoba was built in 1651 to commemorate the first visit to Peking of the Dalai Lama of Tibet. The hills and pagoda to the left of the picture are Alexander's invention, this particular part of Peking being in reality quite flat. He probably based this aspect of the composition on the hilly area near the Summer Palace (fig. 4) which is dominated by a pagoda. Another version of this picture, of almost the same size (24 × 38 cm.), was sold at Sotheby's on 1 April 1976 as lot 15. It was purchased by the Martyn Gregory Gallery where it was included in an exhibition *British Artists (together with some Chinese) working in China in the 18th and 19th Centuries* (catalogue no. 2), 7–26 November 1977. The Victoria and Albert Museum picture is part of the William Smith bequest of 1876. Thomas Allom's illustration *Gardens of the Imperial Palace, Peking*, opposite p. 46 in volume III of the Rev. G. N. Wright's *China Illustrated*, is a thinly disguised copy of this composition.

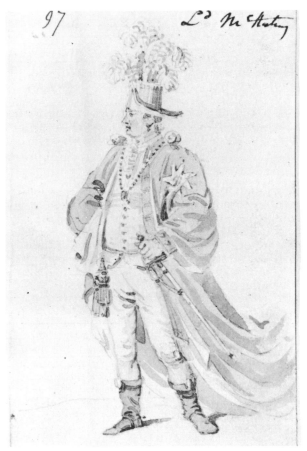

41 *Lord Macartney Dressed in the Robes of the Order of the Bath*
LONDON, India Office Library and Records. Pencil and watercolour 11·2 × 7 cm.

This stunning little watercolour, only 11·2 cm. high, is one of the studies used by Alexander for his reconstruction of the audience ceremony at Jehol of 14 September 1793 (Plates 42 and VI). Since the artist did not attend the audience he must have made the sketch when the ambassador was dressed up for some other occasion. Aeneas Anderson, Macartney's valet, described the costume in his *Narrative*: 'His Excellency was dressed in a suit of spotted mulberry velvet, with a diamond star, and his ribbon; over which he wore the full habit of the order of the Bath, with the hat, and plume of feathers which form a part of it.' Macartney felt that out of respect and courtesy for the Chinese he and Sir George Staunton should be attired as splendidly as possible for the meeting. Staunton was clad in 'a rich embroidered velvet . . . and, being a Doctor of Laws in the University of Oxford, wore the habit of his degree, which is of scarlet silk, full and flowing' (Plates VI and 42).

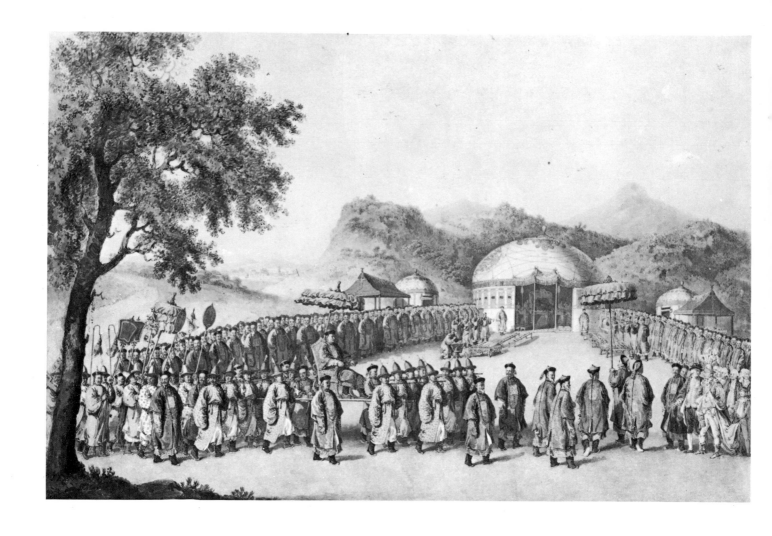

42 *The Approach of the Emperor of China to his Tent in Tartary to Receive the British Ambassador*
LONDON, British Museum, Department of Prints and Drawings. Pencil and watercolour
40 × 60·6 cm. Signed and dated lower left: W. Alexander f.96.

The meeting of Lord Macartney with the Emperor of China was the climax of years of planning, a
great deal of expenditure and a year of travelling. The audience ceremony took place at a tent set
up for the purpose in the Garden of Ten Thousand Trees near Jehol early on the morning of
Saturday 14 September 1793. In all it lasted five hours and included, as well as the official
exchange of messages and presents, entertainments such as wrestling and a display of acrobatics.
Macartney likened the occasion to the witnessing of 'Solomon in all his glory'. In this picture
Macartney and Staunton are seen to the right, watching the emperor being carried to his throne in
the tent. Five other watercolour versions of the composition are known. They belong respectively to
volume III of the India Office Library collection, London, the Martyn Gregory Gallery, London,
the Indianapolis Museum of Art, Indianapolis, the Birmingham City Art Gallery, Birmingham,
and the Royal Asiatic Society, London. The Indianapolis picture was engraved by James Fittler for
plate twenty-five of *Staunton.* Although the Martyn Gregory Gallery picture, which came from the
Sotheby's sale of 1 April 1976, is inscribed on the old mount 'from a sketch by Captain Parish',
Alexander's main source for his design was a print after Giuseppe Castiglione, *The Emperor Giving a
Victory Banquet in Peking to the Officers and Soldiers who Distinguished themselves in Battle* (fig. 9) which
represents an audience given by Ch'ien-lung over thirty years earlier. Alexander did refer to a
sketch by Parish (fig. 8) for the general appearance of the countryside and the grouping of the
figures awaiting the emperor's arrival, but for details of the imperial tent and the smaller tents on
either side he borrows directly from Castiglione. He also adopts Castiglione's placing of the figures
of the emperor's retinue, showing the moment when the leader of the procession is just turning in
towards the tent. The chronology of all six versions of Alexander's picture can be established on the
basis of style and their relationship with the Castiglione engraving. The two smallest, least finished
and earliest versions, both of which are undated, are those in the India Office Library collection
and the Martyn Gregory Gallery. Following them is the Indianapolis watercolour, which, although
it was used for Fittler's engraving of 1796, is less developed than the Birmingham picture which is
dated 1795. The only version later than the one illustrated here is the watercolour belonging to the
Royal Asiatic Society which is indistinctly dated 1799. It was probably commissioned by one of the
Stauntons and was presented to the Society in 1856 by George Thomas Staunton, who was the
page to Lord Macartney in the picture. The British Museum drawing was purchased from a Mr.
White in 1872.

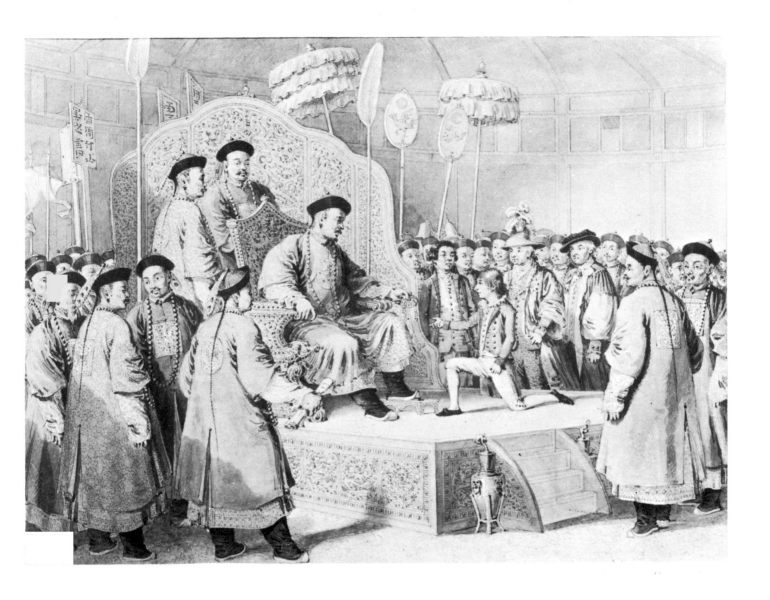

43 *Ch'ien-lung presenting a Purse to George Thomas Staunton inside the Imperial Tent at Jehol*
SAN MARINO (CALIFORNIA), Henry E. Huntington Library and Art Gallery. Pencil and watercolour
19 × 25·4 cm.

This scene represents what was perhaps the most human moment in the long ceremony at Jehol.
Having completed the formalities of exchanging official messages and presents with Macartney and
Sir George Staunton, Ch'ien-lung enquired if any of the British understood the Chinese language.
When he was told that the twelve-year-old page George Thomas Staunton had acquired some
knowledge of it, he asked for the boy to be brought to him. The ensuing scene was described by
young Staunton's father: 'Either what he [George Thomas Staunton] said, or his modest
countenance or manner, was so pleasing to his Imperial Majesty, that he took from his girdle a
purse hanging from it, for holding areca nut, and presented it to him. Purses are the ribands of the
Chinese monarch, which he distributes as rewards of merit among his subjects, but his own purse
was deemed a mark of personal favour, according to the ideas of Eastern nations, among whom
anything worn by the person of the sovereign is prized beyond all other gifts . . .'. Alexander must
have reconstructed the scene from eyewitness accounts. A sketch in pencil and grey wash in
volume III of the India Office Library collection shows the same scene slightly earlier in time, with
Lord Macartney bending on one knee before the emperor. In this sketch more members of the
British party are shown behind Macartney and each is identified with his name. Sir George
Staunton stands to the right. The portraits of Macartney and Staunton are very carefully executed
as is the figure of the young Staunton, for which a study is preserved in volume I of the India
Office Library collection. It is possible that the Huntington watercolour was, like the late version of
The Approach of the Emperor of China to his Tent (see Plates 42 and VI), commissioned by one of the
Stauntons. It belonged to Miss Gertrude Lynch-Staunton before it was purchased from Colnaghi,
London, for the Huntington Library and Art Gallery on 26 June 1957. A very attractive full-length
oil portrait of young Staunton by Thomas Hickey, looking much the same age as he does in this
picture and dressed very similarly, was sold from the collection of Captain G. S. Lynch-Staunton at
Brussels in 1929. Its present home is not known. A pretty pencil and watercolour head-and-
shoulders sketch of the boy made in 1793 by Alexander is in the Ashmolean Museum, Oxford.

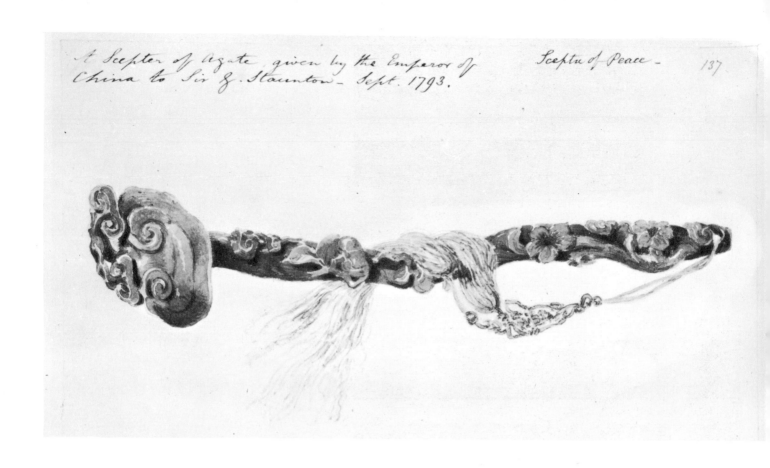

44 *A Jade Sceptre presented by Ch'ien-lung to Sir George Staunton*
LONDON, India Office Library and Records. Pencil and watercolour 14 × 24·3 cm.

Alexander inscribed this drawing, now in volume I of the India Office Library collection, 'A Scepter of agate given by the Emperor of China to Sir G. Staunton. Sept. 1793', and 'Sceptre of Peace.' The sceptre was in fact of carved jade and was one of three presented by Ch'ien-lung during the audience at Jehol, the other two being given to Lord Macartney, one for himself and the other for the King of England. These gifts, although symbols of prosperity and peace, seemed but little in return for the mass of expensive and elaborate presents brought for the emperor from England. In his *Journal* Lord Macartney described the sceptre intended for the king as 'a whitish agate-looking stone about a foot and a half long, curiousely carved, and highly prized by the Chinese, but to me it does not appear in itself to be of any great value.' The British gifts, the majority of which were being assembled at Yuan-ming Yuan while the ambassador was at Jehol, included as the principal item a planetarium which was reputed to have taken thirty years to build, a large orrery, several clocks and lustres, examples of Wedgwood and other pottery and porcelain and even three carriages which, it was later learnt, were never used. On 6 September, while travelling to Jehol, Lord Macartney was shown an astonishing report from a Tientsin newspaper detailing gifts the British were believed to have brought with them for the emperor. It listed 'an elephant not larger than a cat, a horse the size of a mouse' and a number of other equally surprising curiosities.

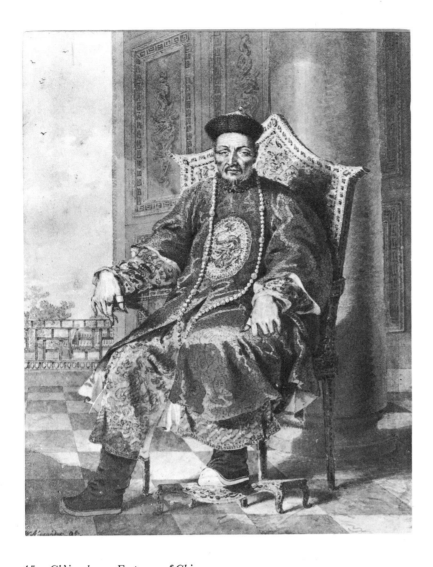

45 *Ch'ien-lung, Emperor of China*
LONDON, collection of the late S. R. Hughes-Smith. Pencil and watercolour 23 × 18 cm. Signed and dated lower left: W. Alexander 95.

In composition, treatment, colouring and size this powerful watercolour is almost identical to one in the Department of Prints and Drawings in the British Museum which is dated 1796. The emperor is dressed in a shimmering blue-grey coat over a gold robe and is seated in a lofty hall near a large pinkish-coloured pillar. Two other slight watercolours of the same composition are known, one in volume I of the India Office Library collection and the other in the Ashmolean Museum, Oxford, and the subject was etched by Alexander in reverse for plate two of *Picturesque Representations . . . of the Chinese* and engraved by Collyer as the frontispiece to the first text volume of *Staunton*. There are also two head-and-shoulder sketches of the emperor in volumes I and III of the India Office Library collection. Sir George Staunton wrote of Alexander's likeness of the emperor: 'It was made under unfavourable circumstances; yet the person, dress and manner are perfectly like the original, but the features of the face, which were taken by stealth, and at a glance, bear a less strong resemblance. This, of all the drawings made by Mr. Alexander throughout the route, the gentlemen of the Embassy who had an opportunity of comparing them with the originals, thought the only one which was defective.' It is probable that Alexander only saw the emperor once, when he was returning from Jehol, carried on a palanquin, on 30 September 1793. A picture by Castiglione, *Kazaks Presenting Horses in Tribute* in the Musée Guimet, Paris, shows Ch'ien-lung to have less heavily-lidded eyes and a generally narrower face than Alexander gave him. At the time of the embassy the emperor was eighty-three years old, but Lord Macartney described him as 'still healthy and vigorous, not having the appearance of a man of more than sixty.' Barrow added that his 'nose was somewhat aquiline and complexion florid.' He lived from 1711–99 and reigned from 1736–96 as one of the most powerful emperors of the Manchu Ch'ing dynasty which lasted from 1646–1912, during a period when the bounds of the empire were wider than at any other time in China's history except the Yuan dynasty of 1271–1369. As a Manchu or Tartar, Ch'ien-lung tended to show partiality towards members of his own race and Lord Macartney noticed that nearly all the viceroys of the provinces were Tartars although the actual business of government was mostly carried out by Chinese who were on the whole better educated and more patient in temperament than their 'foreign' overlords. The exact provenance of this drawing is not known, but a note on the back states that it was purchased in 1867 from the Howard de Walden sale for four guineas.

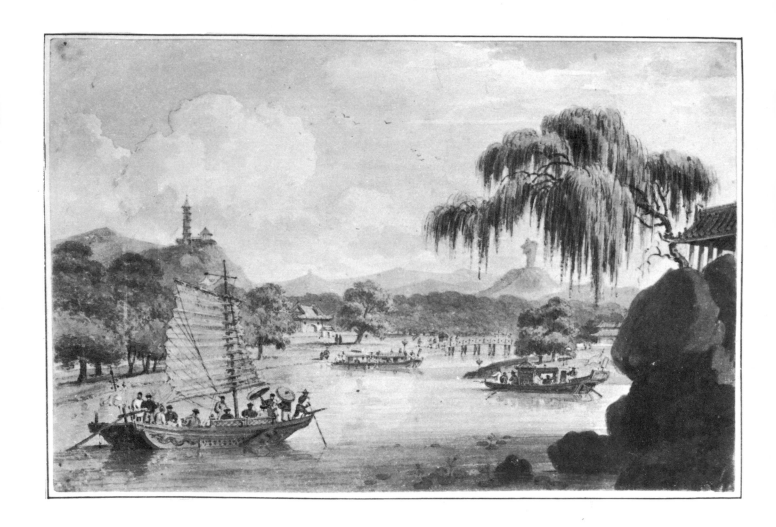

46　*View of the Eastern Side of the Imperial Park at Jehol*
LONDON, British Library, Department of Manuscripts (Add. MS 35300, fol. 27). Pencil and watercolour 16 × 23 cm.

The members of the embassy who went to Jehol were shown the Eastern side of the Imperial Park on Sunday 15 September 1793, the day after the official meeting with the emperor in the Garden of Ten Thousand Trees (Plates 42 and VI). This watercolour by Alexander is the study used for the etched illustration by Thomas Medland published on 2 May 1804 for John Barrow's *Travels in China*. It is mounted in the same album as *The Calvinist Church in Batavia* (Plate 20) in the Additional Manuscripts collection of the British Library. The drawing is inscribed on the mount in Alexander's hand, 'View in the Eastern side of the Imperial Park at Zehol [sic] drawn by W. Alexander from a sketch by Capt. Parish Roȳl. Artill.y. To the engravers the copper on the bottom margin to be just one-fourth of an inch wider. All the rest the same equally as the drawing.' The drawing by Parish which Alexander copied is mounted in the second album of drawings from Barrow's collection entitled *Barrow's Travels in China and Cochin China; Original Drawings by Alexander, Daniell etc.*, also in the Additional Manuscripts collection. It is inscribed 'View of the Emperor's Park at Gehol [sic] with Pong-chu-shong [sic] in the Distance drawn from nature 1793 by W. H. Parish.' John Barrow himself made a drawing of the same view which must also be copied from Parish's sketch, as he was not present on the trip to Jehol. A rather crude watercolour, it was among those sold at Sotheby's on 1 April 1976 as lot 29 and was mistakenly catalogued as the study for the print by Medland for *Travels in China*. The Imperial Park made a great impression on Lord Macartney and he felt particularly honoured to have the Prime Minister of China, Ho-shen, and the Second Minister, Fu-ch'ang-an, as well as several other high-ranking Tartar officials, as his guides for the visit. He wrote, 'It would be an endless task were I to attempt a detail of all the wonders of this charming place. There is no beauty of distribution and contrast, no feature of amenity, no reach of fancy which embellishes our pleasure grounds in England, that is not to be found here.' On the lake the British found a 'magnificent yacht ready to receive us, and a number of smaller ones for the attendants, elegantly fitted up and adorned with numberless vanes, pennants and streamers.'

(*opposite*)
VI　*The Approach of the Emperor of China to his Tent in Tartary to Receive the British Ambassador* (Plate 42)
LONDON, British Museum, Department of Prints and Drawings.

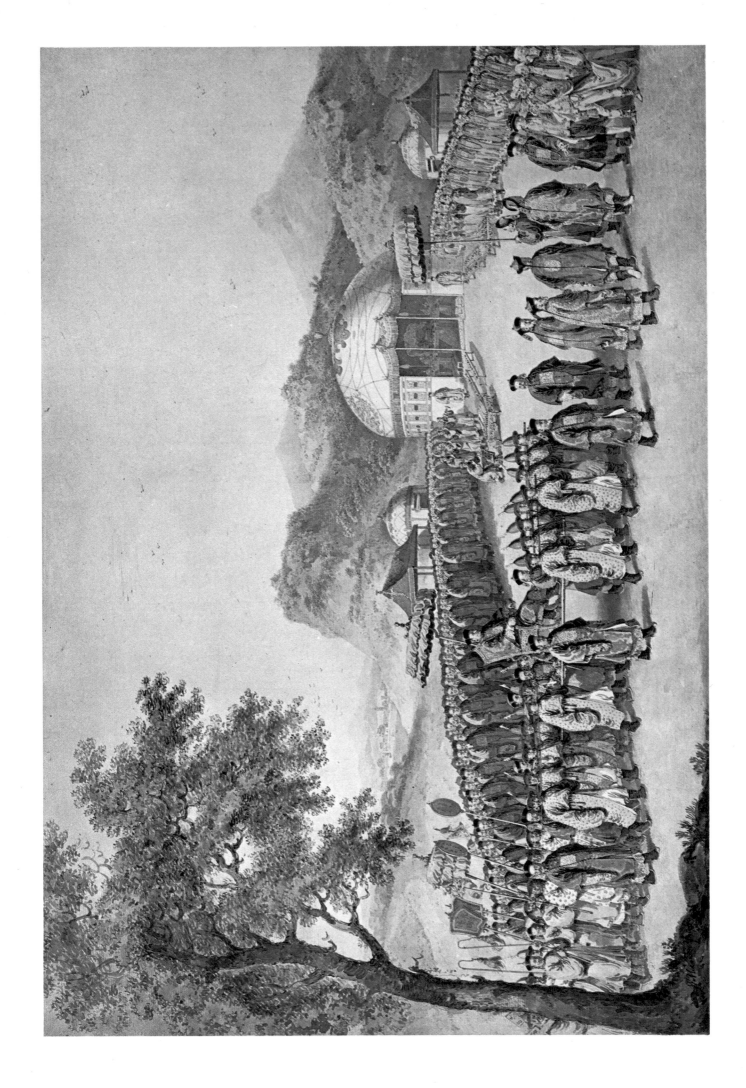

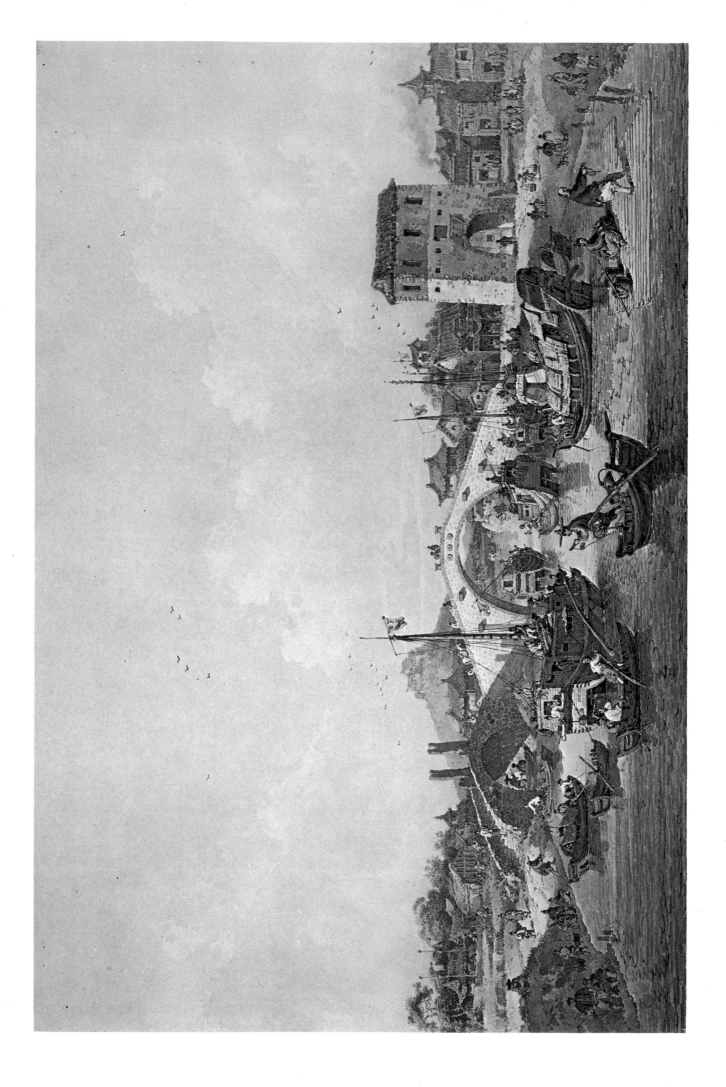

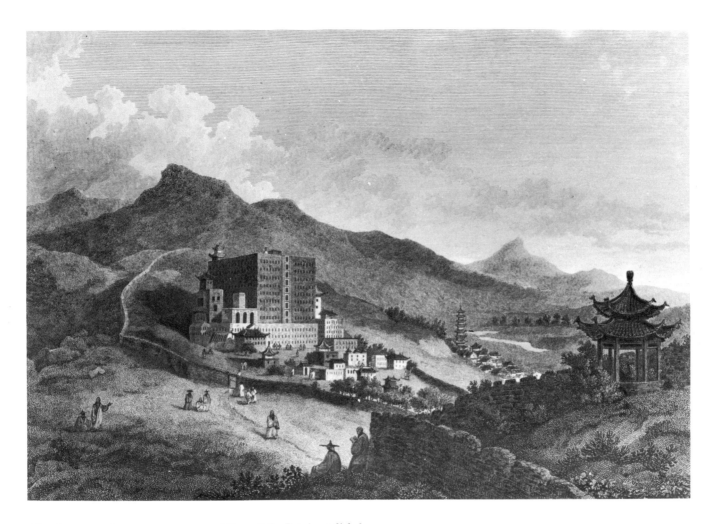

47 *Staunton*, plate twenty-seven: *View of the Potala at Jehol*
Print published 12 April 1796. Line engraving by Benjamin Thomas Pouncy (d. 1799) after
Alexander 24·2 × 35·2 cm.

An inscription against the lower left margin of this print records that the design was drawn by
Alexander after a sketch by Parish. This was necessary as the visit of the embassy to the great
temple of Potala was part of the trip to Jehol from which Alexander was excluded. A drawing by
Parish which was probably the one used as Alexander's source was sold at Sotheby's on 1 April
1976 as lot 28. Alexander elaborated on Parish's sketch by adding a small decorative pavilion in
the foreground and a number of figures and by transforming Parish's feeble hills into respectable
mountains. The Potala still stands. It looks rather less like a twentieth-century building than in this
print, having in reality an upper block of six rather than eight storeys, walls that converge slightly
and a decorated cornice. The vertical column of blank doorways running up the centre of the block
is also richly decorated. On 16 September, when he visited the Potala, Lord Macartney wrote in
his *Journal*, 'It may be considered as the grand cathedral . . . It is an immense edifice and with the
offices belonging to it covers a vast deal of ground . . . and contains, I should conceive, a greater
quantity of materials than St. Paul's.' Apparently the residents were 800 lamas dedicated to the
worship of Fo-hi or Potala, a divinity who occasionally became incarnate and who was believed to
be present in the person of the emperor. A watercolour drawing by Alexander for the print is in
the Victoria and Albert Museum. Benjamin Thomas Pouncy, who made this engraving and several
others after Alexander including the *Chinese Women's Feet* (Plate 38), had, like Alexander, Kentish
connections. He was an accomplished topographical draughtsman and was the brother-in-law and
pupil of William Woollett, the engraver, who was born at Maidstone. Although the facts of
Pouncy's life are obscure the majority of his known original drawings depict scenes in Kent and it
is quite possible that he knew Alexander personally. His interpretation of Alexander's drawings was
more sensitive than that of the other engravers who worked on the illustrations to *Staunton* with the
possible exception of James Fittler (1758–1835), whose engraving of *The Approach of the Emperor of
China to his Tent* (Plates 42 and VI) is quite a sympathetic version of Alexander's original. A distant
view of the Potala appears in the aquatint *Portrait of a Lama or Bonze*, plate thirteen of *The Costume
of China*.

(*opposite*)
VII *Barges of the Embassy Preparing to Pass under a Bridge, Soochow* (Plate 51)
LONDON, British Museum, Department of Prints and Drawings.

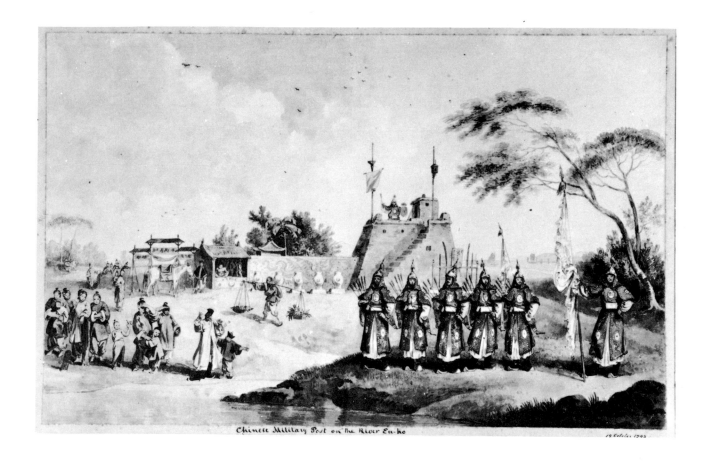

Chinese Military Post on the River Eu-ho

48 *Military Post on the Eu-ho*
LONDON, Sotheby's (sold 1 April 1976). Pencil and watercolour 16·5 × 30 cm.

This picture is inscribed on the old mount by an unidentified hand 'Chinese Military Post on the River Eu-ho, 19 October 1793.' It bears the same inscription 'WA' in the lower right-hand corner as the *Chinese Infantry Soldiers and Peasants* (Plate 16) and *Chinese Watermen* (Plate 17) and several other drawings from the same album, which were all sold at Sotheby's on 1 April 1976. The subject was engraved by J. Pass for plate seventeen of *Staunton* and another watercolour version is in volume III of the India Office Library collection. In the engraving, the onlookers on the left are replaced by two sparring 'tigers of war' (see Plate 16). On 19 October the embassy travelled about fifteen miles along the river from the town of Te-chou. Lord Macartney described the appearance of the country they passed through as 'rather dreary'. In this picture Alexander shows one of the many small forts which were found at intervals along the roads, rivers and canals in this part of China. The man at the top of the fort is banging a gong to herald the arrival of some person of rank, at which the garrison is forming a line outside in readiness to salute the passer-by, in this case presumably Lord Macartney and his embassy. A discussion of the soldiers and their uniforms accompanies Plate 16.

(*opposite top*)
49 *Pagoda of Lin-ching-shih on the Grand Canal*
MAIDSTONE, Maidstone Museums and Art Gallery. Pencil and watercolour 30·5 × 47·5 cm.

Three days after passing the military post depicted in the previous illustration (Plate 48) the embassy came to the end of their journey along the Eu-ho and transferred to the Grand Canal near the town of Lin-ching-shih. This drawing by Alexander of the pagoda at Lin-ching-shih was bequeathed to the Maidstone Museum by Gerald Hughes of York in 1959. He acquired it from Walkers Galleries of Bond Street, London. Very similar watercolour versions of the composition are in the Paul Mellon Collection at the Yale Center for British Art, New Haven (signed and dated 1795), and in a private collection, London (also signed and dated 1795). Two less finished watercolours of the same scene are in volume III of the India Office Library collection. William Byrne engraved the subject for plate thirty-three of *Staunton*. All six versions show slight variations in the placing and attitudes of the figures. Pagodas had much the same function as church towers. They were not in themselves necessarily places of worship but they were usually near a temple or shrine and served to draw attention to the sacred place. The architectural form of the pagoda was already well-known in Britain through Sir William Chambers's tower at Kew which was completed in 1762 in imitation of the pagoda at Nanking. The engraved illustration to *Staunton* calls Alexander's view 'Lin-tsin', John Barrow's map in *Staunton* showing the path of the embassy calls the place 'Lin-sin-tchoo' and Lord Macartney's spelling is 'Lin-chin-chow'. The modern transcription has been used here. A picture by Alexander listed as *Pagoda near Lin-tchin-four* was exhibited at the Royal Academy in 1796.

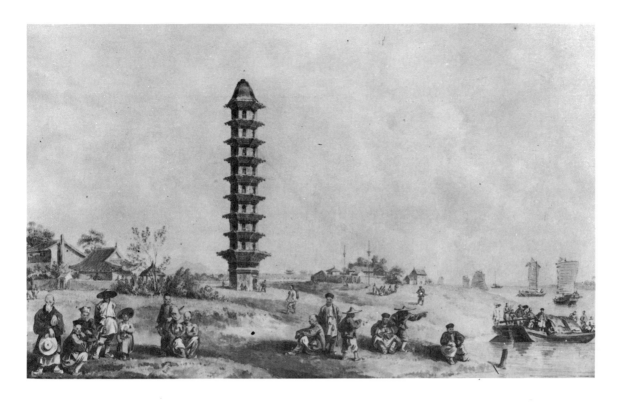

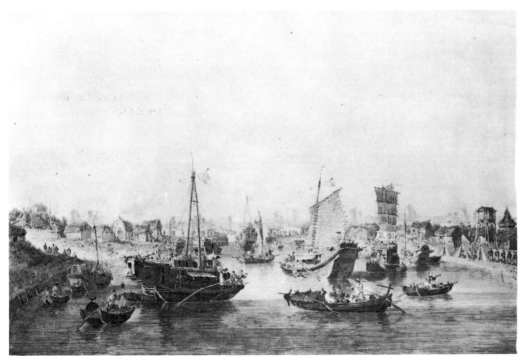

50 *Barges Preparing to Enter the Hwang-ho*
MAIDSTONE, Maidstone Museums and Art Gallery. Pencil and watercolour 30·5 × 45·5 cm. Signed and dated lower left: W. Alexander f.99.

A comparison with two titled drawings in volume III of the India Office Library collection suggests that this scene represents the barges of the embassy preparing to cross the Hwang-ho or Yellow River on 2 November 1793, although the watercolour is traditionally entitled *Chinese Barges of the Embassy Passing through a Sluice on the Grand Canal*. At the point where the Grand Canal intercepted the river the Hwang-ho was about three miles wide and muddy with strong currents. Before guiding their vessel into the treacherous river each junk's crew performed a number of rituals including the slaughtering of a cockerel and the setting-off of firecrackers. Alexander's placid watercolour, made six years after the event, shows no signs of any such excitement. He depicts himself sketching from the nearest barge. In his *Journal* a part of the entry for 2 November reads, 'At 8 a.m. the fleet halted just before entering the Whang-ho [sic] or Yellow River', and an insert in pencil adds, 'vide a drawing of this subject.' Like the previous drawing (Plate 49) this watercolour belonged to Gerald Hughes of York and was bequeathed to Maidstone in 1959.

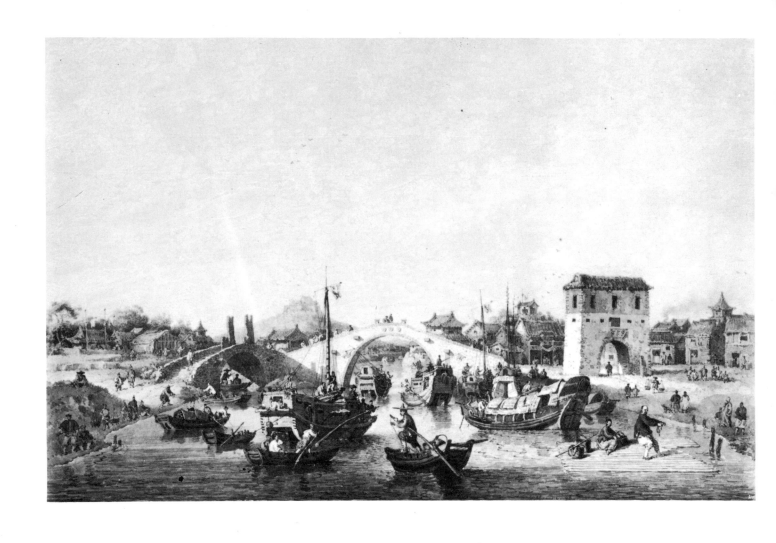

51 *Barges of the Embassy Preparing to Pass under a Bridge, Soochow*
LONDON, British Museum, Department of Prints and Drawings. Pencil and watercolour
30·5 × 45·6 cm. Signed and dated lower right: W. Alexander. 96.

The embassy passed through Soochow, 'The Paradise of China', on the evening of 7 November 1793, five days after crossing the Hwang-ho. Alexander shows the barges lowering their masts in order to be steered under a footbridge. The British noticed that although Chinese bridges were in general elegantly proportioned they must have been weakly constructed, as wheeled vehicles were only allowed to pass over very few of them. This stunning picture is known in five other watercolour versions and as an engraving by William Byrne as plate forty of *Staunton*. In the print the composition is given more weight to the left hand side by the insertion of a portion of canal bank with three seated figures watching the barges. The watercolour versions belong respectively to volume III of the India Office Library collection, London, Maidstone Museums and Art Gallery, a private collection in London, the Cecil Higgins Art Gallery, Bedford, and one was formerly with The Leger Galleries, London. Only the British Museum picture and the print are dated, both 1796. Alexander again portrays himself sketching from one of the barges. John Barrow in *Travels in China* described the 'yachts' of the embassy as having an antechamber for servants and baggage, in the middle a sitting-and dining-room about fifteen feet square and behind this two or three sleeping rooms and a kitchen. At the extreme rear were 'small places like dog kennels' for the boatmen. The provenance of this drawing is unrecorded.

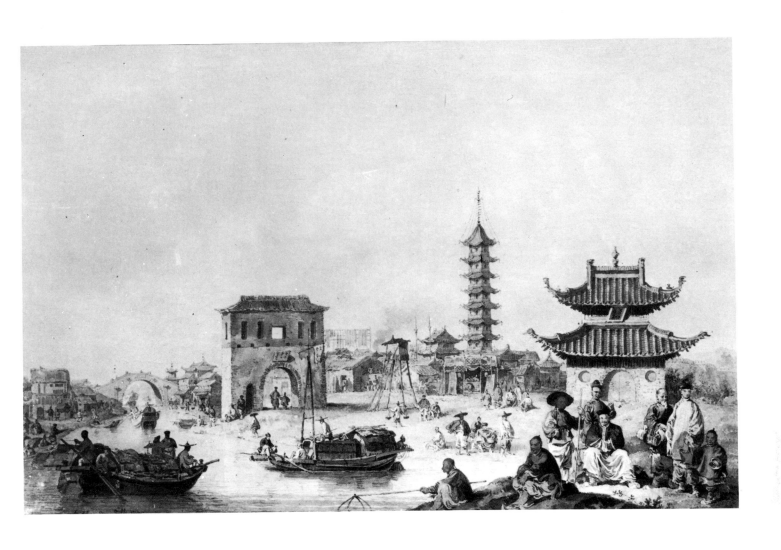

52　*Suburbs of a Chinese City*
DUBLIN, National Gallery of Ireland (Smith gift). Pencil and watercolour 39·9 × 45·2 cm. Signed and dated lower left: Wm. Alexander delt. 1795.

The scene of this picture has yet to be identified. The watercolour is close in design to the engraving by Pouncy for plate thirty-eight of *Staunton*, but it seems likely that the print was made after another version of the watercolour which was bought by The Leger Galleries from a sale at Christie's on 5 June 1973. The Dublin drawing differs from the *Staunton* plate in the angle of the bridge in the background and in one or two other small details. The fisherman in the foreground and the man seated near him appear in one of the wall paintings in the Music Room of the Royal Pavilion, Brighton, derived no doubt from the engraving rather than from either of the watercolours. The bridge and the arch or gateway building are very close to features of the *Barges of the Embassy Preparing to Pass under a Bridge, Soochow* (Plates 51 and VII). This drawing was part of the Smith gift to the National Gallery of Ireland in 1872.

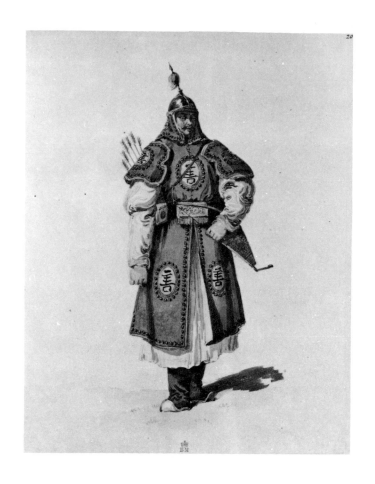

The Loo-za or famous fishing Bird of China.

(*above left*)
53 *A Soldier in his Full Uniform*
LONDON, British Museum, Department of Prints and Drawings. Pencil and watercolour
23·2 × 18·2 cm.

A version of this drawing showing the quiver to the soldier's right and a sword in his left hand is in the Paul Mellon collection at the Yale Center for British Art, New Haven. Plate seventeen of *The Costume of China* is etched after the Mellon design, with some minor changes. The subject is an infantry soldier in the same uniform as those guarding a small fortress in the *Military Post on the Eu-ho* (Plate 48). The British found the appearance of the soldiers somewhat ludicrous. On 6 November 1793 Macartney wrote in his *Journal*, 'Many of them wore steel helmets, as they are supposed to be, though I suspect they are only of burnished leather or glittering pasteboard. The uniforms which are very showy and of different colours, red, white, blue, buff or yellow, must be very expensive, but after all these troops have a slovenly unmilitary air, and their quilted boots and long petticoats make them look heavy, inactive and effeminate.' The drawing belongs to the album of Chinese scenes by Alexander purchased in 1865 from the Rev. Charles Burney for the Department of Prints and Drawings in the British Museum.

(*above right*)
54 *The Famous Fishing Bird of China*
LONDON, British Museum, Department of Prints and Drawings. Pencil and watercolour
22·8 × 17·9 cm.

A less-finished version of this drawing is in volume III of the India Office Library collection. Alexander described the use of the fishing bird, which he calls the *Loo-za, Louah* or *Leutze*, on 6 November 1793: 'These curious birds are sent into the lake to dive for fish, which they generally find very soon, and bring immediately in their beaks to [the] boat of their master, a ring is put on the lower part of the neck to prevent gorging their prey, the throat being very capacious. When they encounter a larger fish than could be brought in the beak, the boatmen go to their assistance. One of these birds well trained is worth a considerable sum, 2 or 3 procuring sufficient maintenance for a man and his family. The Louah is about the size of a duck, in form something like a Raven of dark colour . . .'. From this last sentence and from the drawing it is clear that Alexander was far from being an ornithologist and his sketch of the bird had to be reworked by the botanical and zoological draughtsman Sydenham Edwards (c. 1768–1819) before it could be engraved by William Skelton for plate thirty-seven of *Staunton*. Edwards successfully transformed Alexander's scruffy bird into a well-groomed creature worthy of its correct Latin name *Pelicanus Sinensis*. This drawing by Alexander belongs to the same album as the previous illustration of a soldier (Plate 53).

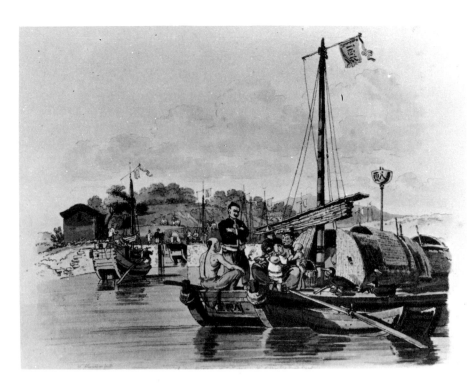

55 *The Costume of China*, plate forty-eight: *Fisherman and his Family*
Print published 1 November 1804. Hand-coloured aquatint 32 × 26 cm.

Fisherman and their families lived together on board their junks. In some parts of China there were as many people living on the water as in the surrounding countryside. Alexander's *Journal* tells us that two or three *Louah* birds could maintain a family (see Plate 54). The family in this picture appears to have three. The standing man with folded arms is perhaps a visitor. One of the small children has a gourd strapped to his back; this was to act as a float should he fall overboard.

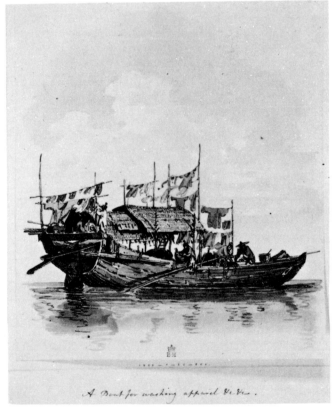

A Boat for washing apparel &c &c.

56 *A Boat for Washing Apparel*
LONDON, British Museum, Department of Prints and Drawings. Pencil and watercolour 19·3 × 16·3 cm.

Alexander noted at the beginning of the album containing this drawing. 'These boats are the residence of women who live by washing, and travel among the vessels of the canals to procure business.' If what John Barrow has to say on the subject of Chinese cleanliness is true, business may not have been very swift for the washerwomen. In *Travels in China* he wrote, 'They [the Chinese] are what Swift would call a *frowzy* people. The comfort of clean linen, or frequent change of undergarments is equally unknown to the Sovereign and to the peasant', and he also claimed that the use of soap was unknown in China. Lord Macartney echoed Barrow's words and elaborated: 'They seldom have recourse to pocket handkerchiefs, but spit about the rooms without mercy, blow their noses in their fingers, and wipe them with their sleeves, or upon anything near them.' There is a slight pencil sketch for this drawing in volume I of the India Office Library collection.

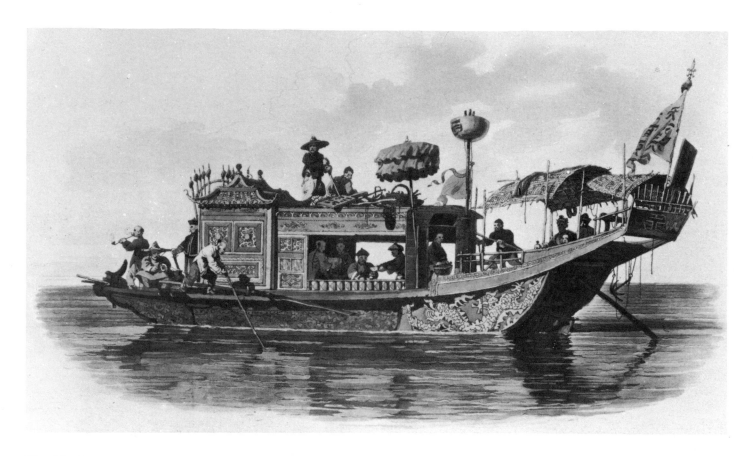

57 *The Costume of China*, plate twenty-four: *A Mandarin's Travelling Boat*
Print published 1 December 1799. Hand-coloured aquatint 32 × 26 cm.

The rich decoration covering every inch of woodwork on this barge singles it out from the humble homes of the fishermen or washerwomen (Plates 55, 56 and VIII). In order to signal other river-users out of its way, it carries a double umbrella which indicates the authority of the traveller and a flag upon which is written his rank and employment. The mandarin can be seen inside being waited on by servants while his wife or mistress sits under a canopy near the stern.

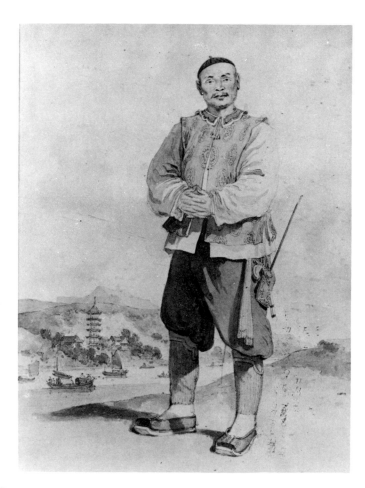

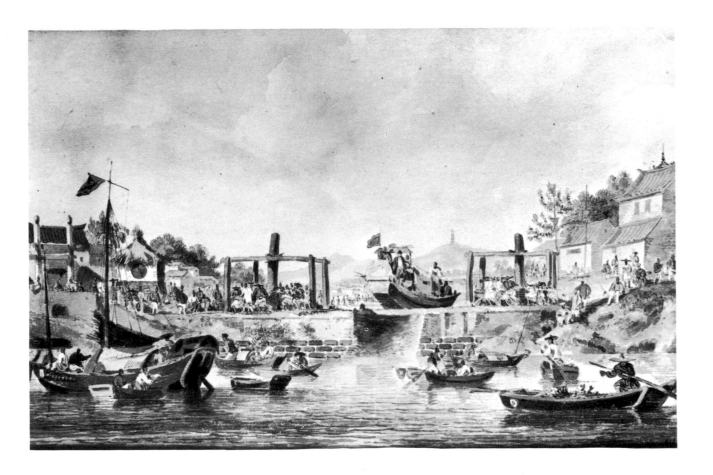

59　*Boat Passing over an Inclined Plane near Ning Po*
MANCHESTER, University of Manchester, Whitworth Art Gallery. Pencil and watercolour
24·1 × 37·3 cm.

On 16 November 1793 Alexander, Dr. Dinwiddie and Colonel Benson travelled together from
Hangchow towards Chusan, having separated from the other members of the embassy who were
proceeding south to Canton. Near Ning Po they encountered a new and rather alarming method of
manoeuvring from one canal to another. The inclined plane or glacis over which the flat-bottomed
junks were hauled by man-powered capstans was situated at the point where one canal met
another at right angles. The boat was dragged up a gravelly slope and propelled forward down
another incline on the opposite side. Alexander recorded in his *Journal*, 'The impetus in launching
down nearly run us into the opposite bank . . . the declivity was so sudden that we were obliged to
stand by glasses, cups and other moveables.' In the drawing one of the embassy barges is about to
be 'launched' over the edge of a glacis. One of the British gentlemen is bravely standing near the
front and a member of the Chinese crew holds up a piece of semi-circular matting to prevent too
much water being taken aboard. Two other drawings of the front view of a barge crossing a glacis
are in volume III of the India Office Library collection and the subject was etched for *The
Costume of China* (Plate IX). The three drawings represent a less-developed version of the
composition than the print and are probably earlier. Thomas Allom adapted *The Costume of China*
etching for his illustration to the Rev. G. N. Wright's *China Illustrated* which he incorrectly entitled
Junks Passing an Inclined Plane on the Imperial Canal (fig. 10). None of the members of the embassy
mentioned any of these glacis on the Grand Canal. Alexander's drawing was presented to the
Whitworth Art Gallery by Mrs. James Worthington in 1899.

(*opposite bottom*)
58　*A Tradesman, Hangchow*
MAIDSTONE, Maidstone Museums and Art Gallery. Pencil and watercolour 23 × 17 cm.

This beautiful watercolour was given to the Maidstone Museum at the end of the last century by
R. J. Fremlin. Alexander etched the subject for plate forty-five of *The Costume of China*, adding a
basket containing birds' nests on the man's right arm. In the caption he noted that the costume, a
sleeveless jacket, quilted cotton stockings and a velvet collar, is that of a middle-class man and
that the background is a scene at Hangchow. The embassy reached Hangchow at noon on 10
November 1793, having taken twenty-seven days to travel the entire length of the Grand Canal.
From Hangchow, Alexander and several of the other gentlemen of the embassy were to be sent to
Chusan and from there to Canton by sea rather than continue with Macartney across country.
This picture is not dated and other sketches of this man are not known, but the high degree of
finish indicates that it is likely to have been executed after the return to England. The *Costume of
China* is dated 1 November 1804.

60 *A Wheel for Raising Water for Irrigation*
LONDON, India Office Library and Records. Pencil and watercolour 18·3 × 23·4 cm.

The numerous alterations suggest this may be Alexander's first attempt at drawing the large water-wheel used by the Chinese for irrigation. A finished drawing of the wheel is in the album of Alexander drawings in the Department of Prints and Drawings in the British Museum and an engraving after Alexander by William Skelton appears as plate forty-four to *Staunton*. Alexander may have seen such a wheel himself but it is more likely that this drawing is copied from one by Parish or another member of the embassy who accompanied Lord Macartney between Hangchow and Canton. On 6 December 1793, when the leaders of the embassy were *en route* for Canton and Alexander was at Chusan, Lord Macartney observed in his *Journal* that sugar-cane plantations on either side of the river rose as much as twenty feet above the level of the water: 'The water is, however, easily raised to the level required by a wheel which the current gives motion to. The nave is made of strong timber, but the other parts, the fellies, the spokes, the scoops etc., are chiefly of light bamboo. As this machine appeared to me equally simple and efficient I desired a model and a drawing to be made from it.'

61 *The Costume of China*, plate eighteen: *Peasantry Playing Dice*
Print published 1 March 1799. Hand-coloured aquatint 32 × 26 cm.

In his *Journal* entry for 28 November 1793 while he was at Chusan Alexander wrote, 'I saw 3 or 4 men at a table playing at a game similar to Dominos, which I had before understood to be of French origin. The double dice used at this game were exactly the same. To see it practiced here was quite unexpected.' The men in the picture are not playing dominoes but they are using dice similar to those known in Europe. The participants are watermen and a farm worker holding a hoe is looking on. The figure in the centre of the group looks very much like the man from Tourane Bay used several times by Alexander (Plates 2–4). The artist has made an extraordinary error of drawing, in the back of the head of the nearest squatting figure. The man's right ear, which should not be visible, appears to have crept round his shaved head with the most disconcerting result. Apart from this peculiarity the figures are well characterized and agree with Alexander's and Macartney's written accounts of the loquacious and querulous nature of the Chinese workmen,

(above right)
62 *The Costume of China*, plate twenty-nine: *A Chinese Comedian as a Military Officer*
Print published 13 August 1801. Hand-coloured aquatint 32 × 26 cm.

In the caption to this illustration Alexander tells us that he drew this actor from life at a performance given for the embassy at Canton on 19 December 1793. The event marked the arrival of the ambassador in Canton and is briefly described in Lord Macartney's *Journal*: 'We then adjourned to the theatre, on which a company of comedians (who are reckoned capital performers, and have been ordered down from Nankin on purpose) were prepared to entertain us.' Alexander noted that these stage performances were accompanied by wind instruments and gongs, the sound of which was often deafeningly loud. He described the actors as 'richly habited, but their gestures were extravagant, and their declamation most boisterous.' The 'female' figure who stands at a door in the background to this print is probably a eunuch since women were not encouraged to show themselves on stage. A preparatory drawing of the head and shoulders of the actor is in volume I of the India Office Library collection and a related watercolour showing a very similar figure, but in reverse, belongs to the Brighton Museum and Art Gallery. In the Brighton drawing the head-dress and costume of the figure differ from the aquatint and a triangular flag replaces the decorative halberd held in the lower hand. One of the staircase window lights at the end of the Corridor or Long Gallery in the Royal Pavilion, Brighton, features a figure loosely based on *The Costume of China* illustration.

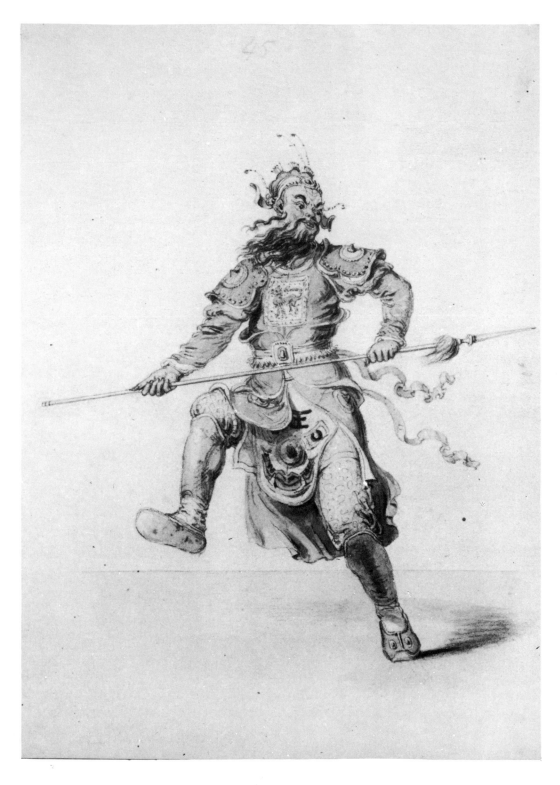

63 *A Stage Player*

CAMBRIDGE, Fitzwilliam Museum. Pencil and watercolour 20 × 14·3 cm.

This drawing, numbered in pencil '45', is reproduced in aquatint as plate forty-five of *Picturesque Representations . . . of the Chinese*. Together with two other studies for the publication, *A Bonze* and *A Chinese Itinerant Musician*, it was purchased for the Fitzwilliam Museum from an album which was with Colnaghi, in 1954. This actor may be another member of the company who performed for the embassy in Canton in December 1793. The day after he was entertained by the comedian featured in the previous illustration (Plate 62) Lord Macartney was surprised to find that when he rose in the morning a play was already in progress. He commented in his *Journal* that 'The actors now here have, I find, received directions to amuse us constantly . . . during the time of our residence. But as soon as I see the conductors I shall endeavour to have them relieved, if I can do it without giving offence . . .'. The efforts of the players were clearly wasted on the British who had no understanding of the content of the marathon performances and disliked the musical accompaniment. Alexander, however, seems to have enjoyed the glittering visual impact of the events and this drawing convincingly captures the fiery spirit of one of the actors.

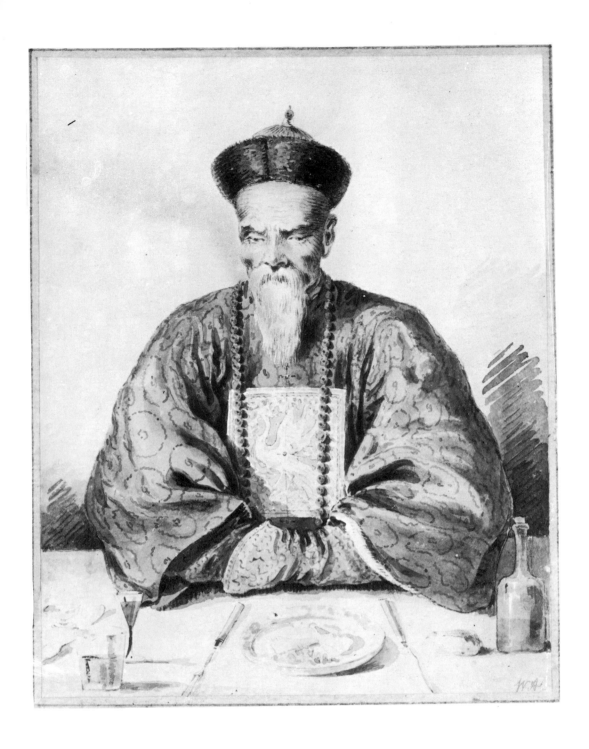

64 *The Fo-yen of Canton*
OXFORD, Ashmolean Museum. Pencil and watercolour 20·9 × 16·4 cm. Initialled lower right: WA.

Alexander inscribed this drawing on the mount 'The Fou-yen of Canton—when sitting at table with the Ambassador etc.' On 8 January 1794 Lord Macartney held talks with the chief mandarins of Canton including the viceroy, the Fo-yen and the Hoppo at the British 'factory' outside the town. Alexander recorded in his *Journal* that 'these mandarins afterwards sat down to an elegant collation in the hall of the Factory.' His description of this particular function leaves us in no doubt that he was present. He noticed that the viceroy appeared to be pro-British and well-disposed towards Macartney, and in Alexander's words, 'It was pleasant to see them hob nob together during the repast.' The Chinese had the same difficulties using European cutlery as the British encountered with chopsticks and the unfortunate Fo-yen appears to have been given his knife and fork the wrong way round. The Fo-yen, who was immediately responsible to the viceroy, was the governor of the province. He in turn was superior to the Hoppo or Fiscal who was in charge of the revenue of the province. Alexander made three other versions of this portrait. They belong respectively to volume III of the India Office Library collection, London, the British Library (Additional Manuscripts) collection and the Department of Prints and Drawings of the British Museum. A watercolour *The Fow-yen* [sic] *of Canton when Sitting at Table with Lord Macartney* was sold for 16 shillings at Christie's on 16 May 1881. The Oxford drawing was purchased for the Museum in 1942.

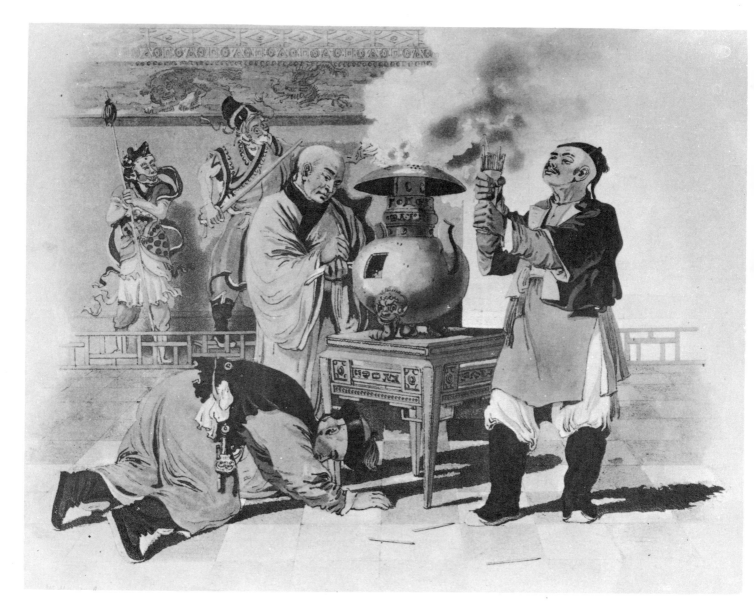

65 *The Costume of China*, plate twenty-five: *A Sacrifice at the Temple*
Print published 19 October 1800. Hand-coloured aquatint 32 × 26 cm.

The embassy left Canton on 8 January 1794 and anchored off the Portuguese settlement of Macao on 12 January. This illustration from *The Costume of China* is probably derived from Alexander's experience of visiting a 'temple' or place of worship in Macao on 12 January. He described what he saw in his *Journal*: 'The favours that votaries have to ask of their idol Fo, to which some were making offerings, seem to depend on chance. One Chinese was holding a vessel containing some tallies marked with Chinese characters. This was shaken till one dropped out, this, being examined, was carefully registered by the officiating Priest. The devotee seemed to be much agitated during the ceremony, and bowed his forehead to the floor occasionally. When all the tallies had fallen from the box some gilt and silvered paper is burnt, and so concludes this rite of the pagan church.' Thomas Allom rearranged Alexander's aquatint for his illustration *A Devotee Consulting the Sticks of Fate* for the Rev. G. N. Wright's *China Illustrated*, disguising it somewhat by the addition of hanging lanterns and the alteration of one or two details, such as the face of the bird-like deity in the background which he made more human in appearance.

66 *The Cave of Camoens at Macao*
LONDON, Martyn Gregory Gallery. Pencil and watercolour 19·5 × 10·5 cm.

This delightful drawing which has much of the quality of a holiday snapshot was one of those sold from an album once in the possession of Lord Macartney at Sotheby's on 1 April 1976. It bears the same false 'WA' inscription as do a number of other drawings in that collection (Plate 16), but in this case what is probably a genuine signature 'WA' can be seen underneath. On the old mount is the inscription 'Cave of Camoens at Macao', and in another hand, 'from a sketch by Cap. Parish.' As with the inscription to the same effect beneath *The Approach of the Emperor of China to his Tent* (Plates 42 and VI) from the same album, the information that the drawing is after Parish is probably incorrect. There is no reason why Alexander could not have visited Camoen's cave himself and the entry in his *Journal* for 12 January 1794 reads like a first-hand account: 'The Gardens of his Excellency's habitation are delightful. They lie on an elevated situation and are laid out with good

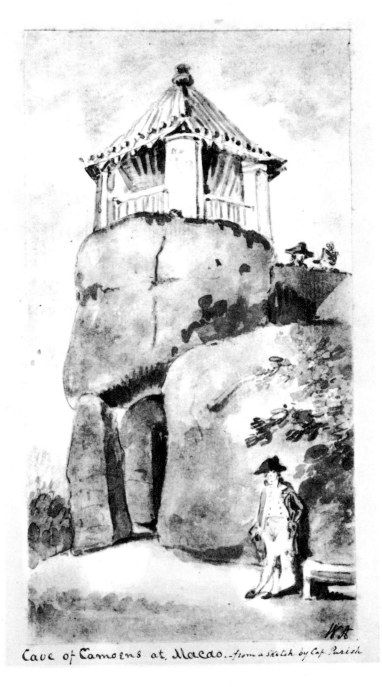

Cave of Camoens at Macao. from a sketch by Cap. Parish

taste, some parts are highly romantic among immense masses of natural rocks. On the summit of one of these is a summer house of Chinese architecture which commands a extensive [sic] and luxuriant view of the inner harbour and part of the city, with the more distant prospect of the sea studded with various islands. This assemblage of rocks is also to be regarded, being the spot where the poet and traveller Camoens wrote his epic poem the Lusiad.' Luiz de Comões (1524–80) was exiled from Portugal for killing a court official in a brawl and sailed for India in 1553. He appeared in Macao a year later and wrote *Os Lusiádas*, an epic poem about the great Portuguese explorers, which was published in 1572, two years after his return to Lisbon. His cave or grotto in the garden rented to the British Supercargo Mr. Drummond was a place of pilgrimage for nearly every British artist who went to the China coast at the end of the eighteenth and beginning of the nineteenth centuries. It inspired James Wathen, who went there in 1812, with an emotion akin to religious awe. 'We entered with reverence this little Temple of the Muse of Portugal. We were shown . . . the stone seat on which the Bard of the 'Lusiad' sat and wrote. And though it was now the latter end of December, the weather was soft and mild; and the sun, sinking Westward, shed a tender warmth, and threw such strong and bold shades from the objects it enlivened, as made them infinitely beautiful.' Another possibly earlier watercolour version of Alexander's drawing is in volume III of the India Office Library collection and one was sold at Sotheby's, Hong Kong, on 1 November 1974. Lot 1224 of the sale of Alexander's collection after his death was 'Camoen's Grotto at *Macao, China* by Mr. Alexander.' The design was also engraved for the second text volume of *Staunton* and a further drawing of the same subject but including an artist, probably Alexander himself, sketching, is in volume III of the India Office Library collection. It was a frequent practice of Alexander's to depict himself in a picture (Plates 50, 51 and VII) and this adds to the weight of evidence against the picture illustrated here being derived from a sketch by Parish.

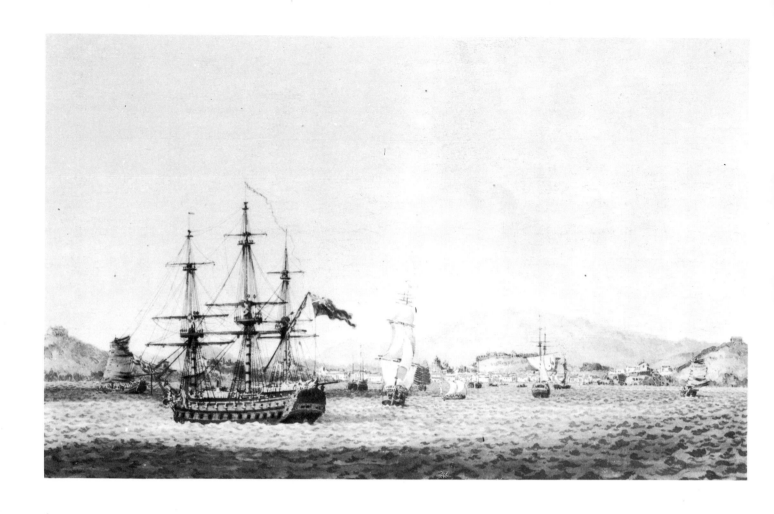

67 *The 'Lion' Anchored off Macao*
LONDON, Martyn Gregory Gallery. Pencil and watercolour 25 × 40 cm.

Another handsome watercolour of the same size, *The Forts of Anunghoi Saluting 'The Lion' in the Bocca Tigris*, also with the Martyn Gregory Gallery in 1977, is a pair to this picture. H.M.S. *Lion*, a sixty-four-gun man-of-war which carried the ambassador and his immediate suite to China and back is here seen at anchor off Macao in January 1794. The embassy did anchor off Macao on the outward journey on 20 June 1793, but on this occasion their distance was calculated to be seven leagues, or about twenty miles away from the town. This watercolour may represent the position described by Macartney on 13 January 1794: 'In the afternoon at four o'clock pm. we came to an anchor in five fathom water in Macao roads, the town bearing west about six miles distant.' In all the *Lion* and the other ships of the embassy, the *Hindostan*, *Jackall* and *Clarence* waited at Macao for about six weeks while other East Indiamen assembled in order to travel back to England in convoy. By coincidence the *Lion* was the ship on which Alexander's brother Harry served for a time as a sailor, and a small drawing of the vessel appears in the background of his portrait (Plate 70).

(*opposite top*)
VIII *The Costume of China*, plate forty-eight: *Fisherman and his Family* (Plate 55) ‹

(*opposite bottom*)
IX *The Costume of China*, plate sixteen: *Boat Passing over an Inclined Plane Near Ning Po*
Print published 1 September 1798. Hand-coloured aquatint 26 × 32 cm.

The subject of this Plate is discussed fully in the caption for Plate 59.

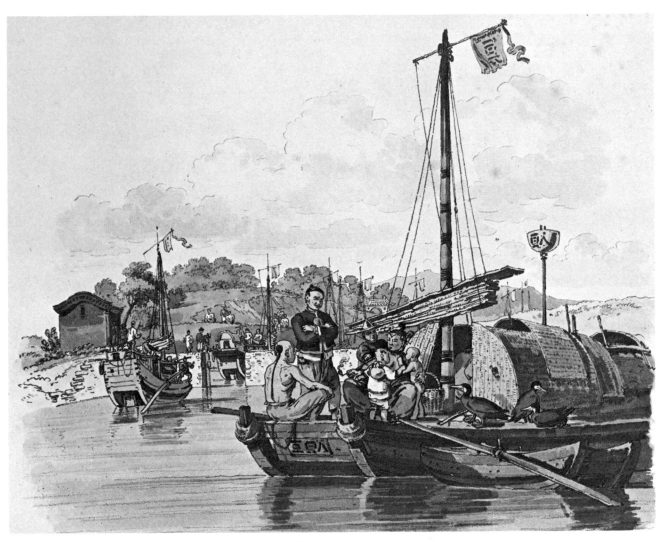

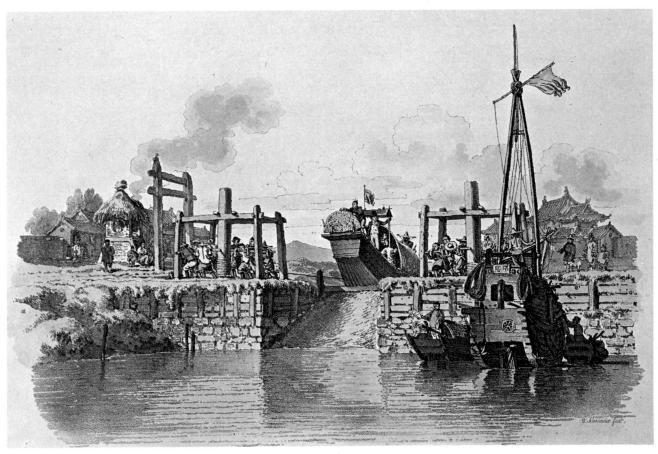

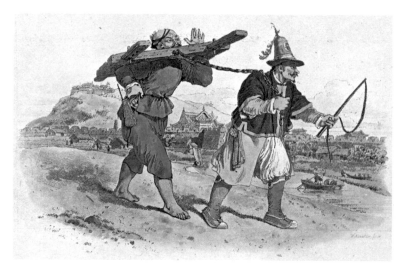

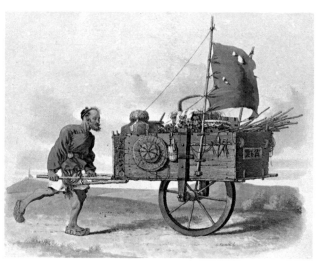

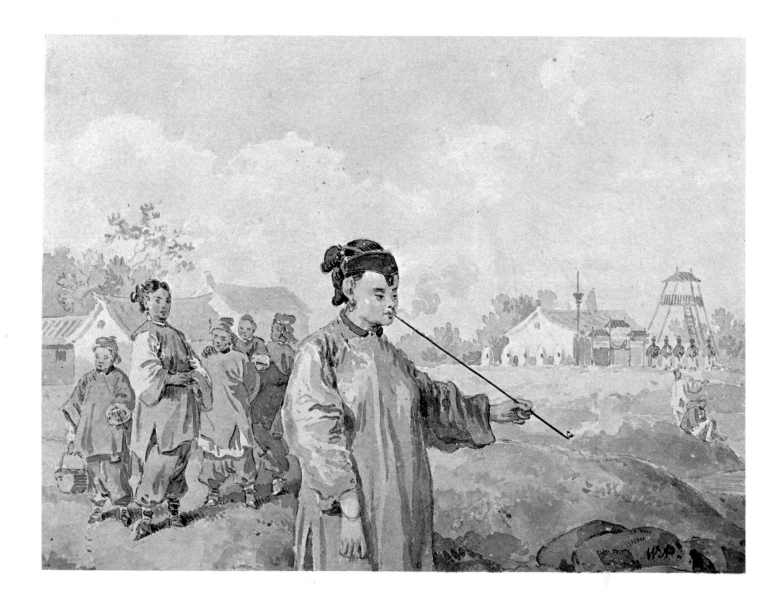

(*opposite top left*)
X *The Costume of China*, plate ten: *The Punishment of the Cangue* (Plate 37)

(*opposite top right*)
XI *The Costume of China*, plate twenty-two: *A Chinese Porter or Carrier*
Print published 1 December 1799. Hand-coloured aquatint 26 × 32 cm.

John Barrow in *Travels in China* recorded that for the last leg of the journey to Peking thirty-nine handcarts were used to transport the embassy luggage. This particular type of one-wheeled cart is equipped with a sail to make the task of the porter less burdensome. A preparatory drawing for this print, showing the man walking rather than running and the legs of the cart lowered in readiness for a stop, is in the Paul Mellon collection at the Yale Center for British Art, New Haven.

(*opposite bottom*)
XII *Chinese Girl Smoking Tobacco*
LONDON, The Leger Galleries. Pencil and watercolour 16·5 × 21 cm. Initialled lower right: WA.

On the old mount to which this drawing was attached was the inscription 'Chinese girl smoking Tobacco which is largely cultivated to the north of Pekin 4 Sep. 1793.' On 4 September Alexander and Hickey were 'immured' at Peking, the main ambassadorial party having left for Jehol, and it seems doubtful that the inscription, which is not in Alexander's hand, gives the actual date on which the drawing was made. A less finished version of the picture is in volume III of the India Office collection. Men, women and children of all ages smoked tobacco, especially in the north of China. The British had not expected to see women walking freely in public and were pleasantly surprised to find many of them not only visible but friendly and intrigued by the appearance of foreign visitors. This drawing was one of those sold at Sotheby's on 1 April 1976. Its unusual composition, with the lower part of the nearest figure cut off by the edge of the paper, recalls pictures by the Impressionists inspired by the new art of photography rather than eighteenth-century notions of form.

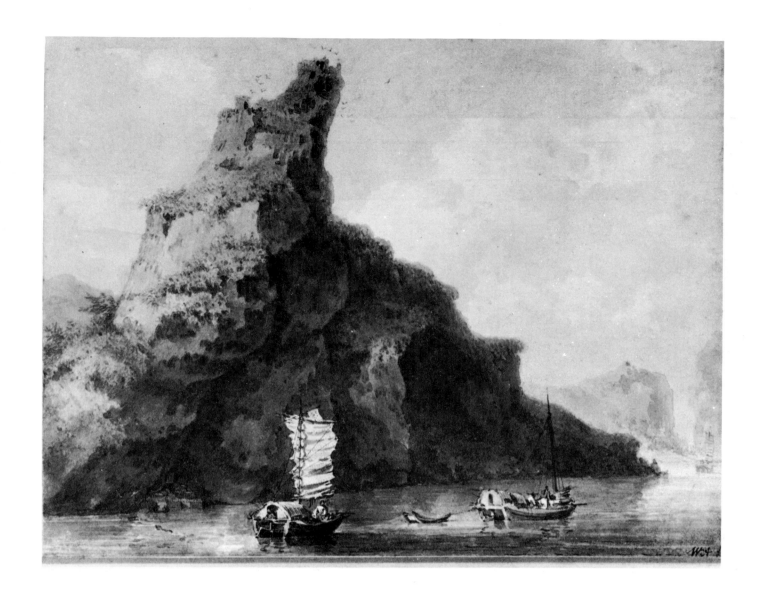

68 *The Rock of Kuan-yin*
LONDON, collection of the late S. R. Hughes-Smith. Pencil and watercolour 18 × 23·5 cm.
Initialled lower right: WA f.

This atmospheric drawing presents something of a mystery as it does not seem to be possible that
Alexander actually visited the cliff of Kuan-yin. Neither this watercolour, nor the version in
volume I of the India Office Library collection, nor the engraving by John Landseer which is plate
forty-three in *Staunton* give any indication that the design is not from nature, but the fact remains
that the rock is situated on the waterway between Hangchow and Canton along which Alexander
did not travel. The members of the embassy who did take this route visited Kuan-yin on 15
December 1793, four days before reaching Canton where Alexander, who had travelled by sea from
Chusan, was waiting. Since the journey between Kuan-yin and Canton took several days it is
unlikely that Alexander could have made an excursion especially to see the rock, and he makes no
mention in his *Journal* of any trips out from Canton. It has to be assumed that once again he had
made a successful adaptation of a drawing by someone else, perhaps Parish or Barrow. The India
Office Library version of the watercolour, which is less finished, is inscribed in Alexander's hand,
'The Rock Quang-yen, in a cavity near the water's edge is a temple of the Bonzes.' The rock was
named after the Goddess of Mercy, Kuan-yin, whose image its natural formation was thought to
resemble. Inside a small community of monks worshipped a bodhisattva of prodigious size and
splendour. Lord Macartney described the entrance to the cave in highly emotive prose: 'The
river . . . bent and elbowed itself into a deep cove or basin, above which enormous masses of rocks
rose abruptly on every side, agglomerating to a stupendous height and menacing collision. The
included flood was motionless, silent, sullen, black. The ledge where we landed was so narrow that
we could not stand upon it without difficulty. We were hemmed around with danger.'

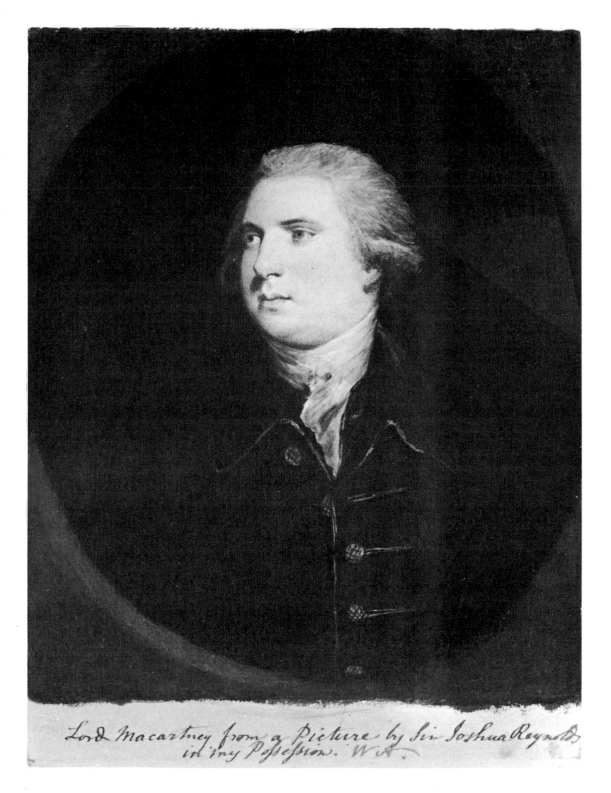

Lord Macartney from a Picture by Sir Joshua Reynolds in my Possession. W A.

69 *Lord Macartney, after a Picture by Reynolds*
LONDON, India Office Library and Records. Watercolour and body colour 20 × 16·4 cm.

Alexander inscribed this portrait 'Lord Macartney from a picture by Sir Joshua Reynolds in my possession. WA.' It appears that the portrait he owned was the one now at Petworth House, or a version of it, painted by Reynolds in 1764. In the Alexander sale at Sotheby's lot 1244 on day 10 was listed as 'Portrait of Lord Macartney by Reynolds in oil', and it sold for 6 guineas to 'Triphook' according to the British Library annotated copy of the sale catalogue. Six guineas was a reasonable buy if the picture was one of quality as in 1764 Reynolds himself charged 30 guineas for a head, 50 for a Kit Cat and 70 for a half-length portrait. According to the *Gentleman's Magazine* obituary, Alexander attracted the attention and praises of Reynolds while a student at the Royal Academy for the skilful copies he made of pictures by other artists. Alexander in turn had a particular interest in Reynolds. In his *Commonplace Book*, now in the British Library, he wrote: 'Sir Joshua Reynolds sometimes prepared (or commenced) his pictures with size and egg as a vehicle for his colours. This he did not make generally known being afraid that his customers would not have been so well satisfied. This was told me by Sir Geo: Beaumont.'

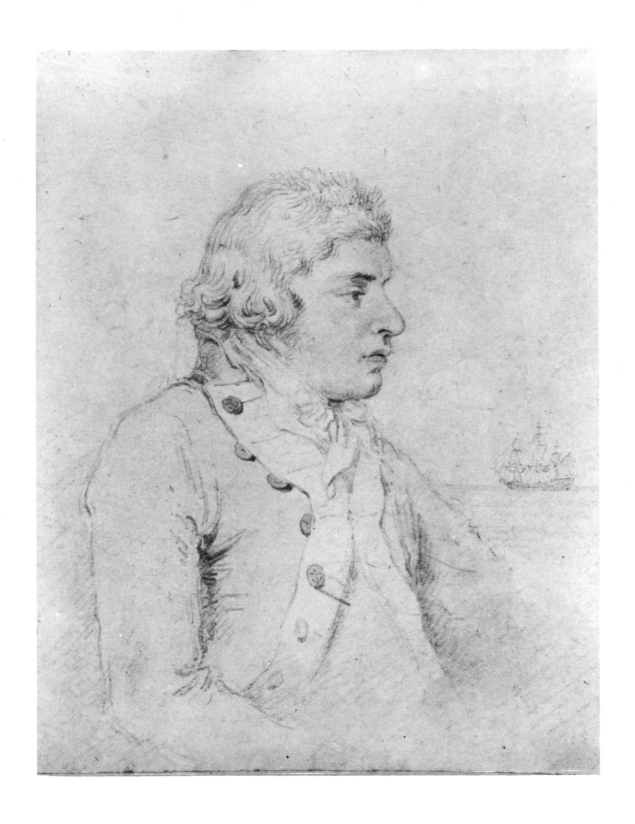

70 *Portrait of Harry Alexander*
LONDON, collection of the late S. R. Hughes-Smith. Pencil and watercolour 15·7 × 12·6 cm.

Harry, one of William Alexander's two brothers, was his junior by four years but died well before him in 1802. This small portrait is inscribed on the back 'My dear Brother of his Majesty's Ship Lion' and 'Dear Brother Harry Alexander of his Majesty's Ship Obiit Jan.y 18th 1802 Aetatis sua 31.' Harry probably served on the *Lion* some time after the ship returned from the embassy to China. He would have been twenty-three in 1794. Had he been present on the embassy Alexander would surely have mentioned the fact in his *Journal*. This drawing is the only known portrait by the artist of a member of his family and it has appropriately remained with the Hughes descendants until the present day.

71 *Figure Studies for the Review of the Kentish Volunteers at Mote Park*
LONDON, private collection. Pencil and watercolour
19 × 26·5 cm.

Formerly attributed to Edward Dayes, this sheet of studies was exhibited by Andrew Wyld and Anthony Reed as the work of Alexander in the autumn of 1977 when it was purchased by a private collector. Studies of British figures are quite rare in Alexander's *oeuvre* as the majority of his work after the embassy was architectural or topographical. The best known exception is the composition for which these studies were made, *The Royal Review of the Kentish Volunteers at Mote Park* (Plate 72).

To the Right Honorable Lord Romney, Lord Lieutenant of the County of Kent, &c. &c.
This Representation of the DINNER GIVEN by his Lordship, TO THE KENTISH VOLUNTEERS, in Presence of their MAJESTIES and the ROYAL FAMILY. Is, with Permission, Inscribed by his Lordship's most obliged humble Servant. Will'm. Alexander.

72 *The Royal Review of the Kentish Volunteers at Mote Park*
NEW HAVEN, Yale Center for British Art (Paul Mellon collection). Published 1 March 1800. Hand-coloured aquatint 39·2 × 56·5 cm.

The following advertisement appeared in the *Maidstone Journal* on 20 August 1799 and on subsequent dates: 'Royal Review of the Kentish Volunteers. On the 26th of October next will be published dedicated by permission to the Right Hon. Lord Romney, Lord Lieutenant of the County, a representation of the interesting spectacle of the volunteers of Kent, as entertained by his Lordship at his Seat, the Mote, near Maidstone on the 1st August 1799, in the presence of their Majesties . . . by William Alexander, Draughtsman to the late Embassy to China. The size of the plate 21 inches by 14, price £1.1.0 plain, £2.2.0 coloured . . .'. A further notice in the *Maidstone Journal* on 22 October regretted the postponement of the publication until 1 January 1800, and a revision of the plate size to 22½ × 17 inches. In the event the print was published on 1 March 1800. Accompanying it was a printed plan of the lay-out of the tables at which the volunteers sat for their meal, a copy of which is in the Maidstone Museums and Art Gallery. This was delivered 'gratis' to subscribers to compensate for the postponement of the aquatint. The banquet given by Lord Romney was for 5,319 men from the county of Kent who volunteered to fight for their country in the event of a Napoleonic invasion. On 1 August 1799 King George III and Queen Charlotte left London at 5.00 am., had breakfast at Sevenoaks and arrived at Maidstone at midday. After the review the whole company sat down at 3.00 p.m. to a meal, the Royal party in a marquee, the volunteers at ninety-one tables which, it was stated, could have covered a distance of 13,333 yards if placed end to end. At these tables were consumed fifty lambs, 220 dishes of boiled beef, 220 of roast beef, 700 fowls, 300 hams, 300 tongues, 220 joints of roast veal and more. To commemorate the event East Lane in Maidstone was renamed 'King Street' and a domed pavilion was erected in the park. In the picture the new Mote House designed by Daniel Alexander (architect of Maidstone, Dartmoor and other prisons) can be seen under construction in the background. After its completion in 1801 the old house was demolished. The attractive clock-tower is now over the stable block beside the 'new' house. An unfinished watercolour version of the *Royal Review* is in the Paul Mellon collection at New Haven and another in the Maidstone Museums and Art Gallery is also unfinished. A third version, which must have been more complete, was exhibited at the Royal Academy in 1800. In the aquatint as in the two known watercolours Alexander included a figure, probably himself, sketching the view among the spectators in the foreground.

73 *Dr. Monro's House at Fetcham, near Leatherhead*
LONDON, British Museum, Department of Prints and Drawings. Pencil and watercolour 19·7 × 29·2 cm.

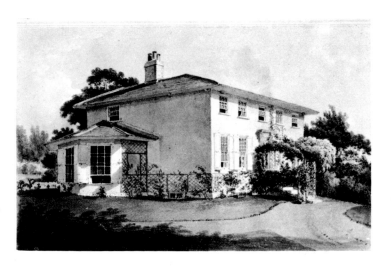

On the back of this attractive watercolour is the inscription 'Fetcham. Cottage of Dr. Monro by Mr. Alexander who was one of the China expedition.' It was presented to the British Museum by P. D. O. Coryton in 1961. Monro rented this house between 1795 and 1805 and there he entertained many of the most eminent landscape artists of the day including Turner, Varley, Cotman, Farington, Hearne and Edridge. This drawing is evidence of one of Alexander's visits to Fetcham. He also visited the Monros after they had taken a new country house, 'Merry Hill' near Watford in Hertfordshire, in 1807. Dr. Monro was described by James Alexander as his brother's 'intimate friend' (see Appendix I).

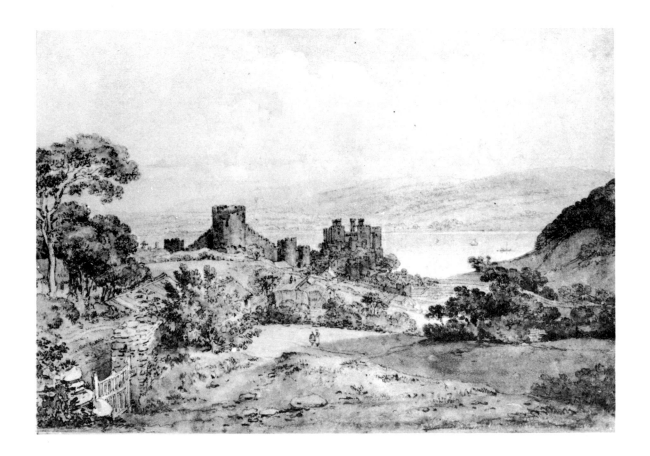

74 *Conway Castle*
HARROW, Harrow School. Pencil and watercolour 20·9 × 29·8 cm.

Conway Castle is situated near the north Wales coast not far from Beaumaris, Anglesey, the native town of Alexander's mother. It was a favourite subject for topographical artists in the late eighteenth and early nineteenth centuries and was seen to much better advantage before the building of the railway in 1848. Three more sketches of Conway Castle are in the collection of the late S. R. Hughes-Smith, London, and another drawing is in the Laing Art Gallery, Newcastle. At the Alexander sale at Sotheby's in 1817, lot 610 on day 5 included 'Conway Castle in colours' and lot 803 on day 7 was comprised of sixteen sheets of drawings, including an unspecified number of the castle. This watercolour shows a view from the south-west. Alexander's drawing is undated but it may belong to the same trip to north Wales as the drawing of *Plas Mawr, Conway* (Plate 75) which is dated 1802. As in a number of his Chinese landscapes, Alexander gave the picture a sense of depth by placing the foreground in shadow and selecting a view which contains a natural serpentine path leading from the foreground to the middle distance. The watercolour was part of the collection of C. J. Heagen which was bequeathed to Harrow School before 1937. Its earlier provenance is unrecorded.

75 *Plas Mawr, Conway*
CARDIFF, National Museum of Wales. Pencil and
watercolour 30·5 × 23·5 cm. Dated lower left: 1802.

This watercolour of Plas Mawr at Conway, is typical of
Alexander's British drawings. It is inscribed on the back
of the mount, 'W. Alexander, Ancient House at Conway
called the *Plas Mawr* 1802'. Carefully delineated in
pencil and tinted with transparent coloured washes, it
represents the kind of close-up view of village life amidst
crumbling architecture that became one of his favourite
subjects. The sleeping dog and the woman at the well
have counterparts in numerous other drawings by the
artist. The National Museum of Wales purchased the
drawing from Agnew's in 1970.

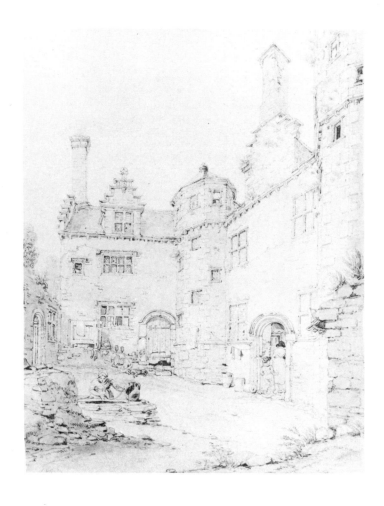

(*opposite top*)
76 *The Dent-de-Lion Gatehouse near Margate*
LONDON, collection of the Late S. R. Hughes-Smith. Pencil 20 × 26·4 cm.

The Dent-de-Lion gatehouse is all that remains of what must have been a sizeable fifteenth-century
mansion at Garlinge, about two miles south-west of Margate in Kent. It is named after the family
of Daundelyon who died out in 1445 and whose arms are over the main arch. In Alexander's time,
as now, the ruins stood in a farmyard. It is just possible that the artist sitting on a barrel making a
sketch is Alexander's friend Henry Edridge rather than the usual self-portrait. In the Alexander sale
in 1817, lot 721 on day 6 was a drawing *Dandelion Gate* by Edridge. It is known that Alexander and
Edridge spent a good deal of time in each other's company and it would not be surprising if they
went sketching together, especially in Alexander's home county. The subject of the Dent-de-Lion
gatehouse was also drawn by the young Turner (the picture is reproduced in A. J. Finberg's *Life of
J. M. W. Turner R.A.*, Oxford, 1939; second edition, 1961) and Benjamin Pouncy. Pouncy's view
was exhibited under the title *A Haycart Approaching a Castle Gateway* in Agnew's *105th Annual
Exhibition of Watercolours and Drawings*, 23 January–24 February 1978. In addition the subject was
engraved by Walker after a design by William Parsons, the comedian and close friend of William
Woollett. This drawing passed from Edward Hughes through the family to S. R. Hughes-Smith.
Another pencil drawing of the gateway, this time a closer, upright view, is in the Mellon collection
at Yale.

(*opposite bottom*)
77 *Old Cottage near Dorking*
MAIDSTONE, Maidstone Museums and Art Gallery. Pencil 20·8 × 27·5 cm.

Like the previous drawing of *The Dent-de-Lion Gatehouse*, this is in pencil only. It is inscribed at the
upper left edge 'near Dorking W. Alexander.' Inscriptions in the same hand are to be found on a
drawing of *Beaumaris Castle, Anglesey*, also at Maidstone, and a sketch entitled *Machine for Weighing
Hay at Maidenhead* in the Henry E. Huntington Library and Art Gallery, San Marino, California.
This drawing of Dorking is probably associated with one of Alexander's visits to Dr. Monro at
Fetcham between 1795–1805, as Dorking is only a few miles from Leatherhead. The style of the
drawing is also very close to that of various members of the Monro School including Henry and
Alexander Monro, two of Dr. Thomas's sons. In the Department of Prints and Drawings in the
British Museum there is another drawing by Alexander made in the same area, *View of a House in
Westhumble Lane, near Dorking*.

Dent de Lion Gateway. W. Alexr

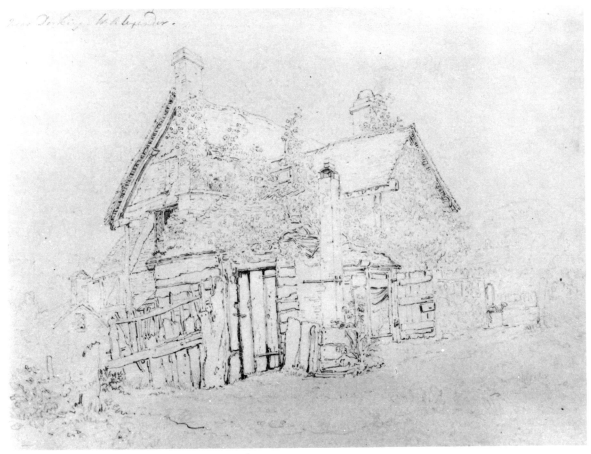

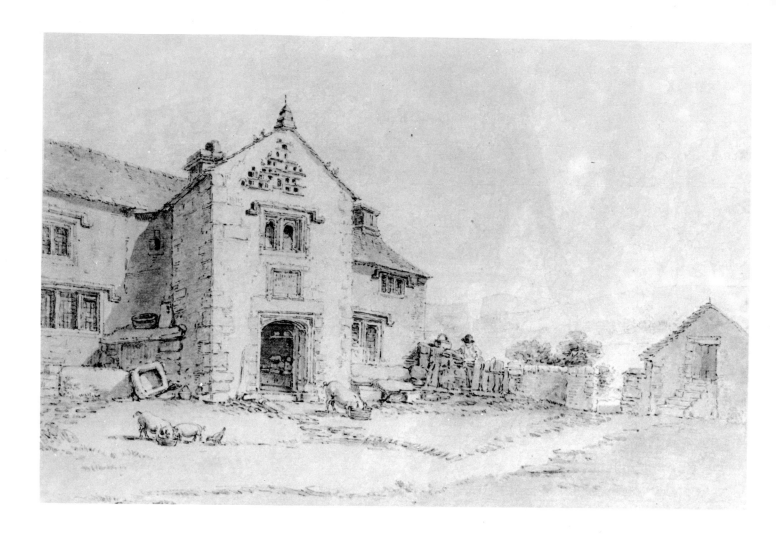

78 *Farmyard*
SAN MARINO (CALIFORNIA), Henry E. Huntington Library and Art Gallery. Pencil and watercolour 23·5 × 34·3 cm.

This attractive rural scene is unidentified but the style of architecture and gentle hills are suggestive of the west of England. A large number of untitled drawings by Alexander present problems for the historian, who is not aided by the fact that the artist is known to have visited practically every corner of the country. At the sale after his death there were drawings by him from counties of England as far apart as Cumberland and Cornwall as well as a number from parts of Wales (Plates 74 and 75). This drawing was purchased for the Henry E. Huntington Library and Art Gallery from the Squire Gallery, London, in 1947.

(*opposite*)

80 *St. Michael's Church, Macclesfield*
MAIDSTONE, Maidstone Museums and Art Gallery. Pencil and watercolour 16·2 × 22 cm. Dated lower left: 1806.

This, one of the finest of Alexander's English watercolours, was engraved by John Neagle for William Byrne's *Britannia Depicta*. The provenance of the picture is known in some detail. It is probably the watercolour *Macclesfield Church* which appeared at Christie's on 8 April 1891 as lot 304 and was sold for £2 and 17 shillings. It was subsequently in the collection of J. M. W. Turner's biographer A. J. Finberg and was exhibited at the Cotswold Gallery, London, in 1926 when the asking price for it was 15 guineas. On 20 December 1949 Agnew's of Bond Street wrote to Gerald Hughes of York offering him the watercolour for seventeen guineas. The letter from Agnew's and a second thanking him for his cheque and dated 30 December 1949 are affixed to the back of the picture. Hughes bequeathed it to Maidstone in 1959. The bold composition with its close attention to the fall of light on architectural detail indicates Alexander's indebtedness to Girtin and Turner in the early years of the nineteenth century. Parts I and II of *Britannia Depicta* also contain views by Alexander of *Eton College, The Market Cross, Leighton Buzzard* (see Plate 81) and *The Cross at Sandbach*. In the entry in his *Diary* for 27 November 1807 Joseph Farington recorded a visit made to him by John Byrne who mentioned that he had 'paid Alexander 8 guineas each for 7 drawings.' Although not concerning the same publication, this incidental remark gives an idea of the fee that was to be earned producing watercolours for architectural or topographical illustration at this time.

79 *Street Scene with an Inn*

BIRMINGHAM, Birmingham Museums and Art Gallery.
Pencil with brown and grey wash 20·4 × 26·7 cm. Signed
on board above window on the right: W. Alexander.

In contrast to the drawings illustrated on the preceding
pages, this study shows the artist just as concerned with
tone as with line. The back lighting, casting the fronts of
the houses into shadow, creates a strongly three-
dimensional effect and shows Alexander moving away
from the pencil style which he derived from Hearne and
from his studies of Old Masters such as Canaletto. Here
he is closer to the stronger watercolour technique of
Girtin and the generation of painters associated with the
Sketching Society. The drawing was in the Fuller
Maitland and J. Leslie Wright collections before entering
the collection of the Birmingham Museums and Art
Gallery.

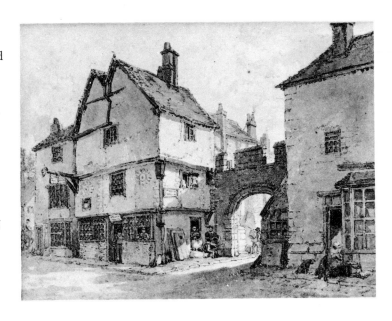

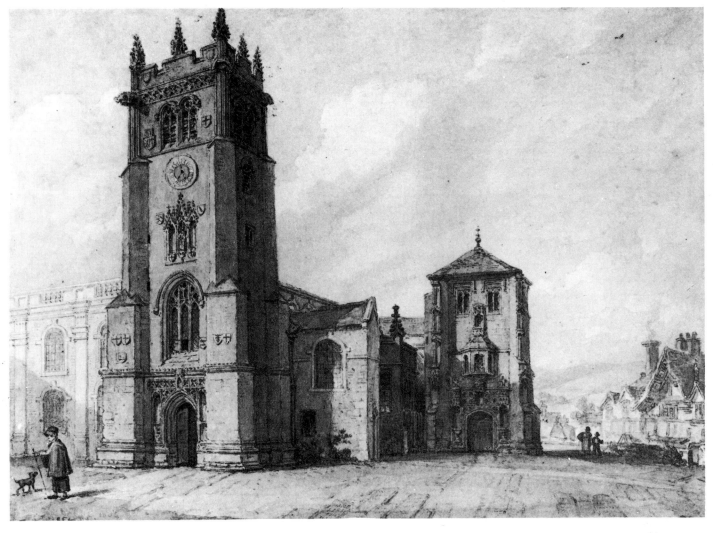

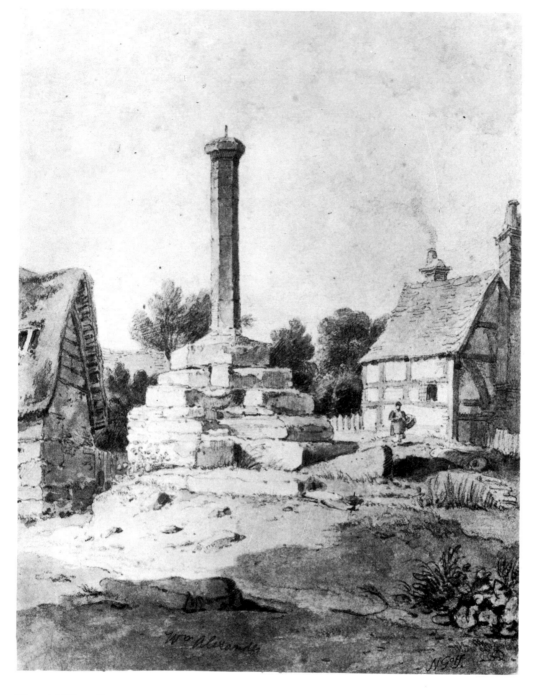

81 *A Village Cross*

EDINBURGH, National Gallery of Scotland. Pencil and watercolour 20·5 × 16·2 cm.

The inscription 'Wm. Alexander' is not a signature but there is little doubt that this watercolour is by the artist. It was bequeathed to the Royal Scottish Academy in the nineteenth century by the antiquary and bibliophile David Laing and came from that institution to the National Gallery of Scotland in 1910. Alexander intended to publish a book on crosses and made a considerable number of drawings throughout the country. At the Royal Academy he exhibited in 1801 a *North View of Waltham Cross, Great Marlow*, and in 1804 a *Cross at Leighton Buzzard*, possibly the drawing which belonged to the West Park Museum, Macclesfield, until 1976 when it was stolen. At the sale of his collection after his death in 1817, lot 950 on day 8 was listed as 'Antient Crosses of England and Wales' and consisted of over a hundred sketches and drawings by Turner, Girtin and Alexander himself as well as other eminent artists. With the drawings was a quarto volume of manuscript notes on the crosses and the catalogue entry indicated that 'The late Mr. Alexander had in view to publish the above collection.' The lot was sold for £63 to a buyer named Booth according to the annotated catalogue in the British Library. This Mr. Booth must have been acting for John Britton. In Britton's *Autobiography*, which is written in the third person, he says, '. . . he purchased a mass of sketches, with manuscript and printed memoranda, relating to Crosses . . .'. One of the illustrations to volume I of John Britton's *The Architectural Antiquities of Great Britain*, a *View of Queen's Cross, Northampton*, engraved by J. C. Smith after George Shepherd, is dedicated 'To Wm. Alexander Esq.r F.A.S. whose very accurate Sketches and Drawings of ancient Crosses, and other subjects of Antiquity, has afforded much information to his obliged friend the Author.'

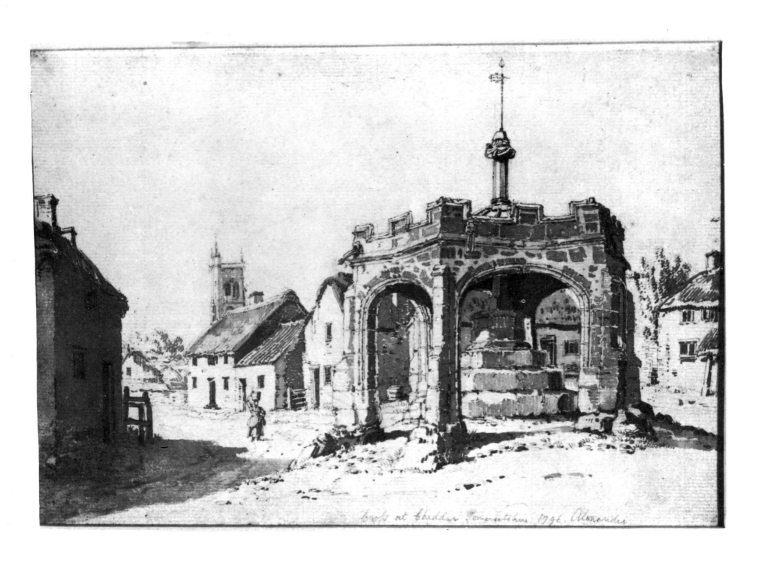

Cross at Cheddar Somersetshire 1796. Alexander

82 *Cross at Cheddar, Somerset*
PENRITH, private collection. Pencil and wash 18 × 25·5 cm.

This drawing is inscribed in pencil 'Cross at Cheddar
Somersetshire 1796. Alexander' by an unidentified hand.
It was etched by John Smith in 1806 for volume I of
John Britton's *The Architectural Antiquities of Great Britain*.
If the date on the drawing is correct it suggests an early
beginning to Alexander's interest in market crosses. The
picture was purchased for a private collection from the
Ruskin Gallery, Birmingham, in July 1933.

83 *An Account of the English Colony in New South Wales: A Night Scene in the Neighbourhood of Sydney*
Print published 29 June 1802. Line engraving by T. Powell after Alexander 16·8 × 24·5 cm.

This strange illustration of rather European-looking natives cavorting by a camp fire is included
here as it shows Alexander employed at the rather menial task of working up a drawing by another
artist for an engraver. The original sketch was probably by an amateur Thomas Watling (1762–?),
a limner of Dumfries who was sentenced to fourteen years transportation to Australia in 1789 for
forging Bank of Scotland guinea notes. It may be assumed that the wooded landscape, which looks
very unlike 'the neighbourhood of Sydney', is largely the invention of Alexander. It is probable that
Alexander was forced to take on work of this kind purely for financial reasons before he obtained
the post of drawing master at Great Marlow in August 1802 which ensured him a regular salary.
Two other illustrations in this book *Natives round a Fire* and *Native Family Sheltering from a Storm*, are
also after drawings by Alexander.

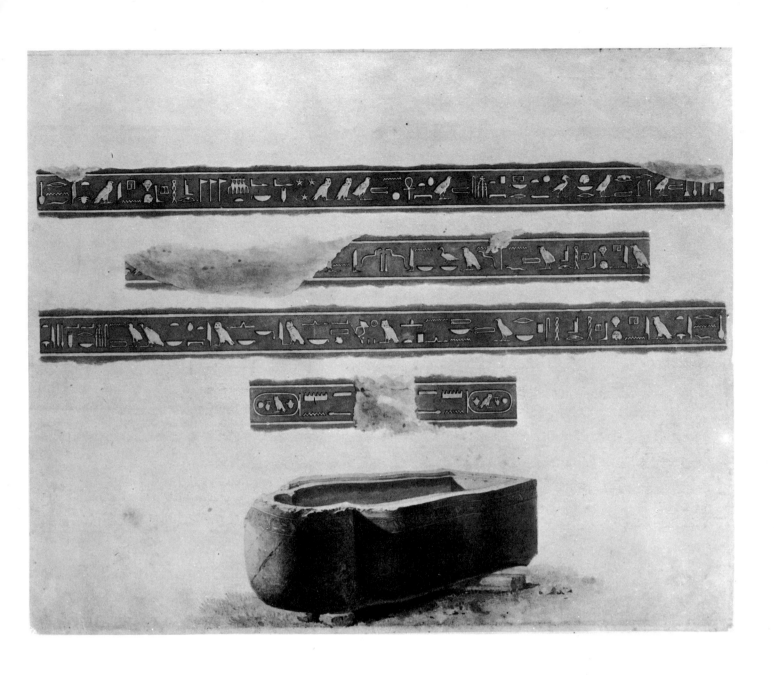

84 *The Sarcophagus of Hanata*
LONDON, British Museum, Department of Prints and Drawings. Pencil and watercolour
30·1 × 36·2 cm.

Joseph Farington recorded in his *Diary* on 19 December 1802, 'Alexander during the vacation [from Great Marlow] which is from the last day of November to the first day of February, is employed in copying the Egyptian Antiquities at the Museum which he means to publish.' This drawing of a sarcophagus is contained in an album *Drawings of Egyptian Antiquities Collected by the Institute of France in Egypt under Napolean's Direction and Surrendered to the British Army.* It seems likely that Alexander's work in drawing the Egyptian antiquities stood him in good stead when he came to apply for the post of keeper in the department of Antiquities at the British Museum a few years later.

85 *Actaeon Attacked by his Hounds*
LONDON, British Museum, Department of Prints and
Drawings. Pencil and monochrome wash 22·3 × 16 cm.

This is one of the studies from volume II of Alexander's
*Drawings from the Gallery of Antiquities in the British
Museum*, made while he was a keeper at the British
Museum. Joseph Farington wrote in his *Diary* on 4 March
1810: 'Alexander said that the Trustees of the British
Museum had voted to him 250 guineas for drawings
which he made from antiquities in that Collection.' This
particular drawing was engraved by William Worthington
and published as plate forty-five to part II of Taylor
Combe's *A Description of the Collection of Ancient Marbles in
the British Museum*, published in 1815, only a year before
Alexander's death. The sculpture of Actaeon was found
by the artist Gavin Hamilton in the ruins of the villa of
Antoninus Pius in 1774. It is now in the reserve collection
of the Museum.